THE WITNEY & FAIRFORD BRANCH

THROUGH TIME

Stanley C. Jenkins

AMBERLEY PUBLISHING

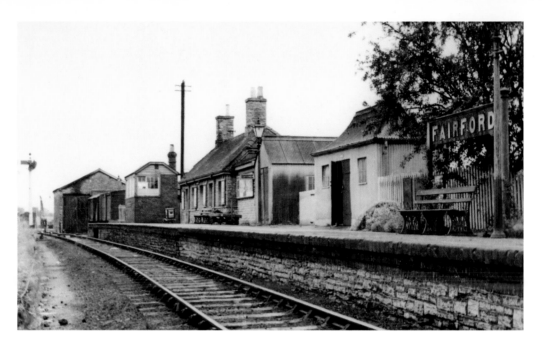

Fairford Station
Fairford station, the terminus of the East Gloucestershire Railway, looking west towards the goods yard in the early 1960s.

First published 2013

Amberley Publishing
The Hill, Stroud, Gloucestershire, GL5 4EP
www.amberley-books.com

Copyright © Stanley C. Jenkins, 2013

The right of Stanley C. Jenkins to be identified as the
Author of this work has been asserted in accordance with
the Copyrights, Designs and Patents Act 1988.

ISBN 978 1 4456 1649 0 (print)
ISBN 978 1 4456 1668 1 (ebook)

British Library Cataloguing in Publication Data.
A catalogue record for this book is available from the
British Library.

Typesetting by Amberley Publishing.
Printed in Great Britain.

The Origins of the Railway

The first plans for a railway through the blanket-making town of Witney were made as early as 1836, when the London & Birmingham Railway promoted a line from Tring, through Oxford and Witney, to Cheltenham. This line, which would have been built to what later became the standard gauge of 4 feet 8½ inches, was rejected by Parliament in favour of the broad-gauge (7-foot) Cheltenham & Great Western Union Railway, which joined the Great Western main line at Swindon.

A spate of schemes came during the 1840s, including the 'Oxford, Witney, Cheltenham & Gloucester Independent Railway', which obtained an Act of Parliament for the construction of a 'mixed-gauge' (i.e. dual-gauge) line from Oxford to Cheltenham. The Great Western Railway (GWR) and its ally the Oxford Worcester & Wolverhampton Railway (OW&WR) then obtained powers for a branch line to Witney via North Leigh, while the standard-gauge faction resurrected their earlier scheme for a line from Tring to Cheltenham. Other railways were projected at that time, but few can have been serious attempts to build new railways. In particular, it seems that the GWR schemes were 'bluffs', designed to keep rival companies well away from the Oxford and Cheltenham areas.

It appeared that Witney would remain isolated from the railway network and thereby cut off from the mainstream of Victorian economic development. Happily, Witney was saved from the fate of towns such as Northleach and Burford by an unexpected occurrence. Relations between the OW&WR and the parent GWR company had been strained for some time – mainly because the Banbury to Birmingham line had been adopted as the main GWR route to the north. The OW&WR directors felt that this was a breach of faith, and began negotiations with rival companies. By 1854, standard-gauge trains were running from Worcester to Euston via the Yarnton Loop – a short connecting line to the north of Oxford.

This was good news for the inhabitants of Witney, as it meant that there was now a chance of their rail link being built. Indeed, in the previous year, the OW&WR had sought powers for a line between Yarnton, Witney and Cheltenham. The Bill had been thrown out by Parliament, but it did, nevertheless, suggest to the promoters of the Witney Railway that powerful main-line interests would support them if they presented a more modest scheme to Parliament.

As the first step towards implementing their scheme, the leading supporters of the venture held a public meeting in Witney on 23 December 1858. Around 400 people turned up, and it soon became clear that local people had lost patience with the GWR and other main-line companies which had, for many years, done little more than talk about a railway between Oxford and Witney. The meeting enthusiastically decided to form a company in order to build a branch line from Witney to the OW&WR at Yarnton, and a provisional committee set about raising capital for the new project.

The committee engaged Sir Charles Fox (1810–74) as its engineer, and in November 1858 the promoters gave formal notice that they intended to make an application to Parliament in the ensuing session for 'An Act to Incorporate a Company for Making and Maintaining a Railway from Witney to Yarnton, in the County of Oxford', with 'all necessary stations, works, and conveniences connected therewith'.

The Witney Railway Bill went before Parliament in the following year. The GWR opposed the Bill, but the Witney Company had the support of the rival standard-gauge companies, and the scheme received the Royal Assent on 1 August 1859. The resulting Act of Parliament (22 & 23 Vic. cap. 46) provided consent for the construction of a railway from Witney to Yarnton, a distance of 8 miles 13 chains.

A time limit of four years was set for completion of the works, while the authorised capital was £50,000 in £10 shares, with a further £16,000 by loans. Walter Strickland, Charles Early, Henry Akers, George Hewitt the younger, John Williams Clinch, Joseph Druce, William Holland Furlonge and Charles Locock Webb were mentioned by name as the first directors, and these gentlemen were to continue in office until the first ordinary meeting of the company, at which meeting 'the shareholders present, personally or by proxy, would elect a new body of directors, or allow the original directors to continue in office'.

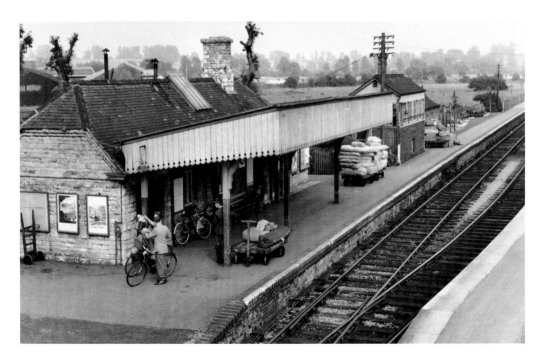

Witney Passenger Station
Witney's second station. It was opened by the East Gloucestershire Railway on 15 January 1873, from which date the original terminus became a goods depot.

The Construction and Opening of the Witney Railway

Construction started at Eynsham in May 1860, and rapid progress was made. In March 1861 Sir Charles Fox was able to report that the heaviest works were nearing completion and 450 tons of rails had been delivered in readiness for the track-laying. On 10 August 1861, the directors announced that the line was in so forward a state that they had been able to travel over it on a locomotive.

Having passed its Board of Trade Inspection, the new railway was opened on Wednesday 13 November 1861. Opening day was treated as a public holiday in Witney, and the town was decorated with flags and bunting. Ignoring the November rain, hundreds of people made their way to the station and by midday vast crowds were milling about on the platform and in Station Lane – a new road that had been made by the railway company to create a better means of access to the terminus.

The official first train arrived around mid-morning and, as the locomotive came to rest in the shadow of St Mary's church, bells rang out from the church tower and the Rifle Volunteers' band played martial airs. The first up train left Witney at 11.00 a.m., 'amid the hearty cheering of the spectators', and at 1.00 p.m. the train returned from Oxford, 'where a large accession of passengers, who had been invited by the directors, availed themselves of the return trip to Witney'. Later, a sheep was roasted in Market Place for the townsfolk, while the directors sat down to a 'very elegant *déjeuner*' in St Mary's School.

The regular service of four trains each way between Witney and Oxford commenced on the following day. Full goods facilities were introduced in 1862 and the railway was soon carrying an inwards traffic of coal and wool, and an outwards traffic of blankets. Gross receipts amounted to £2,237 in the first half of 1863 and, after 50 per cent had been deducted to pay the West Midland Railway for working the line, the directors recommended a dividend of 2½ per cent on ordinary capital and 5 per cent on preference shares. In that same year, the West Midland Railway was amalgamated with the GWR and thereafter all services on the Witney Railway were worked by the Great Western company.

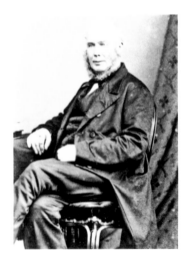

Malachi Bartlett
The photograph shows Malachi Bartlett (1802–75), a local builder who had helped to promote the Witney Railway. In December 1861 he was awarded an £800 contract 'for works at Witney, South Leigh and Eynsham stations', and subsequently carried out a great deal of finishing off work, including bricklaying, carpentry, painting and track laying.

The East Gloucestershire Extension

Although the Witney Railway had been planned as a purely local venture, the directors were keen to extend their branch line beyond Witney, and in 1859 the company surveyed an extension to Northleach, at which point it was hoped to form a connection with a line from Cirencester. In the event, the Witney Railway never progressed beyond Witney, and the extension was eventually built by the East Gloucestershire Railway (EGR), which was formed at a meeting of landowners held at Hatherop Castle near Fairford in 1861.

It was envisaged that the EGR would run from Cheltenham to Andoversford and thence along the Coln Valley to Lechlade. Here the line would divide, with one arm heading eastwards to join the Witney Railway, while the other would run southwards to form a junction with the Faringdon Railway. The scheme was sanctioned by Parliament on 7 August 1862 but, before construction could begin, the GWR withdrew its support. Undeterred, the supporters of the EGR prepared a new Bill for submission to Parliament in the 1864 session.

Having been examined by a Select Committee of the House of Commons, and at even greater length by a Lords Committee, the revised EGR Bill received the Royal Assent on 29 July 1864. The EGR was thereby empowered to build a railway from Cheltenham to Faringdon with a branch from Lechlade to Witney. Construction began at the western end of the route, and by the autumn of 1865 a tunnel was taking shape near Andoversford. Although it was reported that 'considerable progress' had been made, the company was unable to finance its entire scheme and it was therefore decided that the EGR would concentrate its efforts on the completion of a 14-mile branch between Witney and Fairford.

The EGR company obtained an extension of time to complete the works in 1867, and in 1869 construction resumed on the Witney to Fairford section. The line was ceremonially opened on 14 January 1873 when the first down train arrived in Fairford as an 'empty stock working', but the main celebrations took place on Wednesday. Local newspapers reported that the first train had left Fairford at 7.30 a.m., carrying the directors and their invited guests. The engine was 'gaily adorned with flags and evergreens, and a large concourse of people assembled at the several stations to witness the arrival and departure of the trains on this new and capitally-constructed line'.

ON AND AFTER THURSDAY, NOV. 14, 1861,
WITNEY RAILWAY
OPENED
FOR PASSENGER TRAFFIC,
AND TRAINS WILL RUN AT THE FOLLOWING TIMES:
UP TRAINS.

STATIONS					FARES FROM WITNEY
WITNEY	9 15	11 0	4 30	7 35	
SOUTH LEIGH	9 22	11 7	4 37	7 42	
EYNSHAM	9 30	11 15	5 5	7 50	
YARNTON	9 40	11 25	5 15	8 0	
OXFORD	9 50	11 35	5 25	8 10	

DOWN TRAINS.

STATIONS					FARES FROM OXFORD
OXFORD	9 0	11 30	3 40	9 30	
YARNTON	9 10	12 0	3 50	9 40	
EYNSHAM	9 18	12 8	5 57	9 48	
SOUTH LEIGH	9 23	12 13	6 3	9 55	
WITNEY	9 33	12 23	6 13	9 5	

Worcester, November 8, 1861.

A. C. SHERRIFF,
GENERAL MANAGER.

Opening of the Witney Railway
A West Midland Railway time-bill announcing the opening of the Witney Railway on 14 November 1861.

Subsequent History

The East Gloucestershire line was worked as an extension of the earlier Witney Railway, with a service of four trains each way between Oxford and Fairford – a total distance of 25 miles 42 chains. As a result of this extension, Witney's original 1861 station was closed to passengers, and a new station was opened at the bottom of the Church Leys. Thereafter, the old terminus was adapted for use as a goods yard, in which capacity it remained in operation until November 1970.

The GWR continued to operate the Oxford, Witney and Fairford line on behalf of the local companies until 1890, when it purchased the branch outright. Having obtained full possession of the line, the Great Western made many improvements, and Witney station eventually developed into a relatively busy branch-line centre, employing around twenty-six men and handling upwards of 40,000 tons of freight a year. In 1903, goods traffic amounted to 40,935 tons, rising to 46,652 tons in 1913. In that same year, the station dealt with 46,652 parcels, while 38,225 tickets were issued.

Sadly, the railway lost its passenger services in the early 1960s; the last regular trains ran on Saturday 16 June 1962, the East Gloucestershire section being closed in its entirety. Goods services continued on the Witney Railway until 2 November 1970. The very last fare-paying passengers were carried on 31 October 1970, when a special excursion ran from Paddington to Witney. Around 450 people made this sad final journey, which marked the official end of 109 years of railway history in Witney.

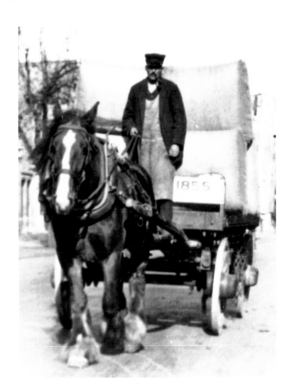

Blanket Traffic
A Great Western horse-dray, piled high with Witney blankets, heads towards the railway station.

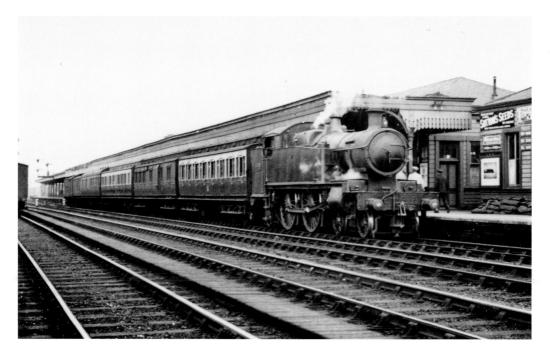

Oxford Station

The railway reached Oxford on 12 June 1844, the first station being a terminus in St Aldate's. The line was extended to Banbury on 2 September 1850, but the existing Oxford station was not opened until 1 October 1852, when the Oxford to Birmingham main line was completed. This second station had a quadruple-track layout, with wooden station buildings. The upper view shows a 'County' class 4-4-2T locomotive alongside the down platform, *c.* 1930, while the lower photograph shows the down-side buildings around 1939.

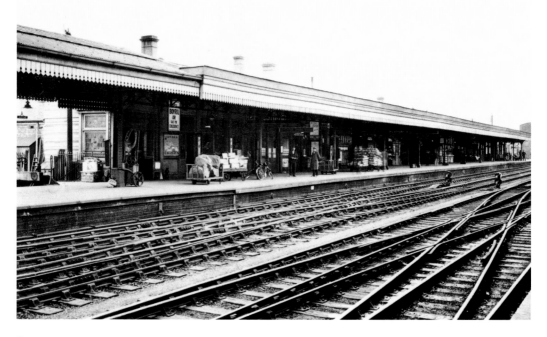

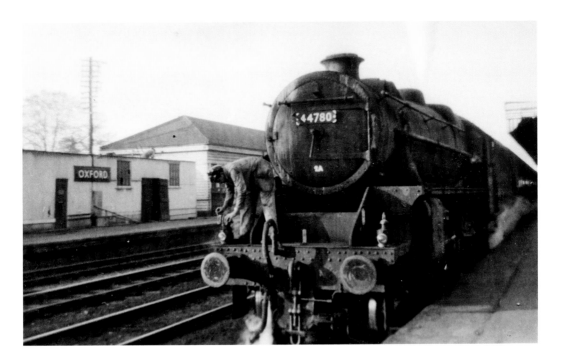

Oxford: Steam and Diesel Motive Power

Above: Ex-London Midland & Scottish Railway class '5MT' locomotive No. 44780 stands in the up platform with a southbound express on a cold but sunny afternoon in November 1965; the fireman is adjusting the headlamps as darkness is about to fall. *Below*: 'Peak' class diesel locomotive No. D48 enters the up platform with a lengthy passenger working, around 1975. The train is probably a long-distance cross-country service between York and Bournemouth. *Inset*: a British Railways platform ticket issued at Oxford.

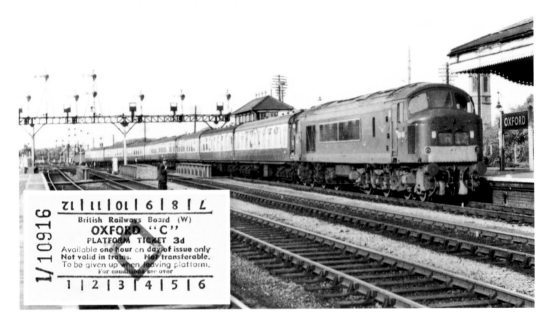

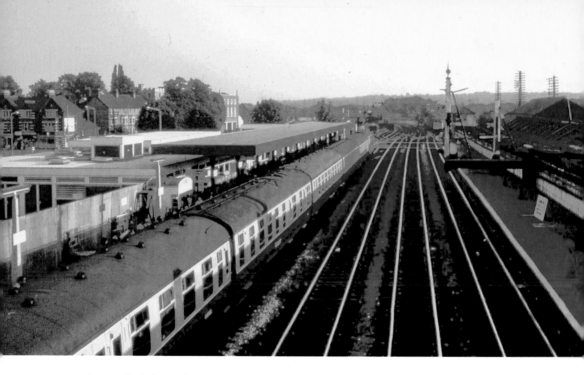

Oxford: Rebuilding Schemes

The station boasted a range of accommodation, including booking facilities, waiting rooms, refreshment room, parcels facilities, mess rooms and toilets. The up and down platforms were linked by an underline subway, and lengthy canopies were provided on both sides. The station was rebuilt in 1970/71, the new station buildings being of purely utilitarian appearance, as shown in the upper picture. However, following a further reconstruction scheme, the present-day station, shown in the lower photograph, was brought into use in 1990.

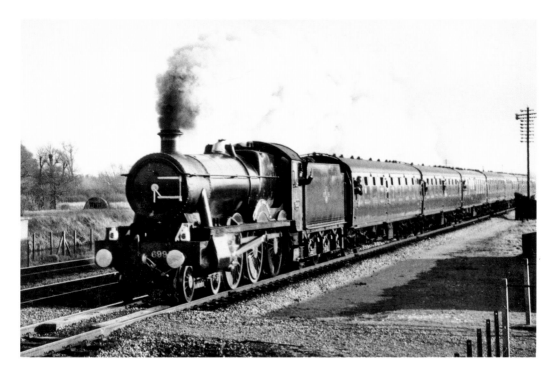

Oxford: Port Meadow

Leaving Oxford, Witney trains ran northwards along the multiple-tracked GWR main line, with the verdant expanse of Port Meadow visible to the left and Wytham Hill discernible in the distance. The upper photograph shows 'Hall' class locomotive No. 6998 *Burton Agnes Hall* heading northwards across Port Meadow with one of the last steam-worked Poole to York workings on 3 January 1966. The colour view, taken in December 2012, shows class '165' unit No. 165104 heading southwards on the same section of track.

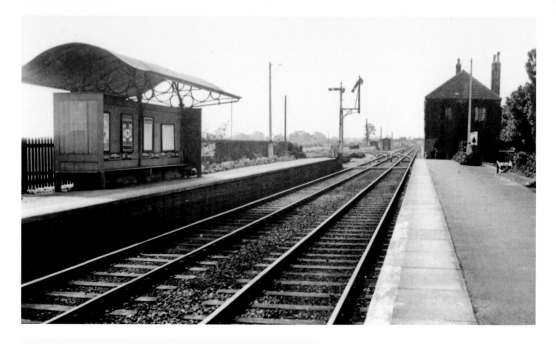

Yarnton Junction

Diverging north-westwards onto the OW&WR route at Wolvercot Junction, trains soon reached Yarnton Junction, some 3 miles 65 chains from Oxford, which was opened in conjunction with the Witney Railway in 1861. This station was laid out with three platforms, although the outer branch platform line was fenced off and used as a siding. Yarnton was a curiously isolated place with no road access and, looking at its primitive facilities, it is easy to sympathise with the Witney Railway directors who in the 1860s had complained that the station was 'unfinished'. The upper photograph, dating from around 1930, shows the ornate waiting shelter that was provided on the down platform, together with a Victorian Gothic building that served as the station building and stationmaster's house. The lower picture provides a detailed study of the signal box, which was erected in 1909 when the station was re-signalled in connection with an early power-signalling scheme.

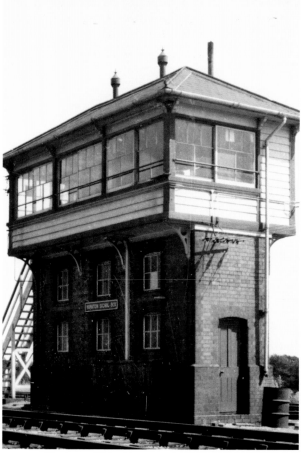

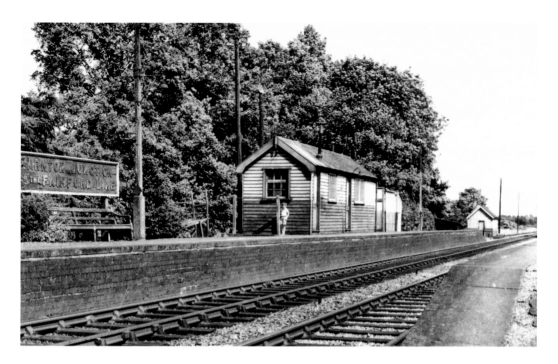

Yarnton Junction

Above: The original station building was sited about 5 feet from the running lines, and it is said to have shaken perceptibly whenever a train ran past! It is believed that the building eventually became unsafe and, rather than rebuild it, the GWR erected a simple wooden hut on the up platform. This timber-framed building contained just two rooms, one of which served as a ticket office while the other sufficed as a waiting room. *Below*: A general view of the station, looking towards Oxford.

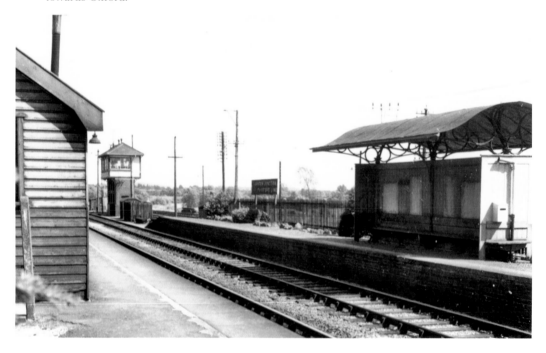

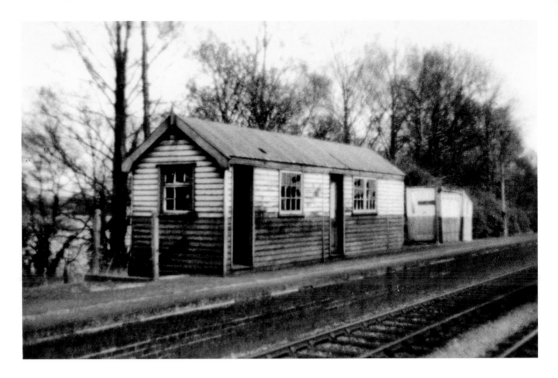

Yarnton Junction

Although no public goods facilities were provided, a marshalling yard with nine lengthy sidings was constructed on the down side during the Second World War. These sidings remained *in situ* after the war, and they were used to re-marshal ironstone trains from the East Midlands, which reached Yarnton via the Yarnton Loop, which converged with the main line at the south end of the platforms. *Below*: Yarnton was closed in 1962 and its site is now obscured by trees and bushes.

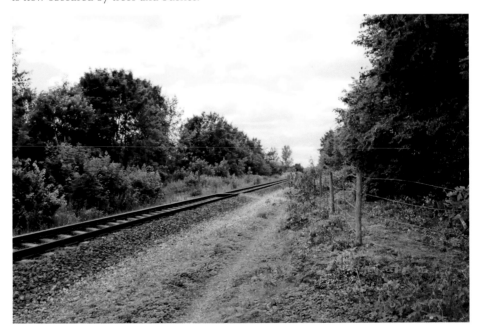

Cassington Halt

Above: As branch trains diverged south-westwards onto the Witney Railway they passed the extensive wartime marshalling sidings, which ran parallel to the Witney route for a distance of about half a mile – albeit on a different level. *Below*: Cassington Halt, 4 miles 75 chains from Oxford, was the first stopping place on the Witney Railway. It was not an original station, having been opened by the GWR on 9 March 1936.

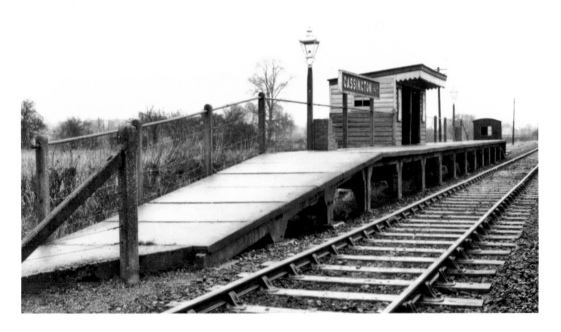

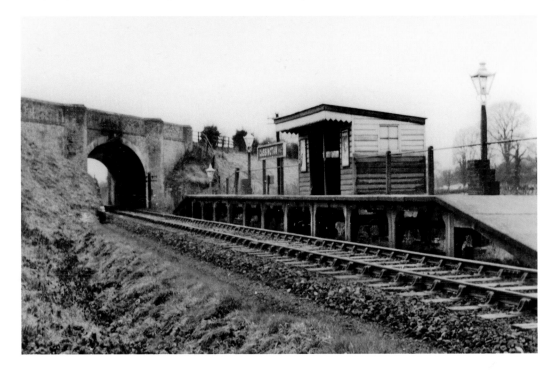

Cassington Halt

Cassington's modest facilities consisted of a pre-cast concrete platform on the up side of the line, with a wooden shelter for the convenience of waiting passengers. The busy A40 road was carried across the line on a skew-arched bridge at the west end of the platform. Beyond, the line continued south-westwards to Eynsham, crossing *en route* the River Evenlode and the Cassington Canal on two girder bridges, which were designated bridges Nos 1 and 2 respectively in the Fairford Branch bridge register.

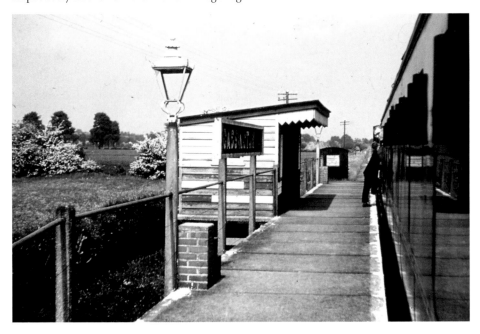

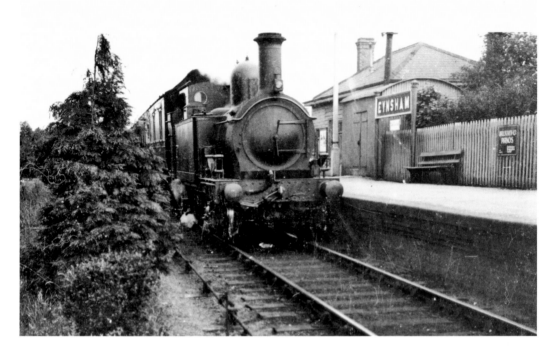

Eynsham

When opened in 1861, Eynsham (7 miles 12 chains) had been the principal intermediate station on the Witney Railway. It originally had just one platform, but a second platform was added in 1944, and Eynsham thereby became a crossing station on the single line. There were three goods sidings, and the station building was of timber-framed construction. The upper picture shows a 'Metro' class 2-4-0T at Eynsham around 1930, while the lower view shows the station after the installation of the second platform.

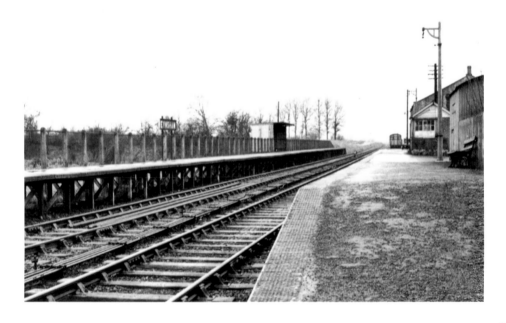

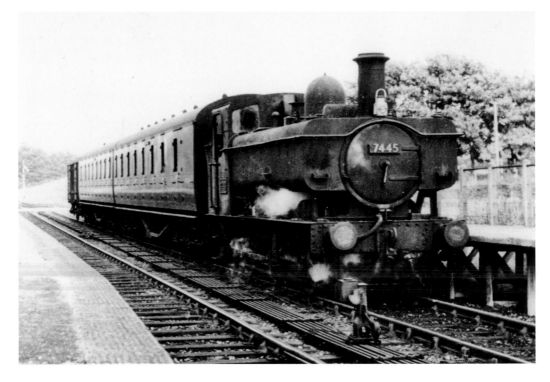

Eynsham: Pannier Tanks at Work on the Branch

Six-coupled pannier tanks of the '74XX' and '57XX' classes were widely used on the Witney line after the Second World War. *Above*: Collett '57XX' class 0-6-0PT No. 7445 pauses in the down platform with a westbound train. *Below*: '57XX' class engine No. 7760 hurries away from Eynsham with a down passenger train; both photographs were probably taken around 1960. No. 7760, which was sold to London Transport in 1961 for use on engineering trains on the underground network, is currently stored at Tyseley.

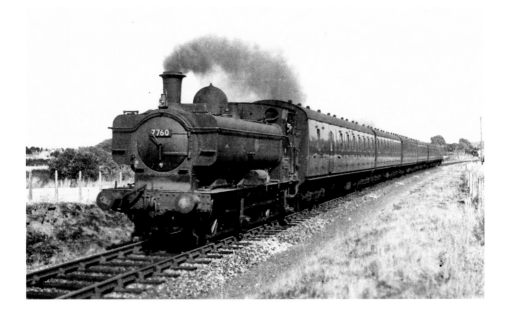

Eynsham

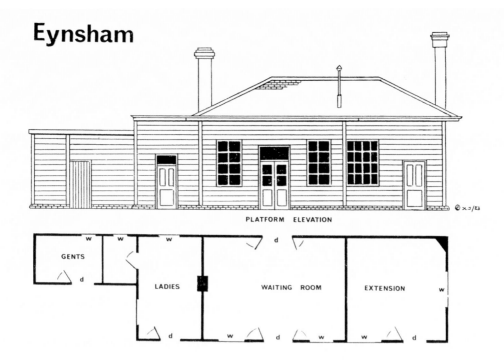

PLATFORM ELEVATION

Eynsham: The Station Building

Eynsham was originally equipped with a small, timber-framed station building that had probably been erected by Malachi Bartlett, the Witney building contractor. This diminutive structure was clad in horizontal weatherboarding and roofed with Welsh slate. In 1878, the Witney Railway and the GWR had shared the cost of enlarging the building, and an extension was added at the eastern end, as shown in the drawing. *Below*: A post-closure photograph taken in 1971, showing the faded green and cream colour scheme.

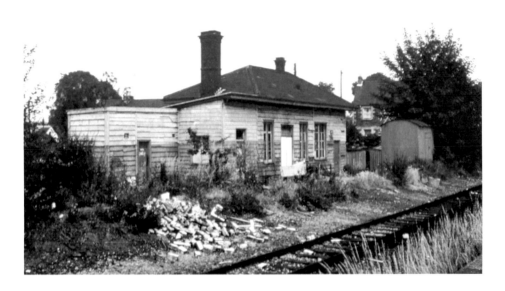

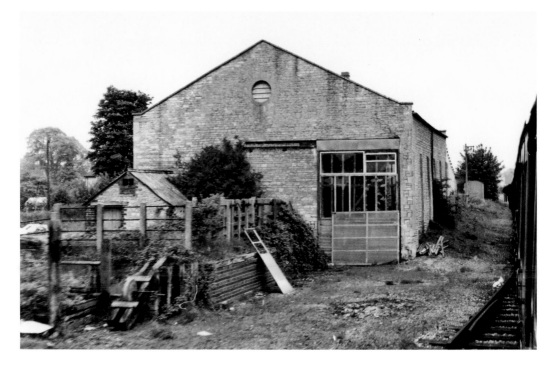

Eynsham: The Goods Shed

Above: The substantial stone goods shed was a gable-roofed structure with a 50-foot loading platform and a checker's office at its eastern end. Other buildings at Eynsham included a weigh house of Witney Railway design (referred to as a 'lodge' in company minutes), a corrugated-iron storage shed and a corrugated-iron shelter on the down platform. The nineteen-lever signal cabin, dating from around 1892, was sited on the up platform. *Below*: The site of the station is now an industrial estate.

Eynsham

Above: Eynsham itself is a small town with many attractive Cotswold-style buildings, as shown in this recent photograph of the Market Square. Until the nineteenth century, Eynsham had been a busy Thames-side port with its own wharf – the Talbot Inn, pictured below, being one of the wharf buildings. In 1927 a large sugar beet factory was opened on part of the former wharf, and this was served by a private siding link from the nearby Witney Railway.

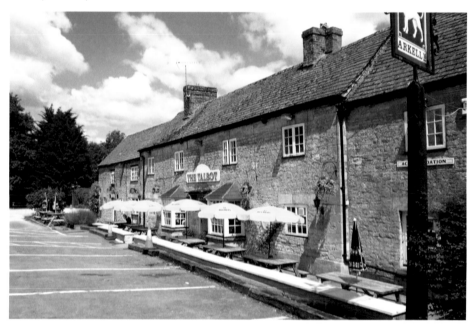

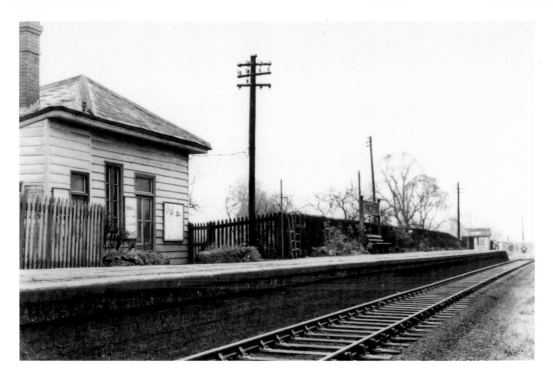

South Leigh

From Eynsham, trains entered a shallow cutting and then climbed at 1 in 200 for a distance of about a mile, after which the ascent eased slightly to 1 in 132 before the line surmounted a miniature summit. Emerging from another shallow cutting, the line dropped towards South Leigh station (*above and below*) on an embankment, which was pierced at one point by an underline bridge (No. 6) that carried the railway over a bridleway known as Love Lane.

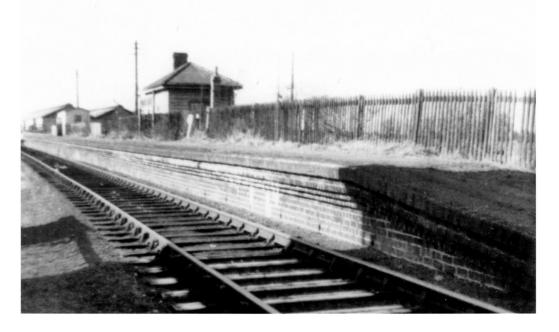

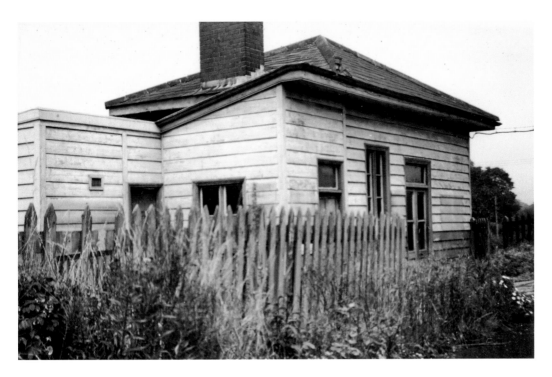

South Leigh

South Leigh station, 9 miles 22 chains from Oxford, changed very little over the years. When opened in 1861, this wayside stopping place had consisted of little more than a short platform on the up side of the line, together with a level crossing and a 'gate lodge'. The platform had a length of around 150 feet, although by the end of the nineteenth century it had been extended to 300 feet. These 1965 views show the station building (*above*) and the goods lock-up (*below*).

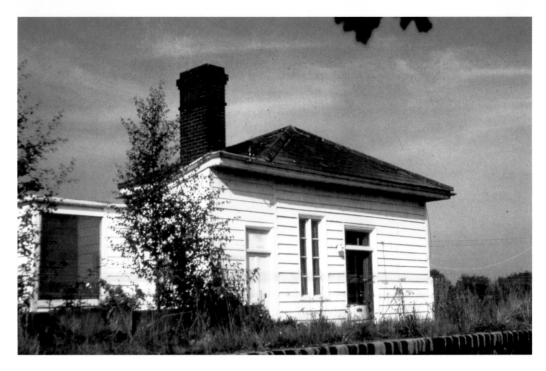

South Leigh: Front and Rear Views of the Station Building

The station building was of considerable interest, insofar as this diminutive wooden structure was an original Witney Railway building that had never been enlarged or rebuilt. The timber-framed building was clad in horizontal weatherboarding and roofed with grey Welsh slate, while the interior walls were finished with lath and plastering. The building featured a low-pitched pyramidal roof, with all four sides meeting at the apex – the overall effect suggesting American 'Wild West' practice.

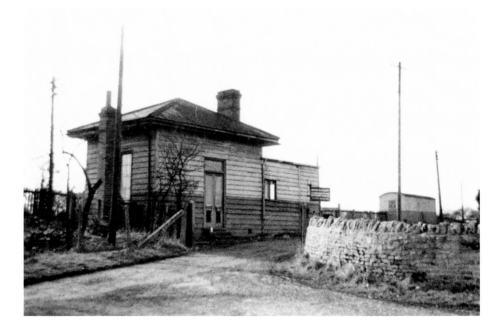

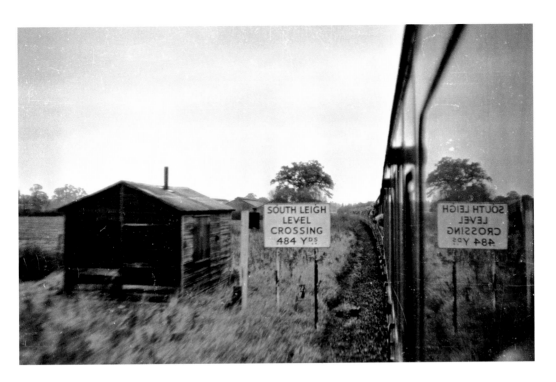

South Leigh

Minor changes were put into effect at South Leigh during the Second World War, when the station's single loop siding was extended in connection with a Ministry of Food depot that was erected beside the goods yard. *Above*: The view from an excursion train on 24 May 1969, with the wartime food depot just about visible in the distance. *Below*: A detailed view of the weigh house. This tiny wooden structure protected the weighing machine, but there was no room for the customary office space.

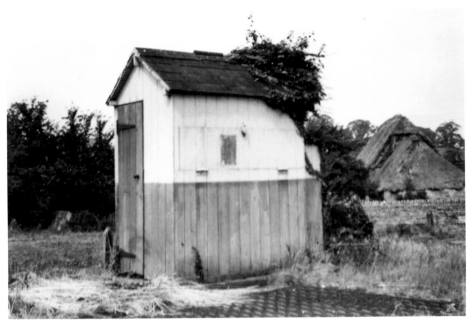

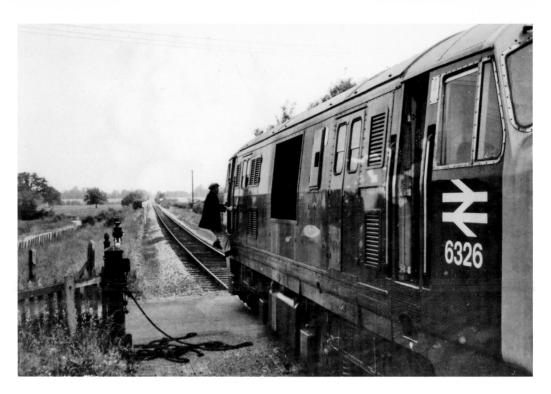

South Leigh: Trains on the Level Crossing

These two views show freight trains on the level crossing, which after June 1962 was worked by the train crews. The lower photograph depicts '57XX' class 0-6-0PT No. 9773 standing on the embankment while the guard closes the gates, while the upper picture shows class '22' diesel-hydraulic No. 6326, newly painted in BR 'rail blue' livery, drawing slowly forward over the crossing after the fireman has opened the one remaining gate – the other gate had recently been struck by a train.

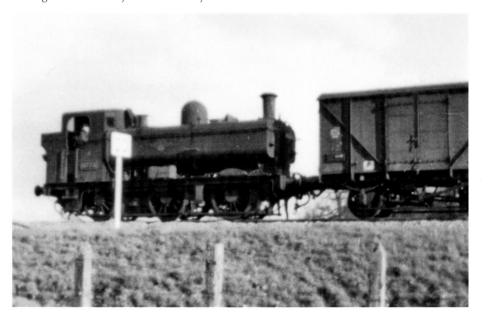

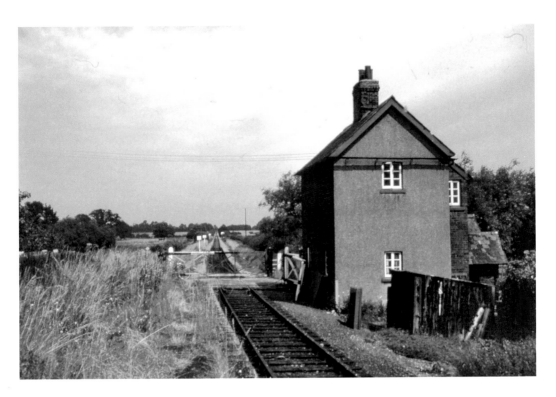

South Leigh: The Station House

Above: The station house was a two-storey brick cottage with a gable roof. Its main frontage faced the Stanton Harcourt Road, and there was a lean-to extension on the south side. This small dwelling house may have been built by the Witney Railway, and there is mention of work at 'South Leigh Lodge' (i.e. gatekeeper's lodge) in Malachi Bartlett's ledger. *Below*: A photograph of the same house in January 2013, showing the extensions that have been added at various times.

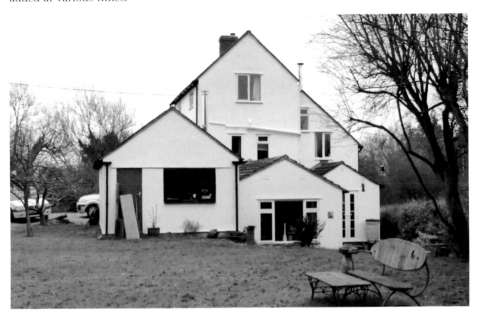

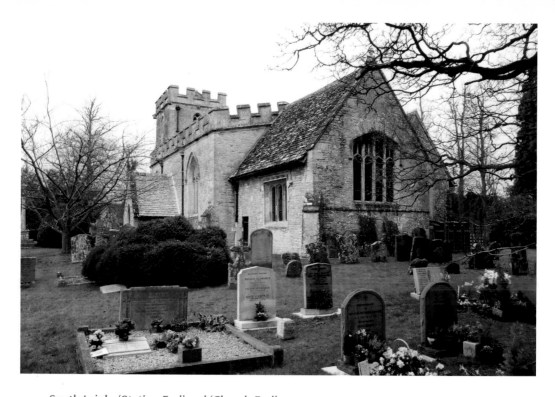

South Leigh: 'Station End' and 'Church End'

Above: The church of St James the Great in January 2013. South Leigh is, in effect, two distinct settlements, the original part of the village being at 'Church End', about half a mile to the north of the railway, while 'Station End' comprises Station Farm, College Farm, the old Manor House and the surrounding cottages. *Below*: A recent view of Station Road, which forms a convenient link for vehicular traffic between the two halves of the village.

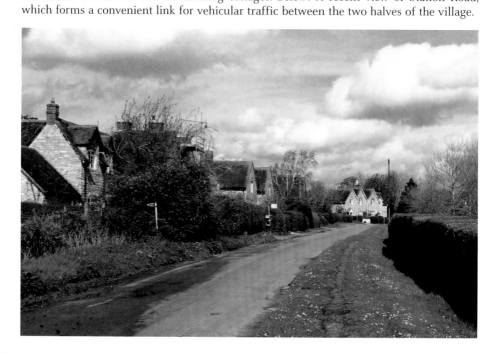

South Leigh: Moor Lane Occupation Crossing

From South Leigh station, down trains climbed at 1 in 100 towards a gated occupation crossing that carried a tree-lined bridleway known as Moor Lane across the railway. There was no infrastructure here, other than a solitary sleeper-built platelayers' hut – one of many that were dotted at regular intervals along the line. *Below*: A view from the Witney Wanderer excursion train, as it heads westwards in the vicinity of Moor Lane Crossing on 31 October 1970.

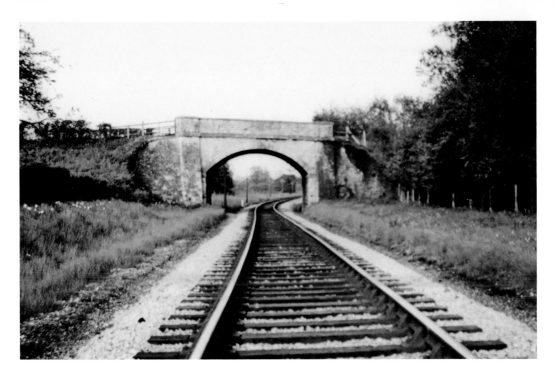

The Ballaso Bridge

Continuing westwards, the railway skirted an old ballast pit known as the Ballast Hole. Here, 10 miles 42 chains from Oxford, the Stanton Harcourt Road was carried over the railway on a stone-arched overbridge (No. 7). Known locally as the Ballaso Bridge, this handsome structure was built on a skewed alignment. It was not entirely of stone construction, as it incorporated a brickwork arch. *Below*: This Victorian cottage was sited alongside the bridge, with its frontage facing the railway.

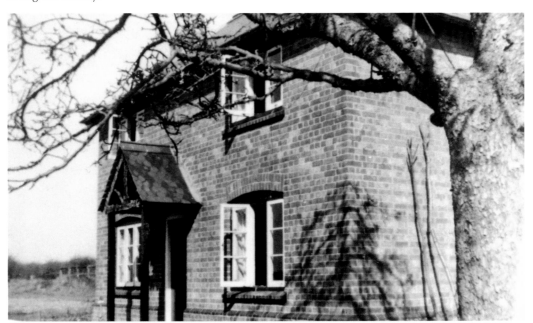

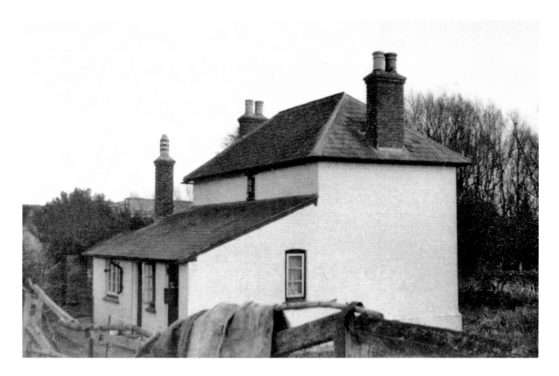

The Ballaso Bridge

Above: The cottage, which is referred to as Cogges Bridge Cottage on the latest Ordnance Survey maps, looks like a railway house, and it may have been built by the Witney Railway as a speculative venture on a strip of railway-owned land that was too narrow for agricultural purposes. *Below*: The cottage and bridge are now totally obscured by rampant vegetation, as shown in this recent view, which is looking along the road towards the bridge, with the cottage garden to the right.

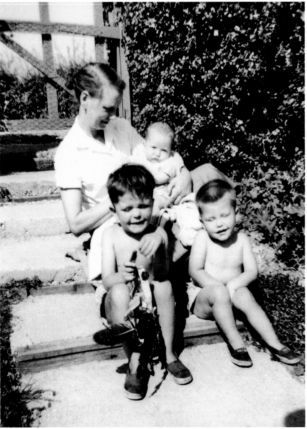

The Ballaso Bridge

Above: This picture gives an impression of the strange, slightly forbidding atmosphere that pervaded the Ballast Hole. Indeed, local legend asserted that this dank, silent pit was haunted by the ghost of a gypsy woman known as Black Bess, who was said to have been murdered here in the 1870s – although there is no record of such a murder in any of the local newspapers. *Left*: In contrast, this photograph was taken on a sunny afternoon around 1954. It shows Pamela Jenkins, a former occupant of the Ballaso Cottage, with her young children, sitting on the steps that led up from her garden to the top of the Ballaso Bridge; a caption on the back of the original photograph reads: 'The steps that Bill & Pamela made'.

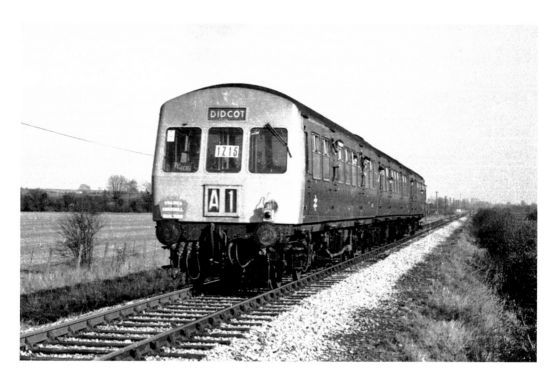

Witney Goods Junction: Approaching Bridge No. 8

Once past the Ballaso, the single line turned west-north-westwards as it approached Witney; to the right, Spring Hill added visual interest in the relatively flat landscape while, dead ahead, Witney church spire rose vertically from the level horizon. The upper view shows a three-car Metro-Cammell class '101' unit on this section of line on 11 April 1970, while the recent view shows the still-extant bridge No. 8 (11 miles 49 chains), which carried the railway over one of two channels of the River Windrush.

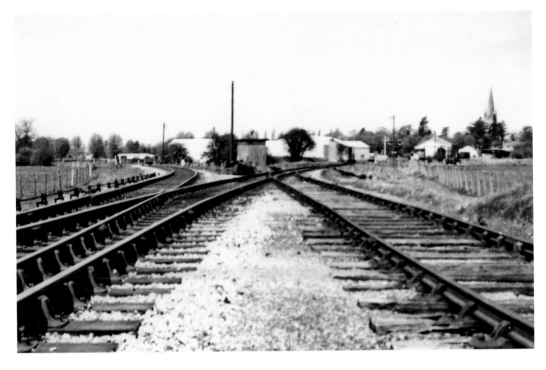

Witney Goods Junction: Looking West

Witney Goods Junction marked the physical boundary between the Witney Railway and the EGR extension to Fairford. The upper picture is looking westwards, the right-hand spur being the 1861 Witney Railway, while the left-hand line was the 1873 extension to Fairford; the siding on the extreme right was used as a 'head-shunt' or shunting neck for the goods yard. The lower photograph, taken from a similar vantage point in 2012, reveals that the site is now a grass-covered open space.

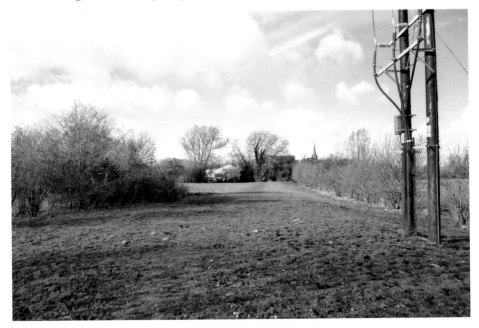

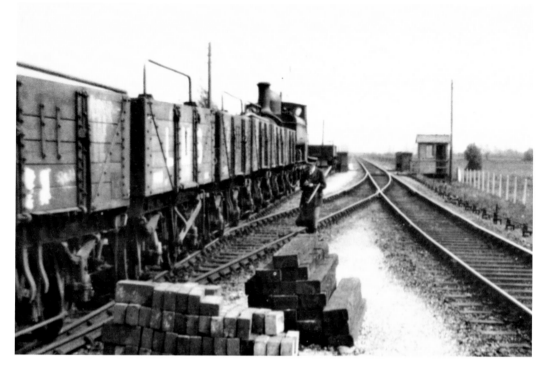

Witney Goods Junction: Looking East

A general view of Witney Goods Junction, looking east towards Oxford, probably during the 1920s. Shunting operations are obviously being carried out, while the girder bridge seen on page 23 is discernible in the distance. The ground frame hut visible to the right contained three levers, which were released by a key on the single-line tablet. *Below*: A recent photograph showing the site of the erstwhile Witney Goods Junction in December 2012.

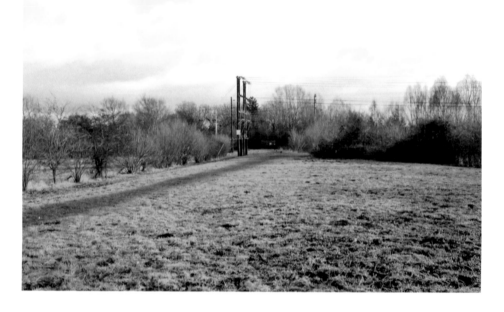

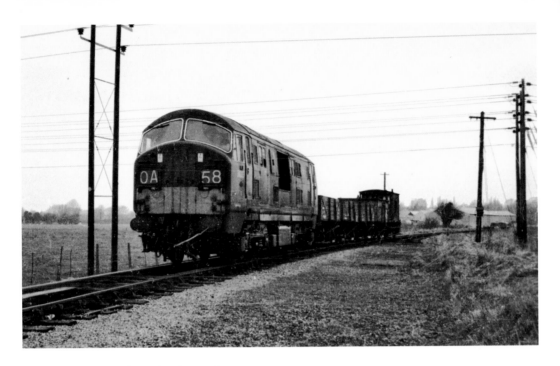

Witney Goods Junction: Diesels at Witney

These two photographs depict diesel trains at Witney Goods Junction in 1969/70. *Above*: This view shows class '22' diesel-hydraulic No. D6327 with a very short goods train. It is formed of one 16-ton mineral wagon and three wooden-bodied 'high-bar' wagons, with a standard British Railways brake van at the rear of the formation. *Below*: A Swindon 'Cross Country' unit is seen working the 'Isis' railtour, which traversed the Witney Railway on 14 February 1970.

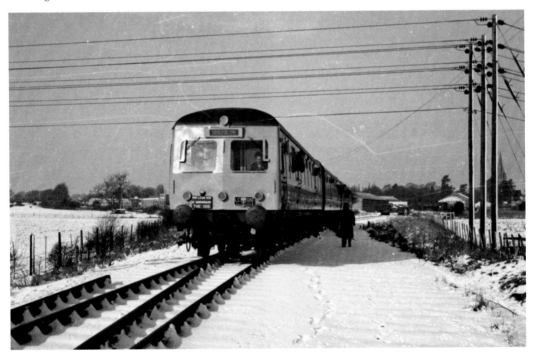

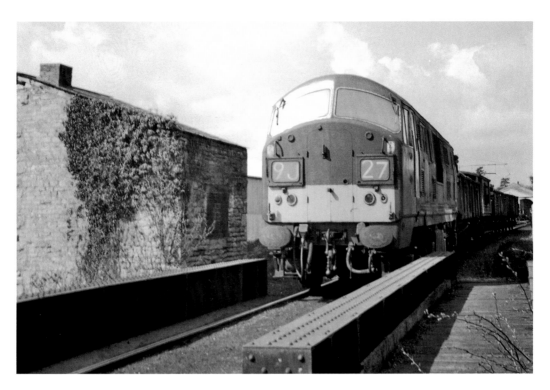

Witney Old Terminus: Windrush Bridge and the Old Tank House

Goods trains taking the right-hand fork at Witney Goods Junction swung away from the main line; descending slightly, they then crossed a branch of the River Windrush on a girder bridge. To the left, a Cotswold-stone 'blockhouse' was all that remained of the 'water tank house' that had been erected by Malachi Bartlett in 1862 at a contract price of £45. *Below*: The bridge was still *in situ* in 2012, but the old tank house has been demolished.

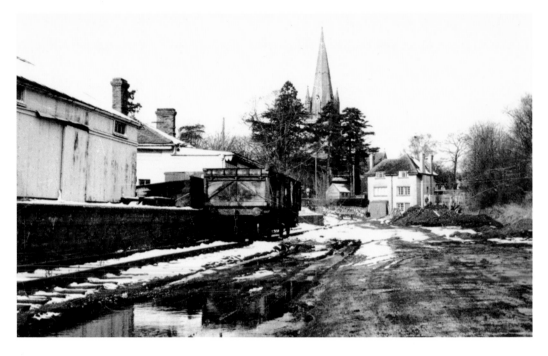

Witney Old Terminus: End of the Line

Continuing north-westwards towards the old Witney Railway terminus, the line then branched into seven parallel sidings and, having passed a large Cotswold-stone goods shed, incoming trains finally came to rest alongside the old passenger station. The upper view shows the old terminus in 1968, with the split-level stationmaster's house visible beyond the terminal buffer stops at the northernmost extremity of the goods yard. The lower view shows the former stationmaster's house in 2012, with Station Lane visible in the foreground.

Witney Old Terminus: The Site of Witney Engine Shed

Witney station once had an engine shed, this corrugated-iron structure being sited at the very end of the running line. Although the shed was closed when the line was extended to Fairford, the building was not demolished until about 1900, and it is clearly depicted on the 1899 Ordnance Survey map. *Above*: A view from around 1930 of the water tank, which was sited immediately to the south of the engine shed. *Below*: The shed's brick foundations can still be identified in this view, which dates from around 1970.

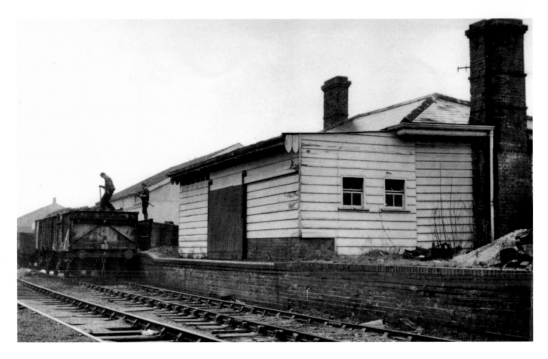

Witney Old Terminus: The 1861 Station Building

The original Witney Railway station building became a goods office after 1873, its platform canopy being boxed in to form a storage area, as shown in the upper photograph. The lower picture shows class '22' locomotive No. D6332 collecting a wagon-load of metal waste from the loading point on the old platform. The corrugated-iron building that can be seen to the right was erected in the 1930s for the benefit of local traders, who were able to rent storage space from the railway company.

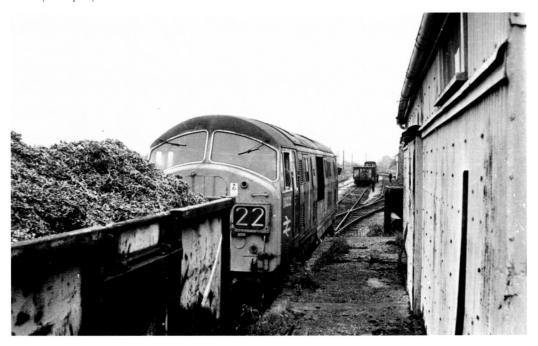

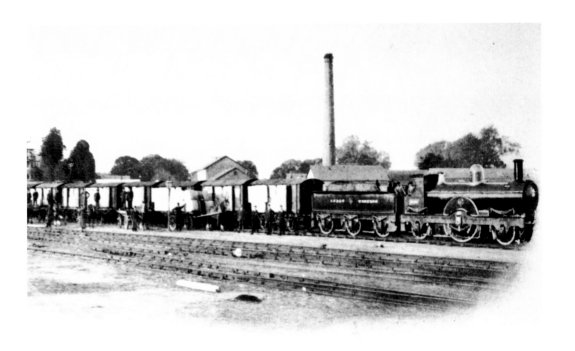

Witney Old Terminus: Edwardian Blanket Specials

London stores such as Maples placed bulk orders for Witney blankets just before Christmas each year throughout the Edwardian period, and it became the practice for 'Blanket Express' specials to run through from Witney to the Paddington goods depot. *Above*: These through-workings were normally formed of up to twenty Mink vans which, for publicity purposes, were often photographed prior to departure from Witney or on arrival in London. *Below*: '1854' class saddle tank No. 1858 heads a 'Blanket Express'.

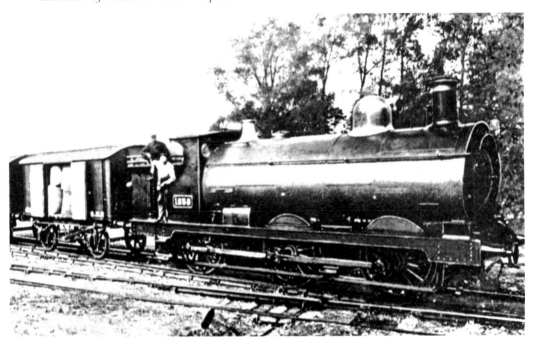

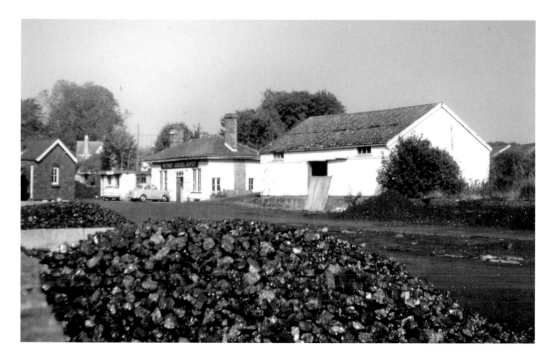

Witney Old Terminus

Two contrasting views, showing the old terminus from Station Lane. The upper view, from a 35-mm colour slide taken in 1972, shows the 1861 station building, with the traders' store to the right and the brick-built weigh house visible to the left of the picture. The recent view, photographed from a similar vantage point in December 2012, shows the Sainsbury's supermarket building which now occupies the northern end of the old station site.

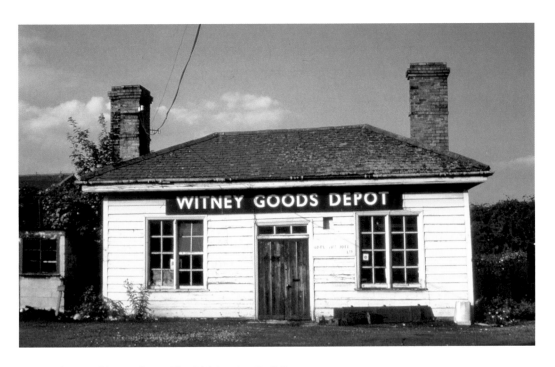

Witney Old Terminus: The Old Station Building

Above: The former Witney Railway station building, seen from the entrance to the goods yard. Several alterations were carried out when the building became a goods office, notably the erection of an internal wall which divided off part of the waiting room to form a new office area. The remaining part of the former waiting room was retained as an internal passage. The former ticket hatch remained in place until the demolition of the building in the 1980s. *Below*: The site of the station building in 2012.

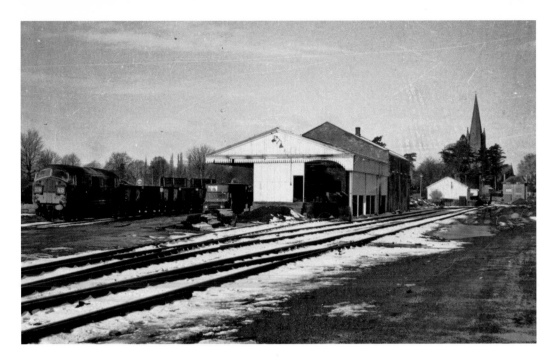

Witney Old Terminus: The Goods Shed

Erected in 1862, the gable-roofed goods shed was identical to its counterpart at Eynsham. It measured 54 feet by 40 feet at ground level and contained a spacious loading platform with a width of around 25 feet, together with a 1 ton 10 cwt fixed hand crane. Extensions were provided at each end; that at the southern end, seen in these two illustrations, dated from around 1900. The lower photograph shows the goods shed in 1971 after removal of the trackwork.

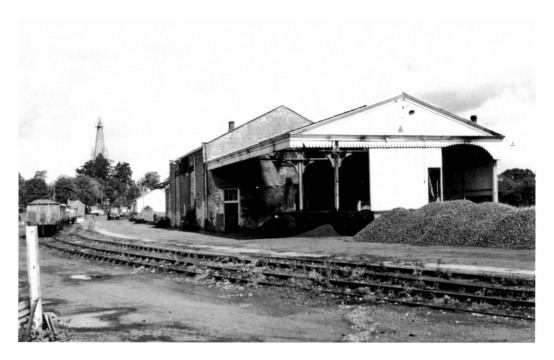

Witney Old Terminus: The Goods Shed and Coal Sidings
Above: Another glimpse of the substantial Cotswold-stone goods shed. The two mileage sidings that can be seen to the left of the building were used for coal, minerals and other types of full wagon-load traffic, whereas smaller consignments were dealt with in the adjacent goods shed. *Below*: An atmospheric photograph, taken from the goods shed's southern extension on a rainswept winter's day in 1968, showing class '22' locomotive No. D6348 shunting 16-ton mineral wagons into the coal sidings.

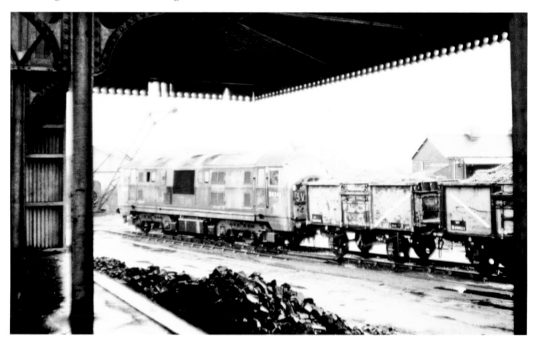

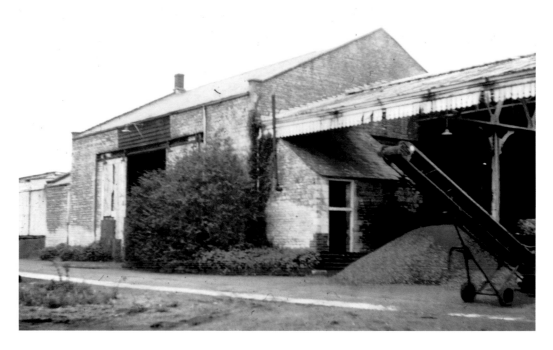

Witney Old Terminus: The Goods Shed

Above: A colour photograph of the goods shed, taken in 1971 – about a year after closure. *Below*: The goods shed was retained when the station site was redeveloped, although the extensions that were once provided at each end of the original block were dismantled. Having been adapted for commercial use, the goods shed now stands, somewhat forlornly, amid a plethora of modern buildings. This Victorian building is now the principal surviving Witney Railway structure.

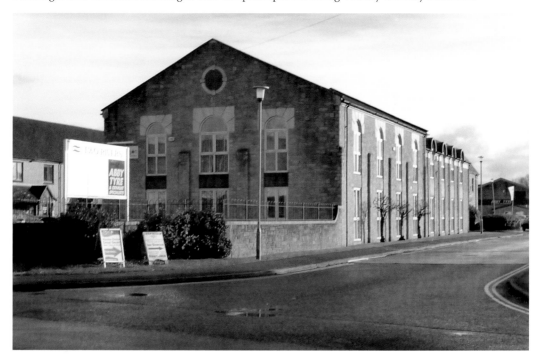

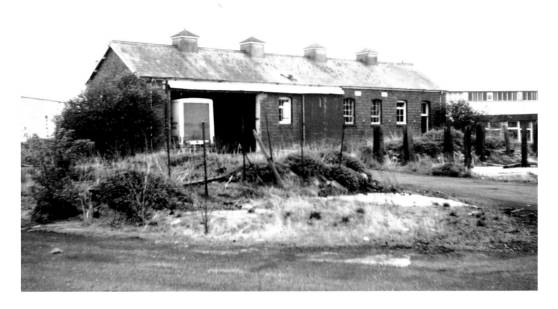

Witney Old Terminus: The GWR Stables

Above: Witney's shunting and dray horses were originally provided by William Payne & Son, of High Street, Witney. However, at the start of the nineteenth century the GWR decided to provide its own cartage services, necessitating the provision of this large, red-brick stable block, which was erected in the south-west corner of the yard around 1905. The stable, which contained stalls for several horses and storage space for wagons or tackle, was later used as a garage. *Below*: A rear view of the stable building.

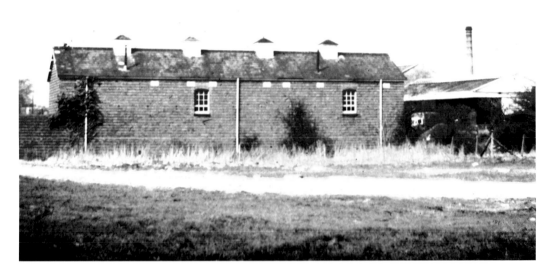

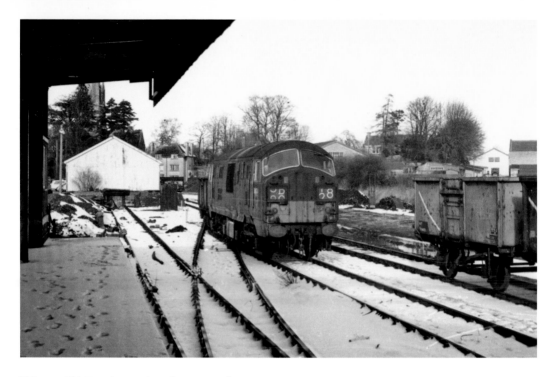

Witney Old Terminus: Shunting Operations

By the late 1960s, the train service had been reduced to just two freight trains a week, the predominant source of traffic being incoming coal, although other forms of traffic, including road salt, agricultural fertiliser and scrap metal were also carried. The upper views shows class '22' locomotive No. D6326 running around its train in February 1968, while the lower illustration shows the same engine at work in the coal sidings around 1970.

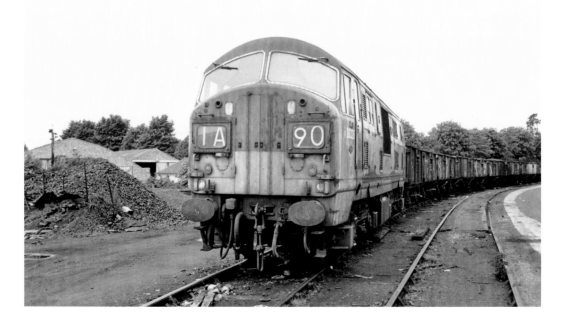

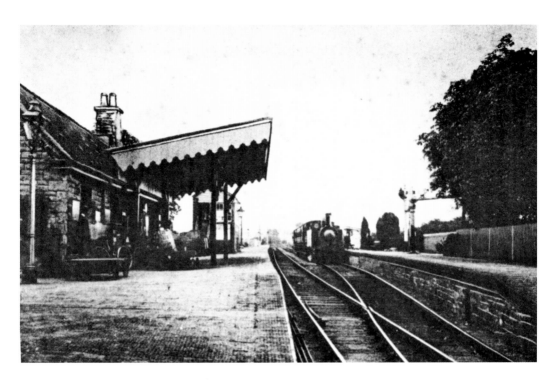

Witney Passenger Station: The 1873 Station

Above: Witney passenger station was situated a little under halfway between Oxford and Fairford, being 11 miles 74 chains from Oxford and 13 miles 48 chains from Fairford. The station was a crossing place with up and down platforms, the station buildings being on the up side, while Station Road was carried across the line on a road overbridge (No. 10) immediately to the west of the platforms. *Below*: An Edwardian postcard view showing the gardens on the up platform.

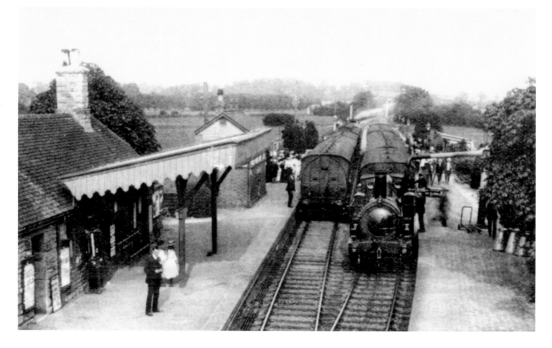

Witney Passenger Station: The Up Platform

Above: Up and down trains passing at Witney, as depicted in another old postcard view. The locomotive that can be seen taking water in the down platform is a 2-4-0T 'Metro' tank. The EGR station building, visible to the left, was an attractive, Cotswold-stone structure with a distinctive half-hipped roof and a wooden platform canopy that was subsequently extended to cover the entire frontage. *Below*: a 2-2-2 single-wheeler enters the up platform, probably around 1912.

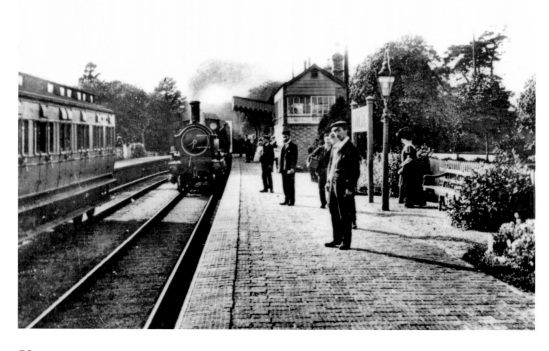

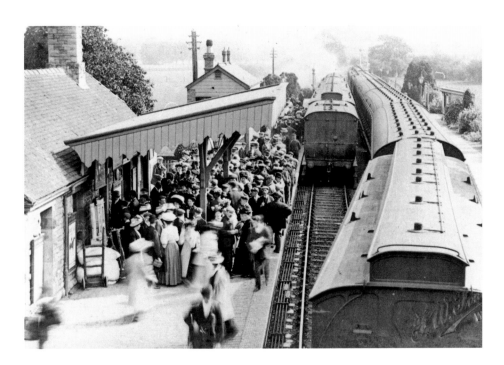

Witney Passenger Station: The 'Witney Trips'

Above: An excursion train at Witney. There was a tradition of excursion traffic on the Witney line dating back to 1879, when stationmaster William Smitheman and William Smith, the proprietor of Bridge Street Mill, initiated the 'Witney Trips'. Although originally conceived as a treat for Mr Smith's own workers, the trips became a local institution. The first trip conveyed 186 people from Witney to Brighton, but subsequent destinations included Bala, Torquay, Weston-super-Mare, Liverpool, Weymouth, Blackpool, Hastings and Southsea. *Below*: The station in the 1960s.

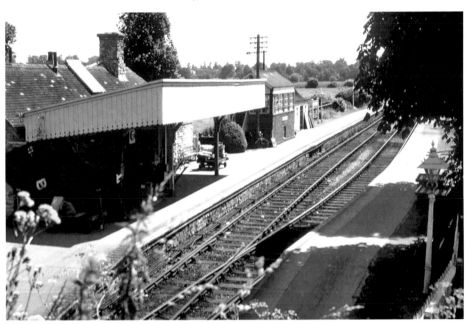

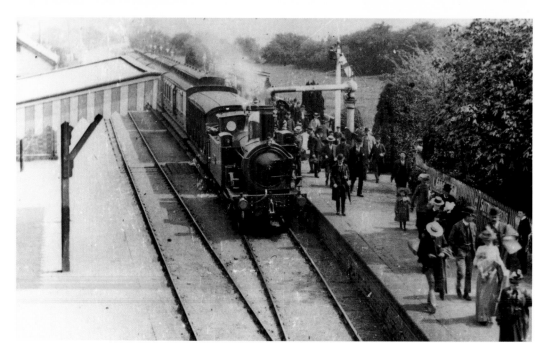

Witney Passenger Station: Side and Saddle Tank Locomotive

Two views showing Edwardian locomotives at Witney. *Above*: A 2-4-0T 'Metro' tank stands in the down platform with a westbound passenger train; introduced in 1866, these locomotives had a long association with the sub-surface lines of the Metropolitan Railway. *Below*: '1854' class 0-6-0 saddle tank No. 1878 waits at Witney with a down freight working. It is interesting to note that the branch train was known in Witney as 'The Witney Flyer', although Bampton residents normally called it 'The Bampton Flyer'!

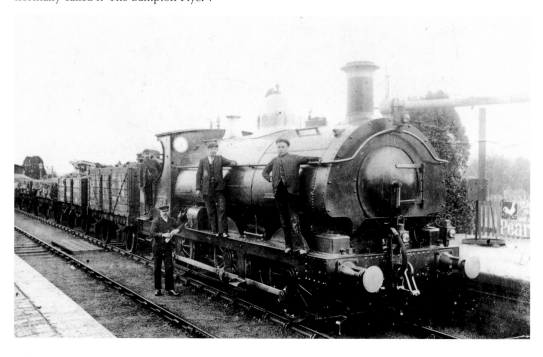

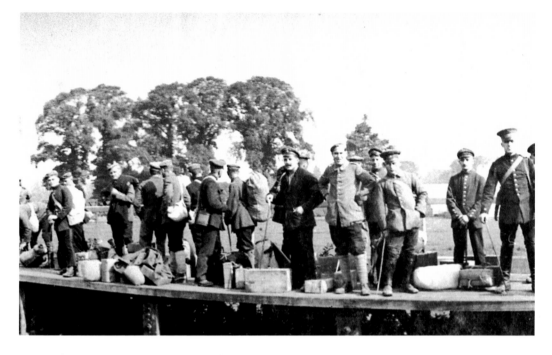

Witney Passenger Station: Wartime Scenes

Above: German prisoners of war and their military escorts wait for a train on the up platform, around 1918. These men had probably been employed as labourers during the construction of Witney Aerodrome at the end of the Great War. *Below*: A group of Second World War evacuees pose for the camera shortly after their arrival at Witney. The station received four trains between 1 September and 4 September 1940, carrying a total of 3,200 passengers, most of them from the East End of London.

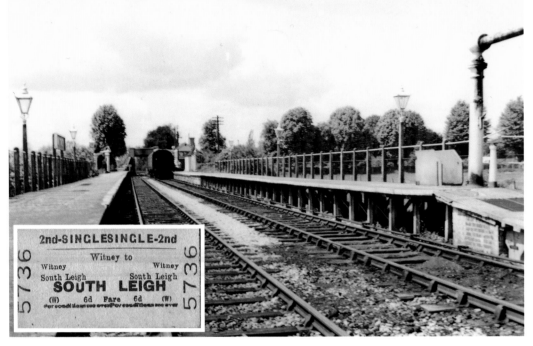

2nd-SINGLESINGLE-2nd

Witney to

5736

Witney	Witney
South Leigh	South Leigh

SOUTH LEIGH

(W) 6d Fare 6d (W)

For conditions see over

5736

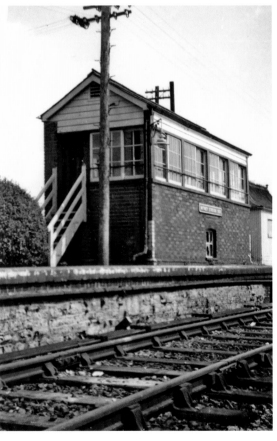

Witney Passenger Station

The upper picture shows the station from the eastern end of the down platform. The station building and signal box can be seen in the distance, while parcels vans occupy the up platform. The lower picture is a detailed view of the signal cabin, which was a typical gable-roofed late-Victorian structure with small paned windows. Its locking room and the rear wall were of brick construction, though the gable ends were weatherboarded. Such cabins were erected in large numbers throughout the Great Western system during the 1890s, and the example at Witney appears to have dated from around 1898 (when a slightly earlier cabin was remodelled). In its post-1898 form, the Witney box measured approximately 25½ feet by 10 feet at ground level. The box was designated Witney Station Signal Box, to distinguish it from a short-lived signal cabin that had once been situated at Witney Goods Junction. *Inset*: a BR single ticket from Witney to South Leigh issued on 2 September 1961.

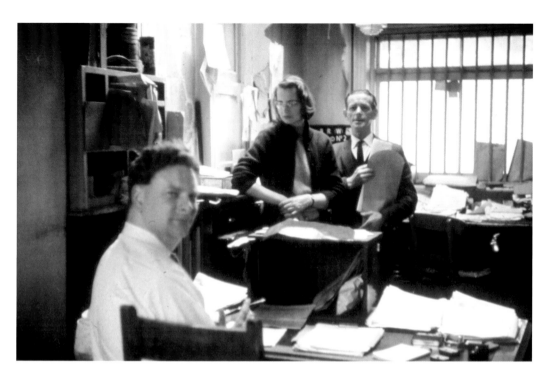

Witney Passenger Station: Interior and Exterior Views
Above: Interior views of the station are comparatively rare; this picture is therefore of considerable interest. It shows the ticket office during the early 1960s, with Miss Davies, one of the ticket clerks, standing beside the ticket hatch. Confusingly, her two colleagues were both called Mr Jones! The station was at that time still lit by gas lamps, one of which can be seen in the photograph. *Below*: This photograph, which dates from around 1962, is looking east towards Oxford.

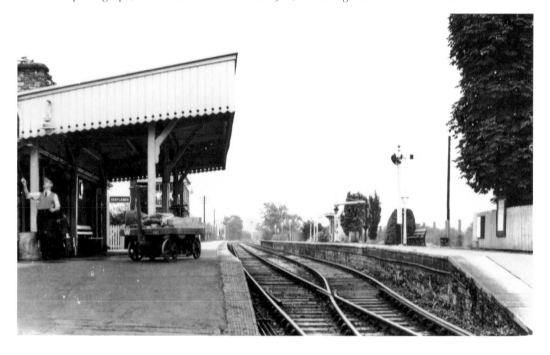

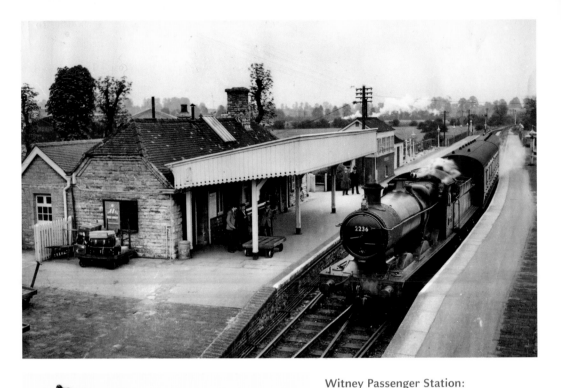

Witney Passenger Station: The Station Building and Water Tower

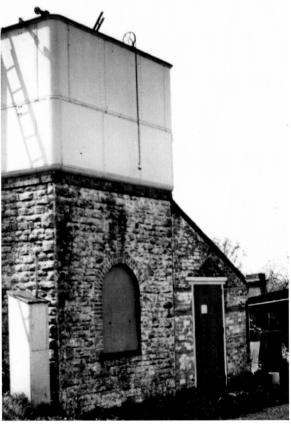

Above: A view of the passenger station in the mid-1950s, looking eastwards from the road overbridge as Collett '2251' class 0-6-0 No. 2236 leaves Witney with a down passenger train. *Left*: The water tower, which was situated immediately to the west of the road overbridge, was a Cotswold-stone structure supporting a rectangular metal tank; the main part of the structure measured approximately 12.5 feet by 12.5 feet at ground level, though a lean-to extension at the west end increased the overall length of the building to around 19 feet. Internally, the tank house contained a deep well, together with pumping equipment that was needed to draw water up from the well to the raised tank. The pumping room was lit by a single round-headed window, while the water tank was painted a cheerful light buff colour.

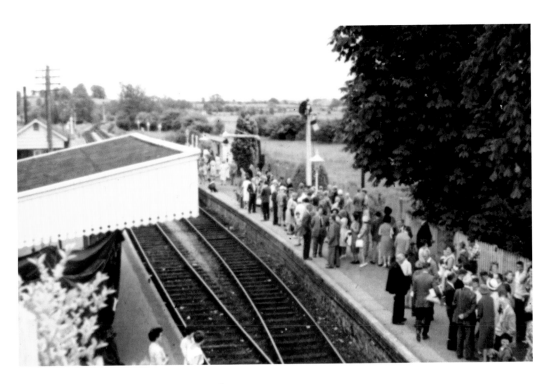

The Last Regular Passenger Services

The last regular passenger trains ran on Saturday 16 June 1962, and numerous photographs were taken. There was a scramble to buy the last tickets and some detonators were set off, but otherwise there was nothing particularly unusual about the day – except that the trains were packed. The last day travellers included Mr B. B. Causer, Latin master at Witney Grammar School and chairman of Witney Urban District Council, who was photographed giving the 'right away' at Witney with a guard's flag.

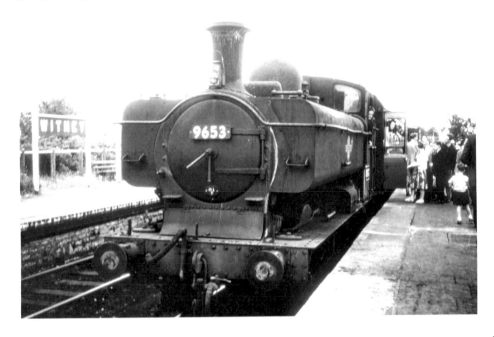

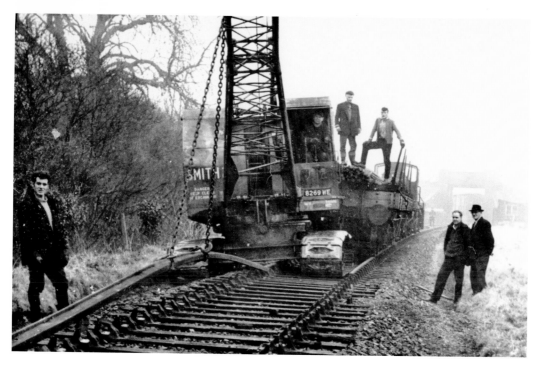

Lifting of the EGR

The EGR was lifted about eighteen months after the cessation of train services. Twice a week, a '57XX' class pannier tank arrived from Oxford to collect the loaded demolition trains, which were some of the longest and heaviest ever seen on the line. *Above*: The last section of rail was removed early in 1965, and Witney once again became the 'End of the Line'. *Below*: The last train to visit Witney passenger station on 14 September 1968.

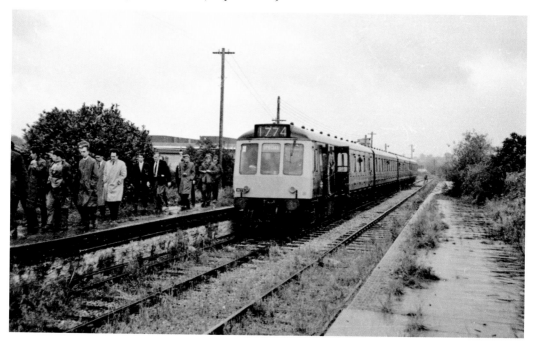

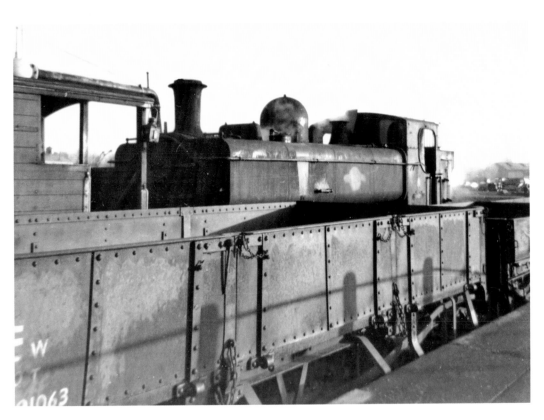

The End of Steam Operation

In January 1966 the Western Region became the first BR region to modernise its motive power, having replaced over 3,000 steam locomotives with diesel traction. On the morning of 30 December 1965, members of the Witney Grammar School Railway Club had assembled at the end of the up platform at Witney station to photograph the departure of '57XX' class 0-6-0PT No. 9773. *Above*: The engine beside the water column. *Right*: The same locomotive leaving Witney passenger station with an ex-LMS brake van. The drop-side open wagons that can be seen in the station were Engineering Department vehicles of the Grampus type that had been used during the lifting of the Fairford line. Once this melancholy task had been completed they were parked at Witney, where they remained for many months.

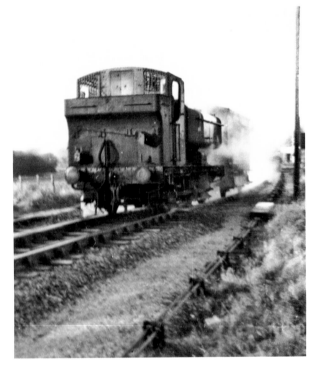

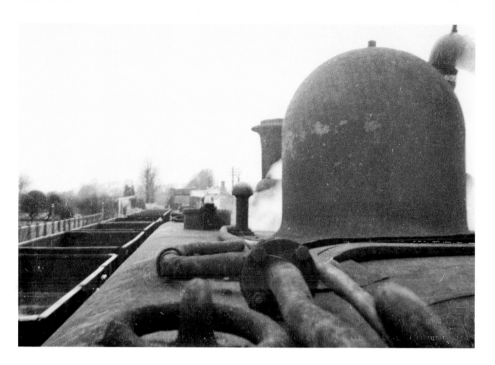

The End of Steam Operation

Witney's very last steam-hauled trains ran on Friday 31 December 1965, and a surprisingly jubilant atmosphere prevailed as the driver treated the inhabitants of Witney to a prolonged and piercing blast of the locomotive's whistle. *Above*: A view from the cab of '57XX' class o-6-oPT No. 9773. *Below*: The evening train was met a party of local railwaymen who, conscious of the historic nature of the occasion, had gathered to see the last steam engine leave Witney station. The photograph shows stationmaster John Barnby shaking hands with driver A. Johnson.

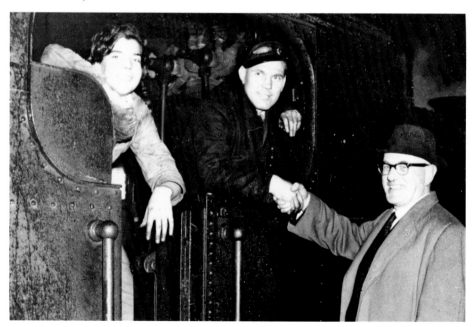

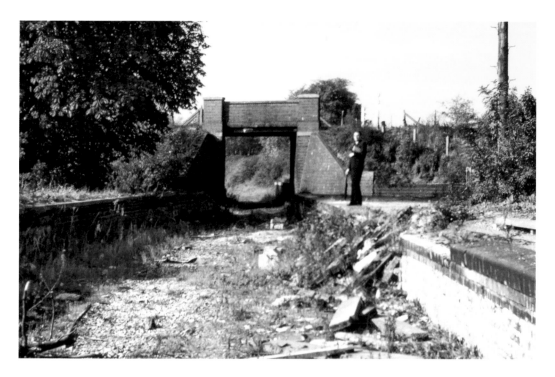

Demolition of Witney Passenger Station

The former EGR station lost its trackwork in the winter of 1968, and two sidings in the goods yard were lifted at the same time – with little traffic being handled they were no longer needed. Meanwhile, a gang of workmen had descended on Witney passenger station and set fire to it, the ruins being bulldozed shortly after. *Above*: This once busy station after demolition. *Below*: The site of the station from the road bridge.

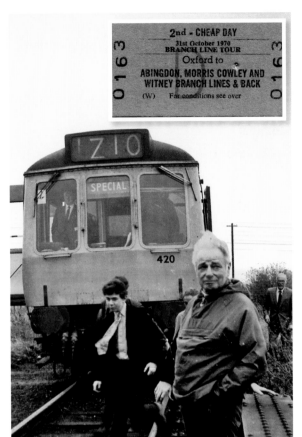

The Witney Wanderer: The Official 'Last Train'

In October 1970, BR arranged a special excursion train from Paddington to Witney to mark the final closure of the Witney Railway. Dubbed the 'Witney Wanderer', it carried over 450 passengers, many of whom were railway enthusiasts from London or Reading, though others were local people who had paid 15s (75p) for the unique experience of riding on this last train. The nine-car class '117' multiple-unit formation left Oxford station at 2.13 p.m. and, after visiting the nearby Abingdon and Morris Cowley branch lines, the special made its historic final trip to Witney. The railway was closed officially on Monday 2 November 1970. The following day, a class '22' locomotive crept up the line to collect the last few wagons from Witney station. Then, lonely and unmourned, it slowly made its way back to Oxford – the very last train. *Inset*: A ticket issued for the last train to Witney on 31 October 1970.

Dismantling of the Railway

Track-lifting began in the summer of 1971, when a gang of Irish labourers descended on the line with oxyacetylene torches and other instruments of destruction. This time there was to be no wrecking train – the rails were cut into sections and taken away on road vehicles. The work went on all through the summer until the railway was utterly destroyed. The upper picture shows demolition work at Witney, while the lower view is looking towards the 1861 terminus after removal of the track.

The Reconstruction of Station Lane

Designated bridge No. 10 in the Fairford Branch bridge register, the girder bridge at the west end of the station carried Station Lane across the line. It showed evidence of a major widening operation that had been carried out around 1900, when the GWR increased the size of the bridge aperture and provided new brick abutments and parapets on each side. The upper photograph dates from 1977, while the lower view, taken from the bridge two years earlier, shows a deviated section of Station Lane under construction on the course of the EGR. A Vauxhall Viva can be seen to the left of the picture, and the houses of Burwell Farm Estate can be seen in the distance. The tarmac surface has been laid at the western end of the new road, but the section in front of the bridge has not yet been surfaced.

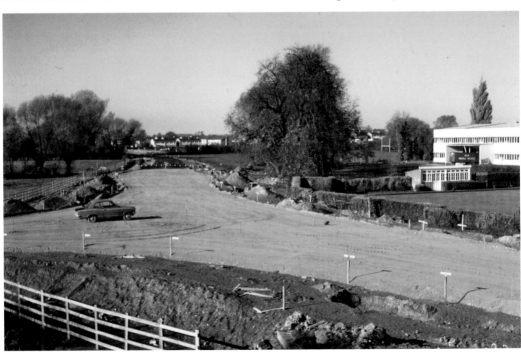

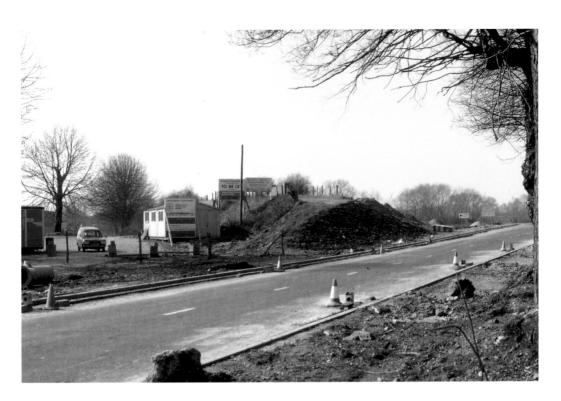

The Reconstruction of Station Lane

This view, taken in the spring of 1976, shows the station yard and the remains of the bridge approach ramp. The new section of Station Lane has been surfaced, but the ubiquitous warehouses and small industrial units that now predominate in this part of Witney have not yet appeared. *Below*: A contrasting picture, taken in December 2012, shows that much redevelopment has taken place.

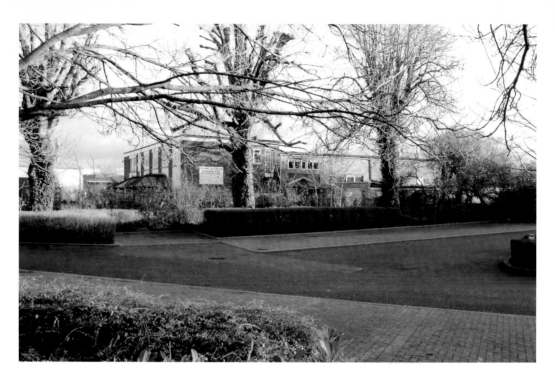

The Reconstruction of Station Lane

These two recent views, taken in 2012, show some of the modern industrial and commercial buildings that have been erected on the Station Lane Industrial Estate. *Above*: The mature trees that feature prominently in this picture once shaded the station yard. *Below*: Taken from a position somewhat further to the west, the photograph shows another part of the industrial estate, the building on the left having been erected on the former railway line.

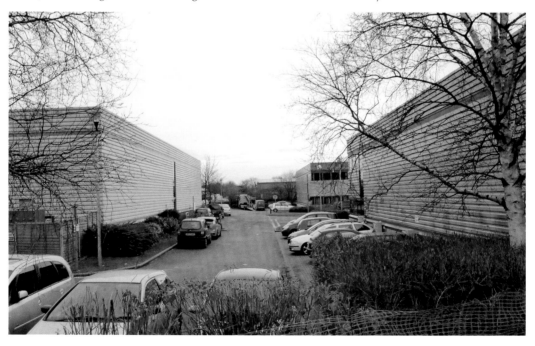

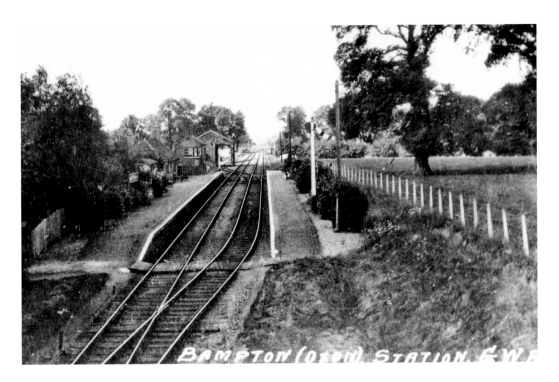

Brize Norton & Bampton

Leaving Witney, trains continued south-westwards to reach Bampton station (15 miles 51 chains). Like Witney, this was a passing station, with up and down platforms on either side of a crossing loop, the station building being on the down side. *Above*: Looking westwards from the road overbridge, around 1930. *Below*: Looking east towards Oxford. The name of the station was changed to Brize Norton & Bampton in 1940, reflecting the importance of nearby Brize Norton Aerodrome.

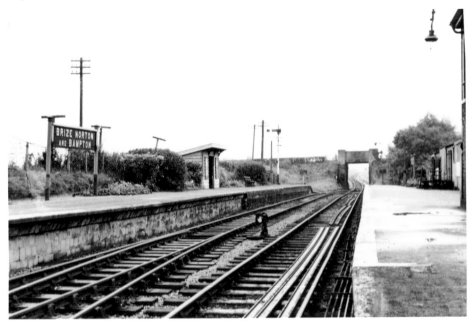

Bampton

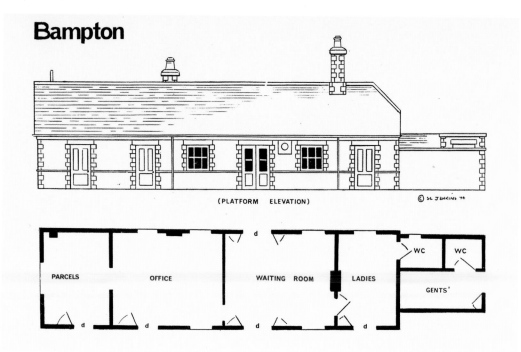

(PLATFORM ELEVATION)

© SC JENKINS 74

PARCELS OFFICE WAITING ROOM LADIES WC WC GENTS'

Brize Norton & Bampton

Above: As originally built, the station building measured 44 feet by 15 feet, with an extension containing toilet facilities. A new parcels office was added to the eastern end of the building after the First World War, and this altered its appearance, in that one of the original half-hipped ends was replaced by a plain gable. *Below*: A down passenger train headed by '57XX' class 0-6-0PT No. 9653 passes an up freight working hauled by '74XX' class locomotive No. 7404, in this photograph taken around 1961.

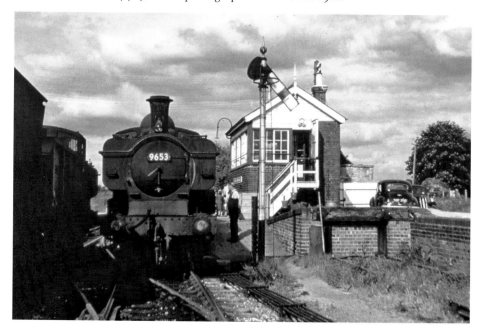

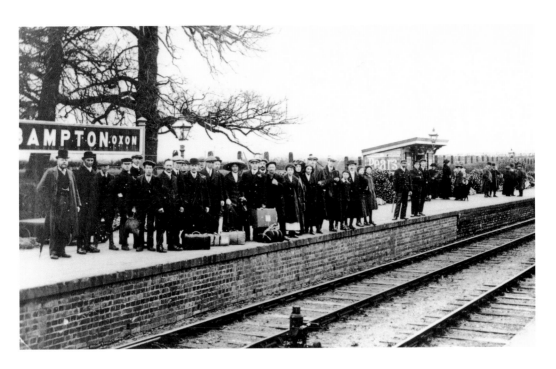

Brize Norton & Bampton

Above: An interesting old photograph, showing a party of emigrants about to leave Bampton for the very last time. *Below*: The goods yard contained two goods sidings, one of which was used for wagon-load traffic, while the other served the Cotswold-stone goods shed – seen here in 1972, with the station building and signal box visible in the background. The goods shed contained a 23-foot loading platform, and there was a checker's office at the west end.

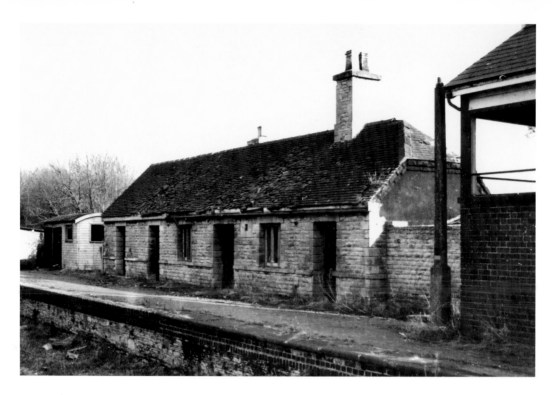

Brize Norton & Bampton

Front and rear views of Bampton station building after closure. Entering the building from the platform, one walked into the general waiting room, while a door to the right gave access to a Ladies Room (which could also be entered from the platform via a separate door). The ticket office was sited to the left of the waiting room and, beyond that, a small room at the far end of the building provided further accommodation for staff purposes and parcels traffic.

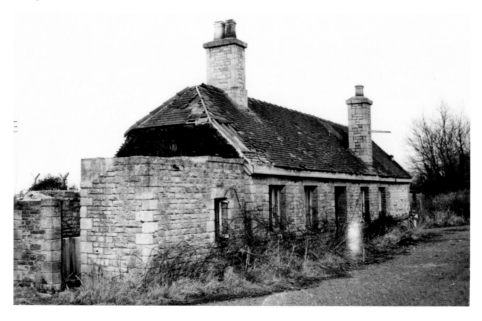

Brize Norton & Bampton

Above: Another post-closure view of Bampton goods shed, taken in 1968. Despite years of vandalism and neglect, the building was still more or less intact. The author's mother can be seen picking blackberries in the lower right-hand corner of the picture. *Below*: A view of the derelict facilities photographed from the signal box in the summer of 1972.

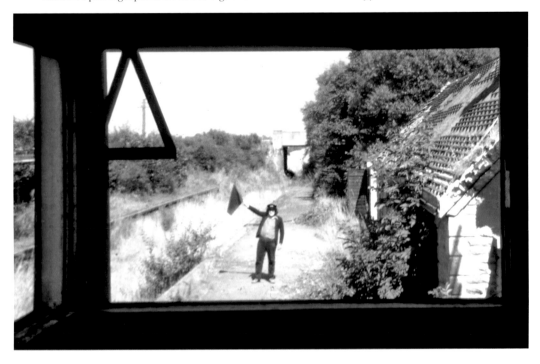

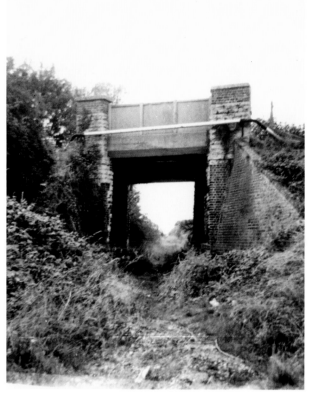

Brize Norton & Bampton

Left: A detailed view of the road overbridge, looking westwards after removal of the permanent way. Designated bridge No. 15 in the Fairford Branch bridge register, it was a typical East Gloucestershire Railway structure with stone abutments and a span of 12 feet 8 inches (13 feet 2 inches on the skew). *Below*: The site of the station is now an industrial estate. This colour view shows the station approach in December 2012; the lengthy bridge ramp is to the right, while the modern buildings that have been built on the trackbed can be seen in the background. The road bridge still exists, although the bridge aperture has been blocked up by tipping.

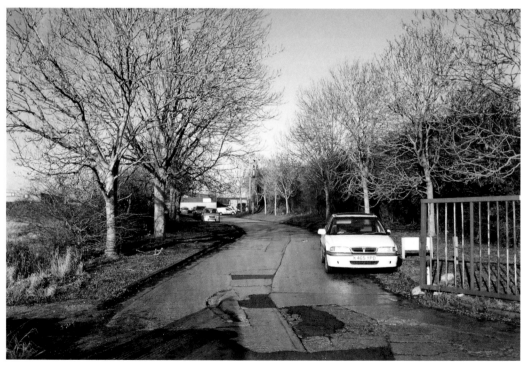

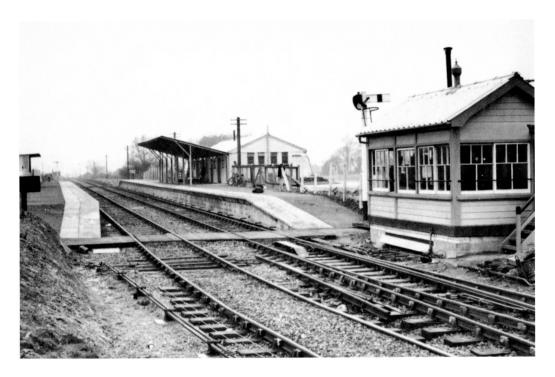

Carterton: A Wartime Station

Continuing westwards, trains soon reached Carterton station (17 miles 3 chains), which was opened on 2 October 1944 to serve the adjacent RAF aerodrome. Its facilities comprised up and down platforms on either side of a crossing loop, with a War Department style station building on the up side as shown in the upper view – which was taken shortly after opening. The station building boasted a large, asbestos-covered canopy, and this can be seen to advantage in the lower illustration.

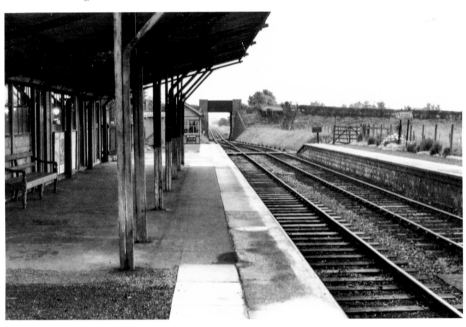

Carterton

Although there was no goods yard at Carterton, the station handled a considerable amount of garden produce from neighbouring smallholdings, which was despatched as parcels traffic. The upper picture, taken from the heavily vandalised signal cabin in 1970, shows the overgrown trackbed, with bridge No. 16 visible in the distance. After a long period of dereliction, the abandoned station building was refurbished and converted into a riding stable, as shown in the lower illustration.

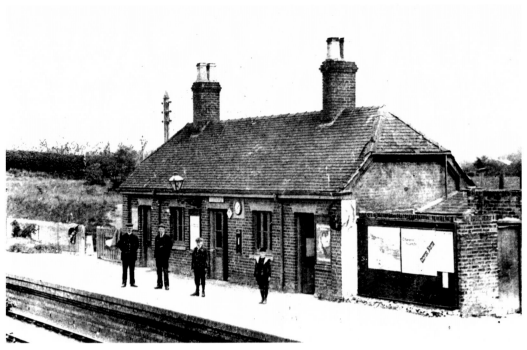

Alvescot

Alvescot station, 17 miles 59 chains from Oxford, was only a short distance further on, and indeed it could be clearly seen from the platforms at Carterton! The station building, shown in the upper photograph, was of similar appearance to its counterparts at Witney and Bampton, although curiously it was built of red brick, instead of the Cotswold stone used elsewhere on the EGR route. The lower photograph shows a local farmer in his horse-drawn trap waiting patiently in the station yard. When opened in 1873, Alvescot had been equipped with just one loop-siding for goods traffic, but a second siding was added around 1890. The main siding could accommodate around twenty-five goods vehicles, while the second siding could hold another twenty-six wagons. The loop-siding incorporated two short spurs at each end, one of which served an end-loading dock and cattle pens; the yard was also equipped with a 1½-ton hand-operated crane.

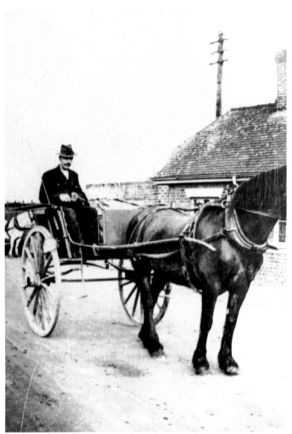

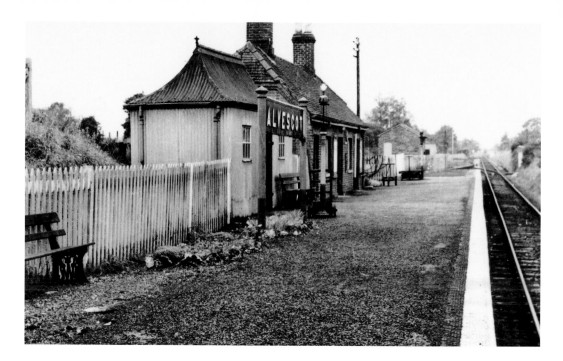

Alvescot

These contrasting views are both looking west towards Fairford. The upper view, dating from around 1962, shows the single platform on the down side of the running line, while the recent photograph, taken from the road overbridge (No. 18), shows the decidedly nondescript group of buildings that now occupy the site. There was no signal box at Alvescot, and access to the goods sidings was controlled from two line-side ground frames, which were known as Alvescot East and Alvescot West frames.

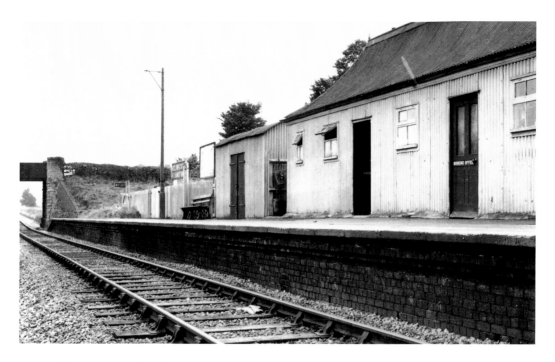

Kelmscott & Langford

After Alvescot, the railway entered a particularly remote stretch of countryside, with only the scattered farms to suggest that the area might possibly be inhabited. *Above*: Kelmscott & Langford station (19 miles 68 chains) was opened on 4 November 1907. It was originally a passenger-only stopping place, although a goods siding was added in 1928. The station was little more than a staffed halt, the station building being an austere corrugated-iron 'pagoda shed'. *Below*: The station in 1972.

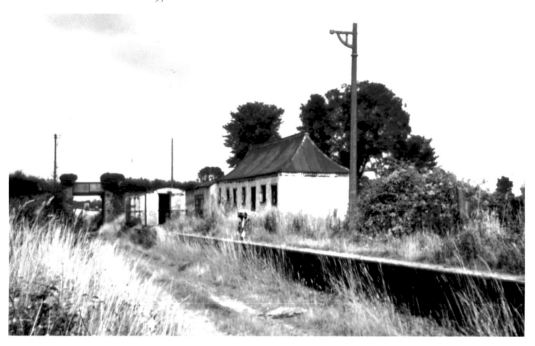

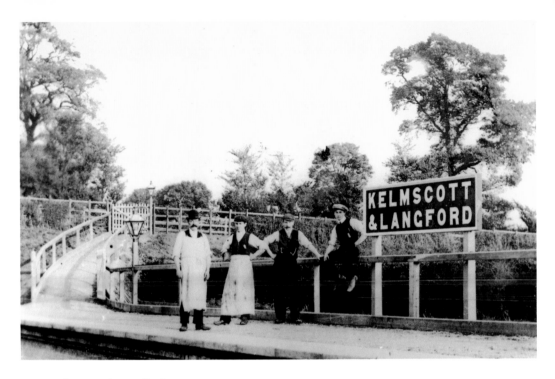

Kelmscott & Langford

Above: Kelmscott & Langford was staffed by just one man, who was graded as a 'class five stationmaster'. He may be one of the people in this photograph from around 1912 – perhaps the gentleman with the watch-chain? *Below*: Collett '57XX' class 0-6-0PT No. 9653 leaves Kelmscott with a down passenger working in June 1962. The goods siding that can be seen to the right was used for cattle and wagon-load traffic; it was worked from a ground frame beside the siding points.

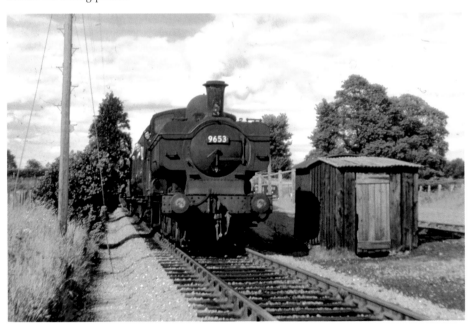

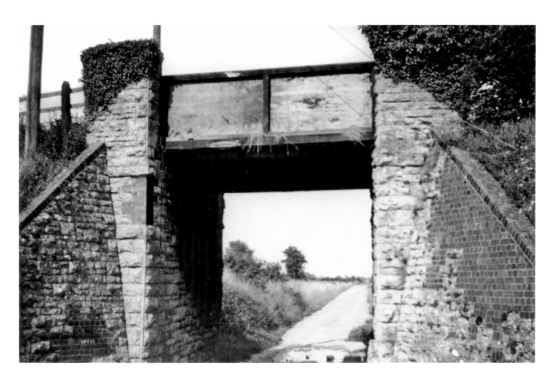

Kelmscott & Langford: Bridge No. 22

Bridge No. 22, at the eastern end of the station, was another typical EGR road bridge with stone abutments, wrought-iron joists and timber decking, its span being 12 feet 8 inches. The upper view shows this still-extant structure in 1965, while the colour photograph shows the bridge in 2012. It is interesting to note that, although the railway has been closed since 1962, the bridge has recently been refurbished and fitted with railings in place of the earlier wooden parapets.

Kelmscott & Langford

As its name implied, Kelmscott & Langford served the nearby villages of Kelmscott and Langford – Kelmscott being 2 miles to the south of the railway, whereas Langford was half a mile to the north. The upper view shows Kelmscott Manor, the 'holiday home' of the artist and social reformer William Morris (1834–96), while the lower view illustration shows some characteristic Cotswold-style buildings at Langford. Morris was buried at Kelmscott following his death in 1896 – his body being conveyed to Lechlade station by train.

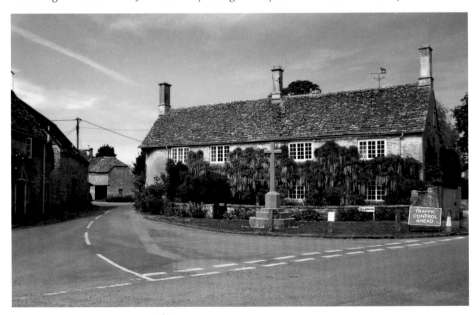

Little Faringdon Level Crossing

From Kelmscott & Langford the line continued towards the Gloucestershire border, curving imperceptibly to the west as it did so. After 1½ miles, a minor road crossed the railway at Little Faringdon Level Crossing. The gatekeeper's two-storey house, on the up side of the line, was built in a vernacular cottage style to match the EGR stations, and it featured a small bay window so that the gatekeeper could see the track in each direction. *Above*: The level crossing and gatekeeper's house in August 1972, at which time the course of the railway was still clearly defined. *Right*: In contrast, this photograph was taken in January 2013 and shows the former gatekeeper's house from the site of the crossing. The building has been considerably extended, but the railway is no more than a rutted farm track.

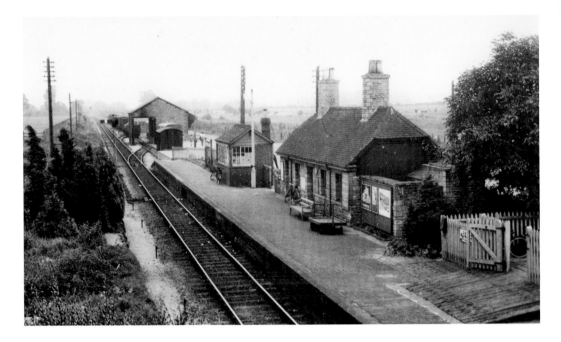

Lechlade

Lechlade, the penultimate stopping place (22 miles 23 chains), was equipped with a single platform and a two-siding goods yard on the down side. The station building was of the now familiar East Gloucestershire Railway type, with distinctive half-hipped gable ends. *Above*: This view, looking towards Oxford from bridge No. 25 at the west end of the station, dates from around 1935. *Below*: '57XX' class 0-6-0PT No. 3653 with an up train in 1962. *Inset*: A GWR 'reduced fare' ticket from Lechlade to Kelmscott, issued on 17 June 1961.

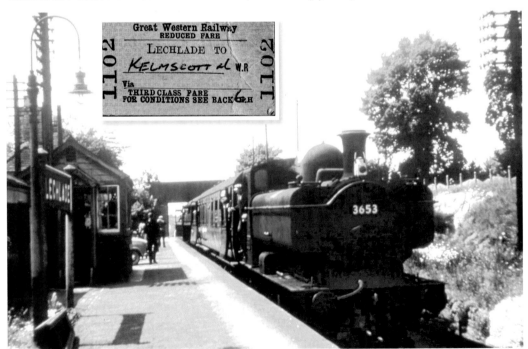

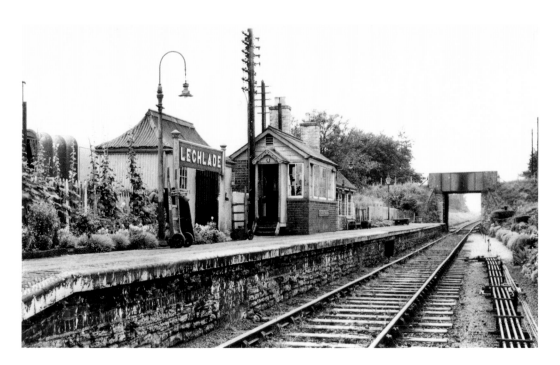

Lechlade

Above: An overall view of the station, looking west towards the road overbridge around 1961. Signalling and trackwork alterations carried out in 1944 enabled Lechlade to be used as a passing station, although, as the crossing loop was situated to the east of the platform, it could not be used for crossing two passenger trains. *Below:* This old coach body was placed in the goods yard and used as a store by local farmers and traders.

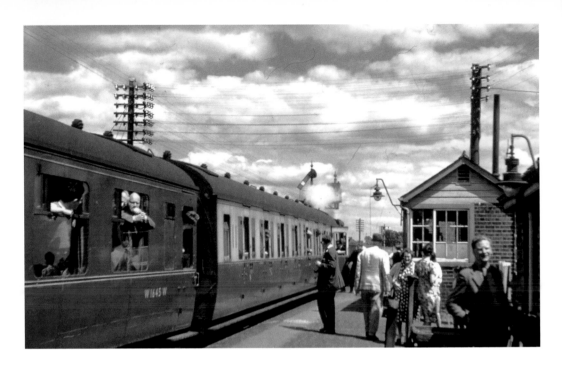

Lechlade

Above: This photograph was taken by John Strange on the last day of operation in June 1962. The standard GWR gable-roofed signal box that can be seen on the platform next to the station building contained a seventeen-lever frame. *Below*: A ground plan and front elevation of Lechlade station building which, like its counterparts elsewhere on the EGR line, was built to a standardised design – although there were several minor differences between the various buildings.

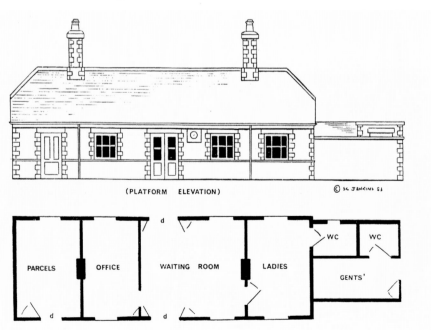

(PLATFORM ELEVATION)

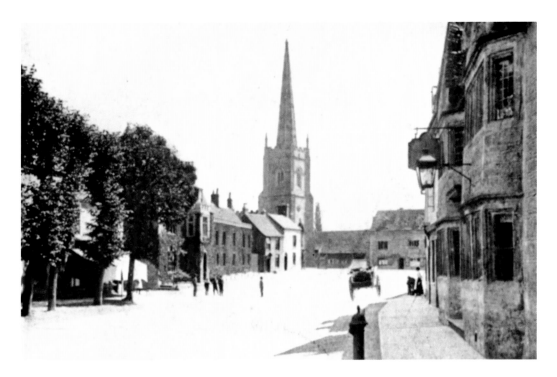

Lechlade: Cotswold Buildings

Lechlade is situated on the upper Thames, and it was also the starting point for the Thames & Severn Canal – the actual junction with the River Thames being at nearby Inglesham. *Above*: Dating from around 1912, this photograph is taken looking southwards along Burford Street, with Market Place and St Lawrence's church visible in the distance. *Below*: Lechlade Mill, about a mile to the east of the town. These Cotswold-style buildings are typical of the surrounding area.

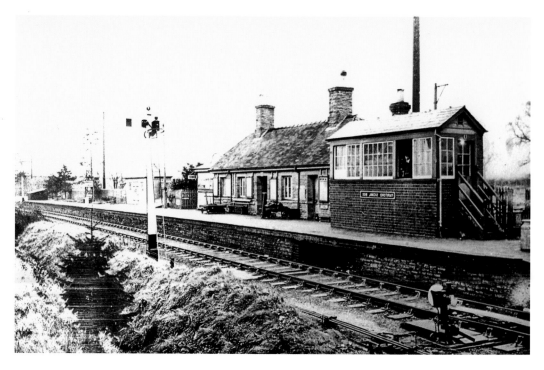

Fairford: General Views of the Passenger Station

Leaving Lechlade, the railway ran westwards for a further 3¼ miles across very flat, open countryside before reaching its destination at Fairford, 25 miles 45 chains from Oxford. Here, the trains came to rest in a single-platform station, with a standard EGR-pattern station building and a GWR signal box. These two images show front and rear views of Fairford passenger station and signal cabin on a rainy day in January 1932.

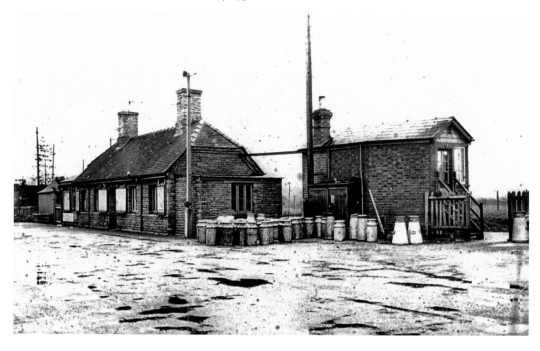

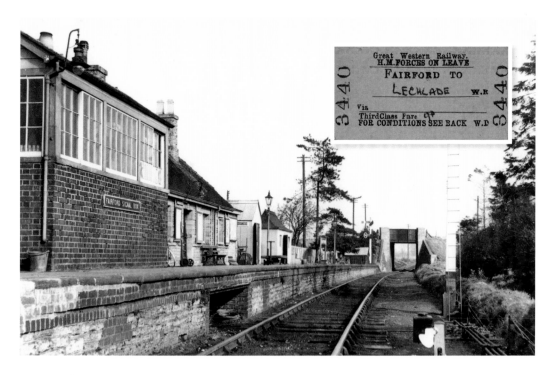

Fairford: The Station Building & Signal Box

Above: A general view of the station, looking east towards the road overbridge, which was designated bridge No. 29 in the Bridge Register. The thirteen-lever signal cabin was of asymmetrical appearance, in that it was a five-sided structure which tapered towards its western end in order to provide easy access to the adjacent end-loading dock. *Below*: The rear of the station building, with a British Railways road delivery vehicle visible to the left. Both of these photographs were taken around 1960. *Inset*: A GWR forces leave ticket from Fairford to Lechlade issued on 2 September 1961.

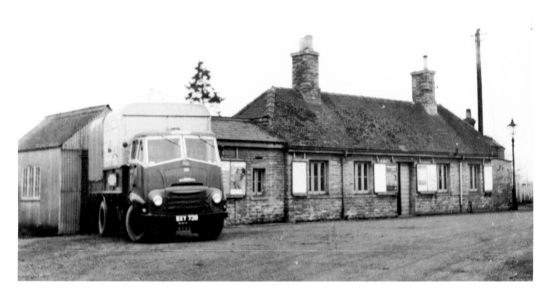

Fairford

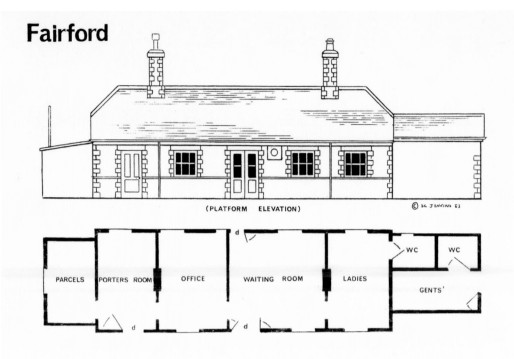

(PLATFORM ELEVATION)

© SC JENKINS 83

PARCELS | PORTERS ROOM | OFFICE | WAITING ROOM | LADIES | WC | WC | GENTS'

Fairford: Details of the Station Building

Above: The front elevation and ground plan of Fairford's EGR station building, showing the internal layout. The small extension at the west end contained additional accommodation for parcels traffic. The building exhibited one unusual feature in that the internal dividing wall between the booking office and waiting room bisected the rear entrance, with the result that only one of the double doors could be used – the right-hand door being boarded up. *Below*: Another view of the station in 1932.

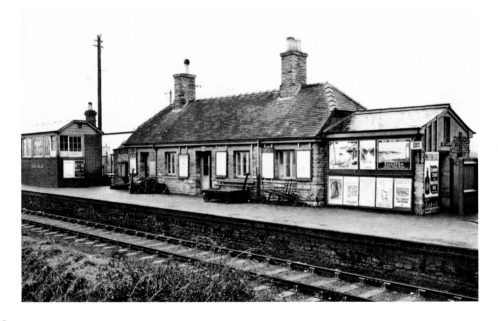

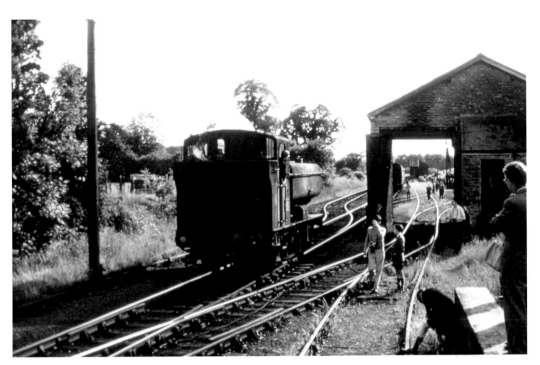

Fairford: The Goods Shed

Although the builders of the railway had provided sufficient land for a double line, the run-around loop was situated beyond the platform, and trains had to draw forward in order to reach the loop and goods sidings. The upper photograph shows '57XX' class locomotive No. 9653 performing this operation, the goods shed being visible to the right. The lower picture is looking eastwards through the open doors of the goods shed. Both of these photographs were taken on 16 June 1962. Coal was the main source of incoming traffic at Fairford, the main coal merchants being James Marriott Ltd and Bernard T. Frost, though in earlier years, a smaller coal dealer, R. Fred Cole, had traded from Fairford and Lechlade stations, using a small fleet of red-painted coal wagons. Outward traffic included agricultural produce such as hay, straw and sugar beet, much of this traffic being of a seasonal nature.

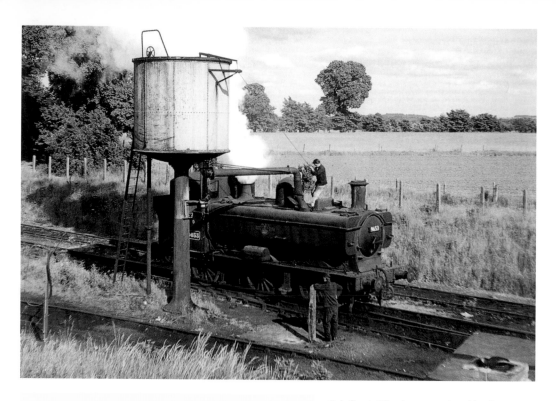

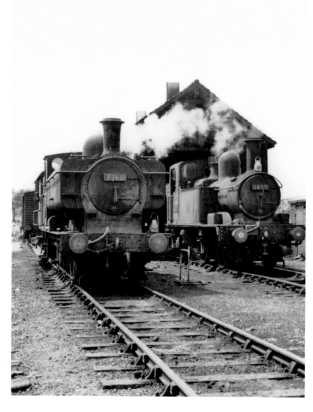

Fairford: The Locomotive Shed

The line continued westwards, beyond the goods yard, and ended abruptly at the end of a shallow cutting, with a carriage siding on one side and a wooden locomotive shed on the other. A centre-column mushroom-type water tank and an old horse box, used as a mess hut, stood nearby, and a short spur served a turntable and coaling stage. The original turntable had a diameter of just 45 feet, but a larger 55-foot table was installed during the 1940s. The shed itself was a GWR timber-framed structure that probably incorporated pre-fabricated components. The last down train of the day always stayed overnight in order to form the first up working, two locomotives and four crews being based at Fairford.
Above: '57XX' class 0-6-0PT No. 9653 takes water at Fairford.
Below: '57XX' 0-6-0PT No. 7760 and '14XX' 0-4-2T No. 1450 stand in the sunshine outside Fairford shed.

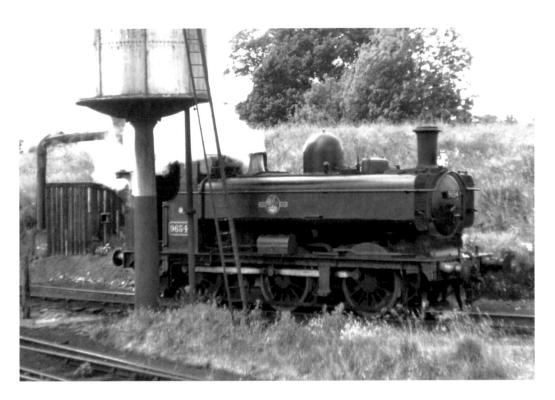

Fairford: Branch Locomotives

The branch passenger services were worked by 'Metro' class 2-4-0Ts for many years, with 0-6-0ST locomotives appearing on freight workings. Pannier tanks of the '57XX' and '74XX' classes were predominant in the 1950s and 1960s, although '14XX', '2251', 'Dean Goods' and '45XX' class locomotives were also employed. *Above*: '57XX' 0-6-0PT No. 9654 beside the water tank. *Below*: '14XX' 0-4-2T No. 1450 stands in the platform at Fairford; this locomotive is currently working on the Dean Forest Railway.

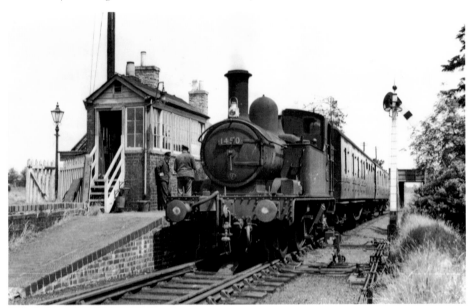

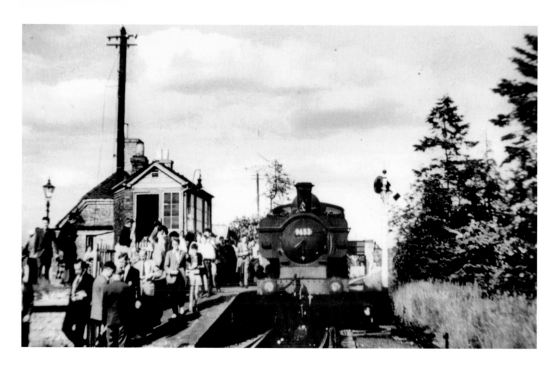

Fairford: The Last Trains

As mentioned earlier, the EGR section between Witney and Fairford was closed to all traffic on Saturday 16 June 1962. These two photographs were taken by John M. Strange on the last day of operation. The upper view shows '57XX' class o-6-oPT locomotive No. 9653 beside the unusually crowded platform, and the lower photograph, which is looking eastwards from the road overbridge, shows one of the last trains pulling away from Fairford.

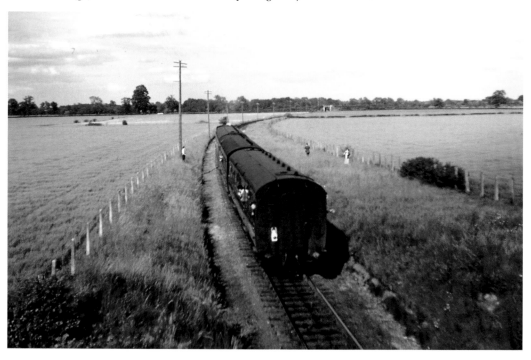

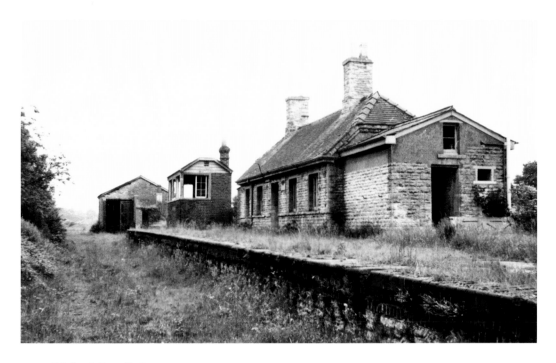

Fairford: Dereliction

Track-lifting commenced in the autumn of 1964 (*see page 58*), by which time Fairford station had been thoroughly vandalised. The derelict buildings nevertheless survived for many years, and the station was still more or less intact when these photographs were taken in 1968. *Above*: Looking west towards the goods shed. *Below*: The rear elevation of the station building – the boarded up right-hand door mentioned on page 88 is clearly visible.

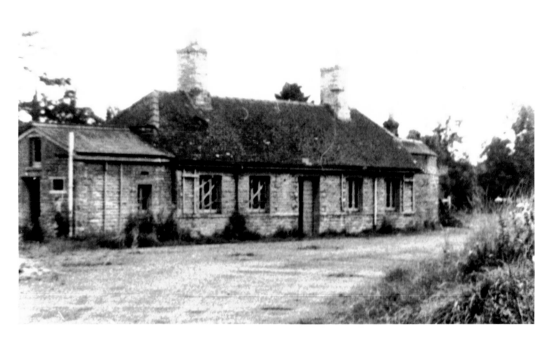

Fairford: Relics of the Railway

Above: The site of Fairford station is now occupied by modern industrial buildings, and all traces of the erstwhile East Gloucestershire Railway terminus have disappeared. *Below*: There is, on the other hand, a pair of semi-detached railway cottages in London Road, one of these being called Station Cottage while the other is known, appropriately enough, as Terminus Cottage. The Railway Inn, situated a little further along the road, also serves as a reminder of the lost railway.

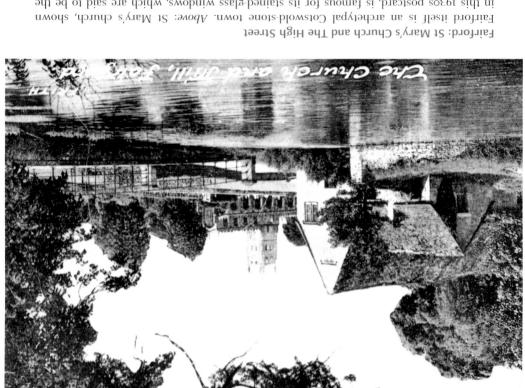

Fairford: St Mary's Church and The High Street

Fairford itself is an archetypal Cotswold-stone town. *Above*: St Mary's church, shown in this 1930s postcard, is famous for its stained-glass windows, which are said to be the most complete set of late-medieval glass windows in England; indeed, these windows were considered to be so important that in the Second World War they were removed for storage in a safe place. *Below*: A general view of Fairford High Street, looking northwards in January 2013.

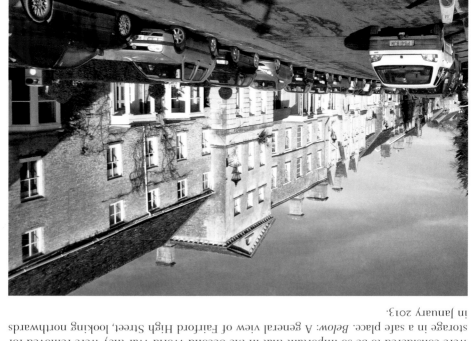

Parting Views

Of the 25½ miles of line between Oxford and Fairford, barely 3¾ miles remain in use – this remnant being the still-extant main line section between Oxford and Yarnton. The rest of the route has been abandoned, its stations demolished and its trackbed obliterated or turned into farm tracks, as exemplified by this recent view of the railway at Little Faringdon Crossing. The lower view provides a departing view of Witney, as seen from the rear of the final passenger train on 31 October 1970.

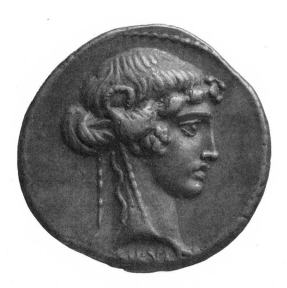

Roman sesterce depicting the profile image of a Sibyl.
Minted circa 65 BCE under Lucius Manlius Torquatus.

(Ashmolean Museum, Oxford.)

SIBYl

SIBYLS

Prophecy and Power in the Ancient World

Jorge Guillermo

OVERLOOK DUCKWORTH
NEW YORK • LONDON

This edition first published in hardcover in the United States and the United Kingdom in 2013 by Overlook Duckworth, Peter Mayer Publishers, Inc.

NEW YORK
141 Wooster Street
New York, NY 10012
www.overlookpress.com
For bulk and special sales, please contact sales@overlookny.com,
or write to the above address.

LONDON
30 Calvin Street
London
info@duckworth-publishers.co.uk
www.ducknet.co.uk
For bulk and special sales, please contact sales@duckworth-publishers.co.uk,
or write to the above address.

Cataloging-in-Publication Data is available from the Library of Congress

Book design and typeformatting by Bernard Schleifer

Manufactured in the United States of America
ISBN US: 978-1-4683-0684-2
ISBN UK: 978-0-7156-4304-4

*This book is dedicated to Esther Pardías
who over the years has been
my own steadfast source of sibylline wisdom*

CONTENTS

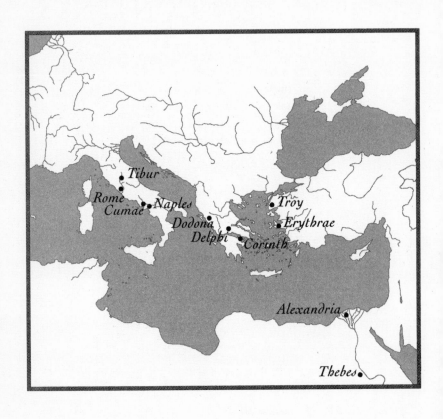

INTRODUCTION

Books dealing with pagan material very quickly disappeared once they had fallen into disuse. The hateful hostility of certain rulers had the same destructive effect, going after these books as fiercely as they would attack their worst enemies. No number could accurately express how much was irretrievably destroyed as a result of this malevolence, not just books of stories but also many others about various subjects.

GIOVANNI BOCCACCIO, *Genealogy of the Pagan Gods*

We are always haunted by the past, even when we try to destroy it.

CHARLES ROSEN, *Freedom and the Arts*

The ultimate triumph of Christianity over pagan polytheism inevitably led to the overthrow and sweeping destruction of all traditional religious figures and practices in the classical world. The sibyls stand out as the rare and spectacular exception: they successfully managed to survive the carnage with their authority still pretty much intact. Nevertheless the individual stories and collective achievements of these extraordinary women have become largely unfamiliar to the majority of people in the twenty-first century. Until fairly recently that would never have been the case. The sibyls remained trusted and admired figures well into modern times, although without any doubt their

reputation, power and fame would have been immeasurably greater in their own day, when people would have flocked to their sanctuaries from even the most remote and isolated corners of the vast Roman Empire.

Not far to the northwest of Naples, high above an inhospitable stretch of coastline facing the depths of the Tyrrhenian Sea, there is a bare patch of ground whose powdery surface is marked only by the gaping entrance to what appears to be an ordinary cavern. Most casual visitors arriving at this spot today would never suspect that two thousand years ago, and for quite a long time before then, this unprepossessing opening in the rocky soil had been renowned all over the Mediterranean world as the dwelling place of the immensely respected Cumaean Sibyl. Unless they had been told in advance, very few of them would know that over many centuries stretching back in an unbroken line for countless generations, throngs of eager pilgrims filled with deep reverence and heightened expectations would have arrived in Cumae every single day. Each of them would have had the same hope in mind: to catch a glimpse of the sibyl and with any luck perhaps be able to hear one of her treasured pronouncements. Throughout her long career she was a hugely influential figure.

The Cumaean Sibyl has always been one of the most famous members of her select circle, but nonetheless she was not the only one who practiced prophecy in ancient times. The sibyls formed an extremely small and yet very powerful group of independent women prophets. The reason why they would come to be known as sibyls is a matter of speculation, but most likely the earliest recorded practitioner of their profession had been given that name, either by her family at the time of her birth or by her loyal and admiring followers at some later moment of her life, and it would automatically

have come to be applied to her successors. In the early years of the Renaissance the cultivated humanistic writer Giovanni Boccaccio expressed the belief that the word would have first come into use simply to identify any of the various women who possessed minds filled with God and other spiritual concerns. It is possible that initially the name would have been bestowed upon a prophetic woman as a polite gesture of respect and public recognition of her powers.

Although the remarkable antiquity of the word *sibyl* has always been recognized, it should not be surprising that its precise etymological origins have never been determined with any degree of finality. Writing in the first century BCE, Marcus Terentius Varro advanced the suggestion that the term had derived from a long-disused dialect of ancient Greek spoken at one time by the Aeolians, a people who lived in Asia Minor along the eastern coast of the Aegean Sea. In view of the fact that Varro held the prestigious post of public librarian under Emperor Julius Caesar and was widely considered by his peers to have been the most learned of all Roman citizens of his day, his opinion on this matter deserves to be taken seriously.

All the same, various authors have found it appropriate to advance several other possibilities. The travel writer Pausanias, who lived three centuries after Varro, declared with equal conviction but with considerably less authority that the term was definitely of North African derivation. Still other scholars have proposed a Semitic etymology, which might reasonably suggest still greater antiquity. Regardless of its antecedents, the word *sibyl* has been in use for an impressively long time. The ancient Greeks and Romans eventually came to apply it across the board to all the women who possessed the gift of divination. Thousands of years later Boccaccio recorded his opinion that the designation had been bestowed only very

sparingly and even then exclusively on those women who possessed the most highly developed prophetic skills.

The conviction that the sibyls drew their vision and consequently their authority directly from the gods appears to have been one point of view which was unanimously shared by everyone in classical times. Plutarch records that "the sibyl with raving mouth, according to Heraclitus, utters things mirthless and unadorned and unperfumed, and her voice carries through a thousand years because of the god who speaks through her." For that reason alone their powers would have been acknowledged by the grandest as well as the humblest of people throughout the classical world.

Virgil reports that Aeneas, the celebrated hero of the Trojan War and legendary founder of what would eventually become the Roman Empire, made a long and arduous journey expressly to consult the Cumaean Sibyl in her inhospitable cave. He was unshakeable in his belief that the sibyl was the only one who possessed the ability to disclose to him his destiny. At a time when the world was almost entirely dominated by men, the very idea that a noble and mighty warrior like Aeneas would deferentially seek the counsel of a helpless old woman living in remote isolation with only a handful of female attendants for companionship clearly demonstrates the profound respect which in ancient times must have been routinely accorded to the sibyls and to their pronouncements. More than two thousand years have passed since Virgil wrote his account of Aeneas's visit to the Cumaean Sibyl, but already by Virgil's lifetime the supremacy and prestige of these visionary women had been solidly established for more than a few centuries. Generations before Virgil, Heraclitus had noted the sibyls' prophetic vision.

It speaks volumes about the sibyls' enduring power that

in 1954, a time far removed from classical antiquity, one of the leading members of the Italian postwar school of neo-realist cinema would choose the cave of the Cumaean Sibyl as the setting for an important scene in a film he wrote and directed. The main characters in Roberto Rossellini's *Journey to Italy*, sensitively played by Ingrid Bergman and George Sanders, drive from London to Naples to arrange the sale of a house they have inherited. Their marriage is visibly breaking down and they agree to go their separate ways until the property is sold and they can afford to divorce. He goes off on his own while she visits the local museums, where she is struck and deeply unsettled by the manifest sexuality of ancient sculptures. When she is taken by a local tourist guide to the abandoned cave of the Cumaean Sibyl, she is inexplicably but all the same powerfully moved by the immense emptiness of the underground spaces; she is probably reminded of the vapid hollowness that undermines her marriage. It is almost certainly while she is there that she decides to seek a reconciliation with the man she still loves. Whether or not the lingering aura of the sibyl had anything to do with guiding her decision is never made explicit by Rossellini, but her visit to the cave most emphatically bears upon her state of mind. At the end of the film the couple unexpectedly encounter a religious procession in the streets of Naples whose spontaneous expressiveness and intense fervor will prompt them to realize that they cannot live without each other. The story is not even remotely about the sibyl, but nevertheless Rossellini presents an encapsulation of all that has ever given currency to the sibylline experience: sexuality, mystery, and, not least of all, an expression of the power of religious faith, in all its many forms, to influence human lives.

The handful of occasional tourists who might make the journey to Cumae today will come upon a deep and windswept

crevice on top of a hill. There are few architectural or topo-
graphical features which might suggest to them that at any
time there could have been something special about the place.
However, if they were to venture into the cavern, their own
perception would be altogether altered and they would begin
to understand why the character played by Ingrid Bergman
reacted the way she did when she was there. Gradually all
visitors will become aware of a bewildering feeling, quite im-
possible to attribute to any determinate reason, which will
begin to take hold of the consciousness and imagination of
even the most phlegmatic and rational among them. The
more inquisitive and determined members of their group
might decide to continue deeper into the vast and tenebrous
underground chamber where it is said that for many centuries
the ageless sibyl would have received her unending stream of
visitors. With only the persistent howling of the wind to
break the unearthly silence, before too long they would feel
compelled to make their way back to the welcome familiarity
of the outside world.

The phenomenon is reported to happen with regular
frequency and it is most commonly put down to predeter-
mined expectations, simple claustrophobia or pathological
anxiety; this book, however, might suggest other possible
points of view. Just the same, its principal purpose will be to
relate the extraordinary circumstances of the lives and achieve-
ments of four separate sibyls and present them against their
historical background in an attempt to explain the develop-
ments, more often than not entirely beyond their own imme-
diate control, which have made it possible for these figures
to survive through extended periods of turbulent political and
theological changes. The strength and durability of their rep-
utation in antiquity do not seem nearly as remarkable as does
their extension into more recent times. More than to any

other determining factor, the continuation of the prestige and authority of the sibyls is due to the almost miraculous metamorphosis of their image from pagan fortune-tellers into Christian visionaries.

Early in the sixteenth century representations of five of the sibyls were painted by Michelangelo on the vaulted ceiling of the Sistine Chapel alongside the images of seven revered Old Testament prophets. Neither during Michelangelo's lifetime nor at any later stage has anyone ever questioned the appropriateness of displaying effigies of these pagan women so conspicuously in the sacrosanct precincts of a papal chapel. Although Michelangelo's frescoes remain the best known and most widely admired representations of the sibyls in Western art, they are by no means unique. Depictions of the sibyls in paint, wood, mosaics and stained glass can be found throughout Europe in abundant numbers, perhaps surprisingly almost always in churches but now and then also in secular settings. Occasionally their images might go unnoticed, and more frequently just unrecognized, but the sibyls have never been entirely forgotten.

In 1612, a century after Michelangelo had completed his frescoes in the Sistine Chapel, Louis XIII, the ten-year-old king of France, was betrothed to a young Spanish princess. At the same time the king's sister became engaged to the bride's brother, who was the heir to the throne of Spain. A double betrothal at this dynastic level was an event of staggering political significance, not only for the two countries involved but also for the rest of Europe. In order to find a fitting manner to celebrate an occasion of such dignity and importance, the formidable Queen Regent, Marie de' Medici, mother of Louis XIII, arranged to hold one of the most opulent and elaborate public festivities ever to have been staged in France. What must have seemed like the entire population

of Paris watched an extravagant ceremonial procession which went on for hours and included soldiers, clerics, courtiers, musicians, acrobats and horsemen.

Decorated elephants and even extremely rare and wildly exotic rhinoceroses marched through the streets and squares of the jubilant city. Graceful chariots pulled by deer were followed by giants bearing enormous bows and arrows. An equestrian ballet was performed to the accompaniment of drums and trumpets as an unceasing pounding could be heard in the background, coming from the direction of the Bastille where cannon salvos were being fired in acclamation. At a certain moment during a lull in the deafening din of the festivities, a small group of sibyls unexpectedly made their appearance, declaiming paeans to the two young couples. These iconic women from the pagan past had been personally selected by the orthodox and devout queen of a staunchly Christian nation, great-niece of two powerful popes, as the most appropriate figures to prognosticate a happy future for her exalted children. It is revealing that not a single person at the time thought it necessary to record either surprise or disapproval.

To a twenty-first-century observer, the longevity of the sibyls' power and reputation might initially appear almost incomprehensible, but the reason for their continuing renown must certainly become immediately clear to anyone who studies their history, even superficially. Any indication of how human lives might eventually unfold has always been not only respected but most eagerly pursued. The sibyls' prestige has always been solidly founded on their alleged ability to look into the future, regardless of what at any given moment might have been considered to be the source of their vision. From the earliest moments of human history until the present day, when horoscopes continue to be one of the most popular

and avidly read features in magazines and newspapers world-wide, men and women of all ages, nationalities and social backgrounds have regularly tried to gain an insight into their personal destinies, exactly as Aeneas once felt he had to do, in the hope of learning how to regulate their actions and possibly derive some advantage from this foreknowledge. For a few millennia the sibyls have both jointly and individually played a significant role in this compelling quest; the intriguing reasons behind their enduring presence, as much as the account of their personal sagas, are more than worthy of our attention in the modern world.

1

PROPHECY IN THE ANCIENT WORLD

I am aware of no people, however refined and learned or however savage and ignorant, who do not think that signs are given of future events, and that certain persons can recognize those signs and foretell events before they occur.

Marcus Tullius Cicero,
De Divinatione, Book One

The sibyls stood at the very pinnacle of their profession. These inspired visionary women are rightly considered to have been the most successful and influential figures ever to practice the art of prophecy in the history of Western civilization. Regardless of their wondrous skill and undeniable authority, the sibyls were exceptional but not quite unique. The classical world valued the presence of a large number of other respected prophets and diviners whose individual names have been forgotten but whose mastery was widely recognized by their contemporaries. Their advice was sought and accepted by multitudes of people over the course of many centuries. Cicero's report of the universal prevalence of prophecy almost two thousand years ago is confirmed by an abundance of documen-

tary evidence. At one time or another probably all cultures in antiquity would have devised and put into practice their own prophetic routines; a short outline of a few of these occasionally whimsical customs will be described later on. The sibyls represent only a small part within a complex system of reception and interpretation of natural signs and divine revelations for the purpose of seeing into the future. If sibylline traditions and accomplishments are to be understood, they need to be looked at in their multifaceted historical and cultural context.

Prophecy is predicated on the conviction that to a greater or lesser degree events in human history have been planned before they actually come to pass; under any other conditions prophets would obviously have very little to prophesy. Only people who believe that the circumstances of their lives had been determined ahead of time would turn to sibyls or prophets to help them discern the future. In this ideological construct, human lives are, if not entirely regulated, at the very minimum influenced by forces which have been traditionally considered to be eternal and omniscient in nature and to belong to a transcendent sphere entirely beyond the physical world. The actual practice of foretelling the future is grounded on the double proposition that there is a spiritual realm which affects human lives and that this realm can be accessed by a select number of people who know the way. These ideas would never have occupied the rudimentary thoughts of the primeval human beings who banded together in reciprocal convenience to form the first communities.

The majority of scholars agree that the very earliest ancestors of modern humanity would never have felt the need for prophecy. It is unlikely that they would have spent much time contemplating the nature of the world they inhabited or

analyzing the separate elements which made up their own lives and personalities. These tribal communities must have been concerned exclusively with their day-to-day survival. They would have had no need to plan their lives as rigidly or to look into the future as regularly as modern humans would begin to do at a much later stage; prophets would have had no role to play within their social structure. It is in fact doubtful that any of them would have ever taken time to think about the possibility of a spiritual side to their nature, or that they would have looked upon the great abundance of animals that surrounded them as anything other than a simple source of sustenance. Regardless of their ingrained single-mindedness, it was inevitable that in time they would begin to detect the presence of a force beyond their power to control. As generations came and went, it was unavoidable that the dramatic and inescapable differences between living and dead creatures, human or otherwise, would begin to intrigue these primeval human beings and motivate at least some of them to seek an explanation for the presence or absence of the breath of life within them.

The arbitrary nature of this tangible but unfathomable phenomenon must have appeared all the more overwhelming because in the majority of cases these people would come face-to-face with death unpredictably, abruptly and in startlingly gruesome circumstances. Only very few of them would enjoy long lives and those who had the good fortune to survive into adulthood would have been confronted every day with the routine unreliability of food supplies along with the random onset of baffling diseases and the unexplained disappearance of relatives, neighbors and other members of their tribe. Life and death were mysteries these human prototypes were not equipped to decipher. Their budding realization of this fact would certainly not

have been enough to keep any of them from continuing their practice of indiscriminately chasing and killing any animal or human enemy in sight.

TENS OF THOUSANDS OF YEARS WOULD HAVE GONE BY BEFORE early modern humans arrived on the scene. They gradually grasped the potential usefulness of the caves they would occasionally come across as they wandered around their immediate surroundings in search of food. These subterranean spaces could offer them not just obvious and easy shelter from predatory animals and bad weather but also a protected setting for their fledgling social gatherings. At some point at least twenty thousand years ago, these distant relatives of the Neanderthals started to paint the walls of their caves with vivid sequences of hunting scenes. The extraordinarily accomplished murals they created represent the oldest known manifestation anywhere in Europe of the distinctive human impulse to express theoretical concepts through pictorial means. Since their fortuitous discovery in the final years of the nineteenth century, they have been recognized as the cradle of the Western artistic tradition, but on a parallel level these wall paintings also record the emergence of ritual in the Western world.

The longer we examine these powerful images, the more obvious it becomes that they illustrate a development of fundamental importance to the history and understanding of the sibyls and of all other prophetic practices. While the survival of a community might have continued to depend on the successful slaughter of wild animals, its members would have decided that from then on these activities would follow a certain unchanging protocol that always had to be observed. The fixed framework of these hunting expeditions would

provide the blueprint for a long list of future ceremonial rituals and ultimately for any public solemnity involving what the scholar David Stone Potter has so expressively called every "human being's relationship with the vast, uncontrollable forces of nature."[1] The prescribed routines that have been performed time after time at harvest festivals, baptisms, bar mitzvahs, presidential inaugurations and imperial coronations all appear to have their roots in the strict organization of these ancient hunts. Reflections of their formal structure can be detected most particularly in certain rites of divination but also in prophetic and sibylline practices: the public consultations of the deity at Delphi would be a prime example. The murals mark not just the birth of European painting but also the starting point of systematically organized communal ceremonies and religious celebrations in the Western tradition.

The fact that these remote spiritual ancestors of the sibyls would take the trouble to create a pictorial record of what by then would have become their normal hunting practice demonstrates that they must have regarded it as a significant development which set them apart from all preceding generations. The task at hand would have been formidable and there would have been no precedents or guidelines for their undertaking. Working by the dim light of rudimentary torches, it must have taken many months of sustained application and painstaking labor for a small team of self-appointed and entirely unschooled artists to experiment and improvise their way until they finally managed to cover the rough, uneven surfaces within these winding caves. Women regularly took part in the hunt and quite likely they would have made up at least half of the workforce. The coarse walls would come to disappear almost entirely under densely composed groups of figures presenting a scene of sufficiently detailed

realism to make it clear that the hunting practices developed by these artist/hunters must have been not just unprecedented but, beyond all else, profoundly meaningful to their growing collective identity.

It is tempting to speculate that one of the operative reasons behind their decision to coordinate and then document their new rituals might have been their recognition that they shared a common life force with each and every one of the other living creatures around them, animal as well as human, and therefore that killing any of them deserved a set of structured moves more dignified than their thoughtless slaughter. Whenever this realization took place, it must have been accompanied by an awareness that their opponents were worthy of their consideration and respect. Gradually over the course of a few millennia, it would have dawned on early modern humans that they were not the only living creatures in possession of what from that moment on would be considered to be a spirit, if not necessarily a soul. At that moment a liminal boundary in the history of humanity would have been crossed.

FROM THIS SIMPLE YET SLIGHTLY DISQUIETING INSIGHT, THERE haltingly evolved the concept of an immanent universal force that pervaded the entire world. At a certain stage in their social and cultural development, most if not all human societies have held some form of belief that manifestations of an unseen but omnipresent divinity could be found throughout the entirety of creation. The designation applied to this compendium of suppositions is *animism*, a term derived from the Latin word *anima*, which means *soul*. The manifestations themselves have been most commonly regarded as emanations of what has been variously identified as an enduring

force or divine spirit that would issue from sacred sources and dwell not merely within human beings and other higher animals but could just as likely be found occupying trees, growing either singly or in forests, and even within inanimate objects as diverse as streams and mountains, rocks, springs and majestic waterfalls.

Until the present day many remnants of animism have openly survived in various Oriental religions, as they surreptitiously have in a startling number of contemporary Western customs and rituals, secular as well as religious. Let us consider for a moment the reason why many people touch wood to invoke good fortune or, even more remarkably, why British monarchs are still expected to sit upon a particular stone at the sacramental moment of their coronation. We might be moved to speculate why infants are anointed with consecrated oil during their christening and certain devout families in Catholic countries keep a small container filled with holy water on the wall next to their entrance door. Unmistakable animist antecedents can be found behind each one of these traditions and a great many others as well. Certainly in classical antiquity animist beliefs permeated the entire world.

Aristotle was only one of numerous philosophers from the past to devote a great deal of time to meditating and writing about the nature of living creatures. When he was active these concerns had been around for what was already in those distant days a very long time. There had been a few thinkers among this select group who believed that the whole of the universe was suffused with divine spirits. Two hundred years before Aristotle, Thales of Miletus, acknowledged as one of the Seven Sages of Greece, had observed that "everything is full of gods." This short and deceptively simple declaration presents a most eloquent summary of animist principles. The next stage along the lengthy process of search-

ing for a set of satisfactory explanations would have been to identify the places where the spirits of these gods rested and then to make an attempt at finding a way to discern what messages, if any, they were able to communicate to the world. This would have been precisely the opportune moment for sibyls and prophets to make their first appearance.

Prophet is but one of the many different terms that have been applied to the various practitioners of prophecy, each one separated from the others by slight gradations of meaning. Nevertheless, at times the words *diviner*, *prophet*, *augur* and *oracle*, among others, have been used interchangeably. In the case of *oracle*, the term continues to be used to describe the place where prophetic advice is sought as well as to the person through whom this advice is transmitted. Broadly speaking, prophecy has always followed a more transcendent approach than divination, which has used distinctly populist methods. Primarily for that reason divination became widespread among early modern humans and eventually throughout the world of their descendants. In the first century BCE, the famously accomplished Roman polymath Cicero declared that he was not aware of any human society, anywhere within the boundaries of the world he knew, that failed to accept the presence of definite indications of events still to happen, and also of human beings who could interpret those signs and thereby foretell the future. Cicero himself would not have necessarily shared any of these beliefs, but their pervasiveness was something which he was fully prepared to accept. Professor Michael Wood has observed with poetically insightful precision that "fears and hopes change as history changes, and so do the relations between fears and hopes. But the balancing of fears and hopes is a human constant, and oracles are an important part of that balancing act."[2]

IN VIEW OF THE UBIQUITY OF PROPHETIC ACTIVITY IN THE CLAS-
sical world, it might seem surprising that so little concrete
evidence has survived about its actual practice. The fact most
obviously illustrated by this scarcity of documentation is that
historically chroniclers have never been as numerous as
spectators. The inevitable corollary to this observation is that
no chronicler would think of taking the trouble to record
incidents or rituals most ordinary bystanders could easily and
routinely have come to notice on their own. In antiquity the
phenomenon was even more pronounced than it is today: at
a time when the general population was illiterate and writing
implements were costly and sourced only with the greatest
difficulty, not many sensible men and women would have
wished to keep a written record of commonplace events.

In fact, the very absence of documentation regarding
the practice of prophecy in ancient times would appear to reveal
nothing more than a confirmation of how firmly ingrained it
must have been throughout the classical world. Professor
Herbert Parke, who devoted his professional life to the study
of oracular matters, notes that "it is typical of our ancient
sources that none of them gives a straight-forward account
of what happened when a consultation took place. The pro-
cedure was no doubt familiar in classical times to many indi-
viduals, whether they had attended as private enquirers or
on official embassies, and Greek authors take it that the gen-
eral lines of the ceremony are known."[3] Nevertheless there
has survived much compelling evidence that by the dawn of
the Current Era the ancient world was literally teeming with
a bewildering assortment of different types of prophetic and
divinatory rituals, each one bearing a distinct label and all
following divergent tracks.

It was the indefatigable Cicero who made what is quite probably the earliest attempt to classify the broad variety of ways in which prophecy was practiced in antiquity. He observed a fundamental distinction between two separate categories. The first was based on inspiration received directly through such means as dreams, trances and divine revelations; the sibyls and their method of operation would inherently have fallen into this more transcendent category. Cicero considered the second type to be what has come to be most generally known as divination, a diverse assortment of time-honored practices based on the skillful observation and interpretation of natural signs. The scholar of Greek religion Walter Burkert explains that "any occurrence which is not entirely a matter of course and which cannot be manipulated may become a sign: a sudden sneeze, a stumble, a twitch; a chance encounter or the sound of a name caught in passing; celestial phenomena such as lightning, comets, shooting stars, eclipses of sun and moon, even a drop of rain."[4] The number, source and variety of possible signs must have appeared almost limitless.

Particular customs such as those known by the arcane names of *rhabdomancy* and *belomancy* would be prime examples of what is generally known as divination, Cicero's second category. Rhabdomancy required the use of a small group of wooden rods which were momentarily held together and then quickly released directly after a question had been asked. The position and arrangement of the rods as they fell upon the ground at random would be studied and analyzed in an effort to discern the correct answer. The principle of belomancy was similar, but the practice involved the use of a handful of arrows and was substantially more elaborate. The celebrant in charge would make an invocation to the gods before commanding an archer to produce his bow and

shoot the projectiles high into the air, all in the same direction and one following the other. Mutually contradictory messages would have been tied around each of the arrows ahead of time. The one that had flown the longest distance and had come down at the point farthest from the archer would then have been considered to have traveled under divine guidance. The particular arrow would be retrieved, the message unrolled, and the directive it conveyed would then be revealed as an authoritative indication of the most propitious course of action to be followed. The ceremony may have been impressive and colorful, but the actual premise behind it was only marginally more sophisticated than the mindless tossing of a coin.

EVEN IN OUR OWN MORE RIGOROUSLY SCIENTIFIC DAYS, NUMERous methods of an equally diverse and irrational nature continue to be used to search for signs of what is going to happen in the future. At this point we might consider the curious story of Paul the octopus, a gentle but not particularly perceptive creature that used to live on its own in a German aquarium. In 2010 a group of reportedly lucid sports fans used the wayward actions of this sleepy marine animal to forecast the results of a number of major international football matches. Paul enjoyed his own brief moment of celebrity following a series of what unexpectedly turned out to be accurate predictions. At some moment before the games got started the hungry octopus would be presented with a choice between two mussels, both confined individually within little glass boxes bearing the respective national flags of the teams involved. The first one selected by Paul for his dinner would reveal the identity of the winning team. Presumably the octopus would have been allowed to eat the second mussel as a

reward for his prophetic efforts. Because increasingly more substantial bets were being placed by Paul's credulous followers, his predictions were accorded such a degree of attention that German radio and television newsreaders found it of national interest to broadcast them.

There have been other methods of divination involving the observation of animals and their movements. The ancient practice of augury demanded the precise observation and subsequent interpretation of the various aspects of birds in flight. Burkert believed that the contemplation of avian habits had played a singularly special role within the development of divination and advanced the possibility that augury had first developed from very ancient Indo-European traditions. By the time of Cicero such venerable antecedents would have lent the practice of augury an extraordinary degree of authority among its followers. Because of its more exacting nature, augury invariably required the intervention of a specialized category of functionary known to the Romans as an *augur*. These men had to undergo a period of formal training and it was their appointed task to accurately identify the type and number of the birds, assess the approximate height of their flight and make a precise record of the formation they would adopt as they moved through the sky. Of equal importance was the direction of the trajectory followed by the birds and in many cases the nature of the sounds they would make in the course of their flight. As they went about their observations, augurs would invariably hold in one hand a short ceremonial staff, unique to their profession, that was known as a *lituus* to the ancient Romans. These marks of office were made with a highly distinctive spiraling top which made augurs immediately recognizable to all those familiar with their particular modus operandi.

Cleromancy, on the other hand, could be attempted by

anyone in practically any setting and mainly for that reason this practice attained tremendous popularity among the ancient Romans. The term was applied to the simple custom of casting lots. Meticulous cleromancers were known to use small tablets finely carved from ivory or rare wood, but in actual practice markers of any size, shape or material were considered perfectly adequate and were in common use all the time. Regardless of their appearance, all different types of tokens were generically known by the Latin term *sortes* from which the modern word *sortilege* has been derived to denote the practice of divination by casting lots. The people who routinely used them would show great versatility in the ways they indulged their personal fancy.

The simplest and most convenient method of casting sortes would have been to toss them on the ground just the way dice are thrown in the modern world. However, there were some devotees who preferred to place them in capacious containers filled with perfumed water where they would be left to drift around freely and to float, sink or just tip over at random. Every different position relative to the others would be observed and assigned a certain meaning. Enthusiastic cleromancers were known to grow sentimentally attached to their own sortes, occasionally to such an extraordinary degree that in quite a few cases personal sets of these tablets would bear private inscriptions. Names of the owners and now and then a favorite popular saying or a few touching lines from a poem of particular significance to the family were the most popular choices for these brief but lovingly engraved notations.

Of all methods of divination prevalent in the classical world, without any doubt the ritual examination of the various internal organs of sacrificed animals is the one considered by modern observers to be the most unimaginable and

even repugnant. Some might be dismayed to learn that this form of divination enjoyed the longest legitimacy over the centuries. The Old Testament book of Ezekiel reports that it was already being practiced in ancient Babylon. However it has the redeeming distinction of also being the one among all its counterparts to have vanished almost entirely from the modern world. Although there have been reports that certain practitioners of voodoo continue to use chicken entrails in their rituals, the analysis of viscera to divine the future has otherwise been completely discontinued.

Over the centuries the traditional custom of examining animal organs for anything other than gastronomic purposes assumed a number of different forms which continued to be practiced side by side. The variant improbably known as *extispicy* was the most general and for that reason quite likely to be the one with the oldest pedigree. Those who adhered to its conventions were not particular about what kind of animal species they would use for their divinations but were in turn expected to give their attention to every one of the viscera on view, regardless of what type of creature might have been their source. The scope of a comparable variant known as *haruspicy* was restricted to the examination of the lungs and the liver, the two viscera the ancients considered to be the most important of all.

Those who followed the practice of *hepatomancy* concentrated exclusively on the liver because in antiquity this organ was regarded as the very source of life in all its animate forms. Burkert has pointed out that in particular the inspection of the liver had developed into a special art. "How the various lobes are formed and coloured is eagerly awaited and evaluated."[5] The conventional belief was that the gods had advisedly placed the liver in its key location within the body for the primary purpose of manufacturing blood. The regular

flow of this essential substance through the veins of every living creature was the mark which distinguished them from all the other types of lesser inanimate matter forming part of the world. The various models of sheep livers both in clay and in cast bronze discovered in the course of archaeological excavations offer an indication of the importance attached to this long-established practice. The surface of these macabre replicas is usually incised with an elaborate network of markings obviously meant to aid the hepatomancer in his work. Haruspicians dealt with organs coming from sheep, but from time to time also from chickens and other species of birds. Hepatomancers, however, had to make do with liver specimens coming exclusively from sheep carefully selected for that purpose.

In spite of all these differences, the particular methodology of each of these related practices followed a nearly identical pattern. At their most elaborate these were highly complex public forms of divination performed exclusively when special circumstances demanded it and, even then, only at the direct command of an important official. The local ruler or high priest would have held the authority to convoke these sessions, but probably not any of the other lesser dignitaries. Normally the grandest proceedings would have been performed in the open before an audience composed of as many of the population as were available and willing to be there. With a large group of vigilant spectators in attendance, it would have been crucial for the rites to follow very carefully every detail of a prescribed set of definite rules and directions. Each participant had a role to play, and no allowance would have been made for improvisation or individual expression of any kind.

A small group of officials clad in their most imposing robes would get the ceremony under way at the appointed hour. By the time they would make their appearance the crowd of onlookers would have begun to gather in literally sanguine expectation. The animals would have been transported there much earlier and would have been kept in a ceremonial enclosure reserved expressly for such occasions somewhere nearby but not too close to the altar of an important temple. The minor functionaries would have done their best to appear knowing and dignified as they looked over the nervous herd. After a cursory first inspection, any beast showing the slightest sign of weakness or disease would have been taken away at once. A second and more comprehensive examination would then have followed.

Making a quick or unstudied choice would not have been an advisable option. Once an animal had been sacrificed, its entrails had to provide signs unambiguous enough to be clearly noted and interpreted. Tremendous care would have been taken to check and double-check all of the external organs. Under its thick, woolly fleece, the skin of each animal would have been subjected to fastidious scrutiny for any signs indicating the presence of fractured bones or internal injuries. A selection hastily made and badly judged could easily have led to an ugly confrontation and the team knew only too well that each one of them personally would have been called to account if anything went wrong. The prospect of possibly having to face an angry crowd would have made them nervous, but at the same time it would at least have kept every single one of them focused and attentive. All the while the waiting spectators would have been growing restless.

The moment an animal had been selected, it would at once be taken away from the others and led to the place of ritual slaughter to be put to death. This part of the ceremony

would never have been permitted to take place within the sacred precincts of the temple area. The execution itself would have been performed according to another carefully ordained ritual. The particular type of blade which would be used for the procedure must have been specifically prescribed. The following step would have been the ritual evisceration of the carcass; after that had been completed each separate organ would be placed on a tray before being brought ceremoniously to the altar for inspection. The task of searching the viscera for meaningful signs would have been the sole prerogative of either the high priest or, most frequently, of another official who would have been trained expressly to perform this exacting function. Those who practiced this uniquely specialized and now extinct profession were most commonly known as *haruspices*.

The viscera would be subjected to a precise and rigorous examination both before and after their dissection, and every one of their physical characteristics would have needed to be noted and analyzed. Naturally the presence of healthy organs would be hailed as a positive sign. On those occasions when discolored viscera were discovered, this would have been interpreted as a bad omen. However, it was the organs found to be excessively bloody that were considered the worst harbingers of misfortune. The degree and individual relevance of each of these conditions were matters which only the high priest and his appointed haruspex were in a position to assess and ultimately interpret. The public announcement of what they had discovered, along with the conclusions they had drawn from their conscientious observations, would have been the most eagerly anticipated moment of the day.

Naturally these labyrinthine procedures would have been so carefully observed only at the most portentous occasions when far-reaching decisions affecting grave affairs of

state would be hanging in the balance. It may seem incredible to modern observers, but in the classical world matters as serious as when or even whether to go to war were not infrequently decided by these methods. Professional diviners were regularly expected to accompany battalions of soldiers into battle. Walter Burkert informs us that before a great confrontation between the Greek and Persian armies, both sides had "remained encamped opposite each other for ten days because the omens—obtained by the same techniques—did not advise either side to attack."[6] An account like this leaves no doubt that in antiquity supernatural signs were taken very seriously and considered totally reliable.

Cicero reports that before the pivotal Battle of Leuctra, King Agesilaus of Sparta had sent envoys to the oracle at Dodona in order to find out what the chances were that his army would prevail against the Thebans under General Epaminondas. The bizarre events that fatally disturbed the consultation were to have long-lasting consequences: an ape scrambled the signs and in the end the Spartans received only a veiled warning of what was to come. The attendants at the oracle had arranged the lots to be consulted exactly as prescribed, but before the high priestess could examine them a monkey suddenly appeared out of nowhere and threw everything into disorder and confusion. Apparently the king of Molossia, a small region directly to the north of Dodona, had been visiting the oracle at the same time as the Spartans and the mischievous ape had been the pet he kept for his amusement. "Then, so we are told, the high priestess at the oracle advised the Spartans to think of their safety and not of victory."[7] Agesilaus supposedly wanted to abandon his well-laid plans and withdraw, but in the end the battle went ahead against his better judgment; despite the superior number of Spartan

forces, the Thebans were victorious and the era of Spartan hegemony came to an end.

It might be worthwhile to take a moment to reflect that there were many other occasions when circumstances would justify the use of simpler and less cumbersome versions of these traditional rituals. It has always been a periodically recurring feature of human existence that the most ordinary man would be as likely as the highest official to be faced with a disheartening range of personal and family problems. With equal regularity many small provincial communities located in remote and inaccessible areas would be left helpless to deal with a local calamity of a kind as commonplace as a destructive hailstorm or a disastrously meager harvest. In the ancient world most of these ordinary events would not have come to the attention of established oracles. Nevertheless there would have been nothing to keep any of these troubled human beings from taking independent action at times like these, either as groups or by themselves, and decide to have a go at divination on their own.

The available historical evidence indicates that people facing a crisis in antiquity would try to find divine guidance as commonly as many of their remote descendants still do today. Michael Wood explains his view that the idea of a god "really speaking through the oracle is not a reflection of a religious faith, but merely the mark of a desperate need for more than human certainty."[8] In the modern world finding a set of supernatural directives can be as quick and easy as looking up the horoscope in a newspaper or an astrological chart on the computer. However, in ancient times those without ready access to formal practitioners to assist them would go about these matters with usually only their closest neighbors and immediate family to give them a hand. Lots could be cast, chicken livers might be examined, and perhaps the

behavior of birds in flight would be observed in an amateur fashion. Neither the specific nature of their simple attempts to find meaningful signs nor any indication of what most probably must have been the pathetic results of their experiments have been preserved.

CICERO WAS MERELY ONE OF A NUMBER OF OBSERVERS IN antiquity who pointedly questioned the reliability and trustworthiness of divination in general and of casual diviners in particular. There were persistent opponents who regarded diviners and their periodic revelations with such deep disdain that in some cases they would take pleasure from routinely mocking and ridiculing them in public. This skepticism of divination had not developed in Cicero's lifetime but is known to have been around as far back as Plato and his contemporaries during the Athenian Golden Age. The ever-informative Walter Burkert draws our attention to the fact that in the case of Plato, who had lived three hundred years before Cicero, his disapproval of divination was "compounded with a moral condemnation of the misuse of ritual."[9] The Greek historian Thucydides, who also lived in the fifth century BCE, had similarly denounced divination as nothing more than a form of worthless popular superstition. He went so far as to entirely dismiss the possible role of divine intervention in human affairs.

All the same the practice of divination continued to enjoy enduring currency. The story has been preserved that a man no lesser than Xenophon, who regularly discussed philosophy with Socrates, had found nothing either irrational or socially demeaning in having sought the assistance of a seer "to discover what was meant by the fact that he had heard a perched eagle screaming to his right: this, he learned, was a great

sign, but one which also portended suffering; this knowledge helped him endure."[10] Aristocratic and learned, Xenophon was a prominent and highly esteemed member of Athenian society. He lived and wrote around the same time as Plato and Thucydides and must have been personally acquainted with both of these men and their views on divination. Nevertheless, at least in this case, Xenophon evidently decided to follow his own counsel.

The classical world comfortably tolerated all different forms of prophecy and divination within the received religious tradition. However, those particular rituals which depended on the vagaries of human interpretive skills for their presumed legitimacy inevitably found favor with the mob more readily than they ever did among the better educated citizens. The available evidence demonstrates that "for the ancient high civilizations it is nevertheless characteristic that the established cult is to a large extent independent of such abnormal phenomena."[11] The very popularity of divination would indicate that the demand for it would have been found primarily beyond the small confines of the highly cultivated upper layers of society. It was instead among the far more numerous but considerably less sophisticated plebeians that divination would have enjoyed its widest acceptance and longest-lasting popularity. Along with those born into slavery, this disparate group of freeborn craftsmen, minor officials, soldiers, merchants and various unskilled laborers would have made up by far the largest part of the population of Rome and her vast domains.

Divination never managed to inspire the enduring confidence and respect regularly enjoyed by other prophetic practices allegedly based not on the observation and interpretation of wayward signs but directly upon what was generally acknowledged to be an authentic transmission of the

words of a divine being. Whenever one of the sibyls would make a pronouncement, it was routinely accepted by all that it had been the god himself who had spoken through her; it was from this fundamental conviction that these women derived their traditional prestige and credibility. The Sibylline Books, which were kept under constant protection on the Capitoline Hill in Rome, were universally regarded as the primary source of authoritative wisdom. The sibyls must never be confused with ordinary diviners; they were taken a great deal more seriously by people on every level of Roman society.

IT WAS DURING THE REIGN OF THE EMPEROR TRAJAN THAT THE Roman Empire would reach its broadest territorial expansion. By the middle of the first decade of the second century CE all the regions immediately surrounding the shores of the Mediterranean basin had finally come under Roman domination. From that point onward the name *Mare Nostrum* (our sea) began to be regularly applied to this inland body of water. The proprietary nature of this designation illustrates to what degree the citizens of Rome considered the Mediterranean Sea to be their exclusive political and cultural preserve. This moment marks the beginning of a long interval of uninterrupted peace and increasing prosperity traditionally known as the *Pax Romana*. It was during this unprecedented period, one that was to last for more than two hundred years, that the Roman Empire enjoyed the highest point of its prestige. The *Pax Romana* reflected the glory of the empire at the summit of its political and cultural power.

Any traveler would have felt free to wander anywhere within the territories governed by Rome without threat of hindrance or delay. It would have been possible to start a

journey in southern Spain, follow the long coastline leading eastward to the Levant and then south to Egypt, move in a westerly direction along the coast and eventually arrive at the northwestern tip of Africa without ever once having had to leave the confines of the Roman Empire or the security provided by its laws and institutions. The rocky promontories at Gibraltar on the southern coast of Spain and Ceuta on the northern coast of Africa were known in antiquity as the Pillars of Hercules and they signaled the outermost boundary of the territories united under Roman control.

It was not just casual tourists but Roman colonists as well who were encouraged to explore all the regions more recently annexed to the imperial dominions. When these adventurous emigrants would move around the expanding Roman world, they would have taken their skills and local traditions with them, along with the tools of whatever trade they practiced. As increasingly larger waves of colonists came to settle down in the newer and more distant regions of the empire, they would discover local religious practices which they gradually but inevitably must have started to blend with their own traditional beliefs and incorporate into their communal rites. The classical scholar Sarolta Takács makes the pertinent observation that "the coming together of communities in ritual celebration not only created a bond among the participants but much more importantly brought them into line and enabled them to work toward one and the same goal: the survival of their communities."[12] The multifaceted hegemony which resulted from Roman military gains made it much easier than it had ever been to establish mutually beneficial political alliances and initiate highly profitable commercial links.

However, history has shown that other developments of greater importance than imperial domination or the accu-

mulation of state treasure would have taken place. The long duration of the *Pax Romana* also produced the gradual evolution of cultural and social contacts between Rome and her colonies which in the end have proved to be conspicuously more durable and infinitely more fruitful. Roman philosophy, jurisprudence, engineering and architecture were all transplanted with equal determination everywhere the Romans put down roots. In these paramount areas of human activity, the influence of Rome and the fundamental principles her finest citizens managed to articulate so well and put into practice so successfully in their own days would continue to enjoy indestructible currency and surprisingly enduring vitality over the centuries. Roman political and cultural theories have continued to shape legal systems and aesthetic standards even in the modern world.

In terms of religion, the operative Roman position appears to have been a benevolent toleration of any local rituals they would encounter, as long as the primacy of Jupiter was recognized and accepted. All the same, Roman religious institutions followed not so far behind their legionnaires. Takács makes it clear that "while territorial acquisition was men's business, the preservation of Empire was linked to female entities, among them the Sibyls."[13] Apollo was the deity traditionally and most regularly connected to the practice of prophecy, but at the same time he was also considered the special protector of Roman colonists. There were sibylline shrines throughout the classical world, but it is revealing that they were most frequently found in the coastal areas bordering the Mediterranean Sea, which is precisely where the greatest number of Roman colonists would have chosen to take up residence.

In the first century BCE the highly accomplished Roman scholar Marcus Terentius Varro assembled a method-

ical catalog of the names, locations, and personal character-
istics of all the sibyls who had come to his attention in the
course of his studies over his entire lifetime. Four hundred
years before him, when Heraclitus of Ephesus had been alive,
the presence of just a single sibyl had been recognized. How-
ever, by the time Varro got around to making his compila-
tion, the number of acknowledged sibyls had increased to
ten. As the decades unfolded, the inventory would eventually
come to include the names of a few more women who quite
possibly might have worked different local traditions into
their personal prophetic practices. In spite of these minor
amendments Varro's compendium of sibyls continued to
enjoy canonical status among sibylline historians well past
pagan antiquity.

THROUGHOUT THE CLASSICAL WORLD, A SIBYL WAS FIRMLY
believed to be the living channel through whom the gods
communicated with humanity. Nevertheless, it was widely
accepted that other means existed to gain access to divine
guidance. Walter Burkert explains that "all Greek gods freely
dispense signs following grace and favor, but none so much
as Zeus; the art of interpreting them is bestowed by his son
Apollo."[14] If "Roman" were to be substituted for "Greek"
and "Jupiter" for "Zeus," the same observation could easily
have been made about the religious beliefs generally held by
the heterogeneous population of the Roman Empire. Apollo,
whose Greek name had been left unchanged by the Romans,
might well have been the god entrusted with the task of
granting the gift of prophetic vision to the sibyls and to all
the other oracles, but Jupiter would have been the one rec-
ognized by everyone as the ultimate source of the revelations
which these prescient men and women had been chosen to

receive and convey to their faithful followers. It was universally believed that all of the gods and goddesses had descended from Jupiter, and it would have seemed only logical to conclude that the most authoritative prophetic pronouncements would naturally have originated directly from him, the father of the extensive Olympian family.

Sanctuaries dedicated to this patriarchal deity would be established in numerous locations throughout the Mediterranean world, but without any doubt the oracle of Zeus at Dodona in northwestern Greece would come to be generally considered the preeminent one among all of them. The place is now called Tcharacovitsa, but the area around it is still known by its historical name of Epirus. A small country town located in a remote mountainous region along the eastern coast of the Ionian Sea, Dodona would come to attain astonishingly widespread renown in the classical world. Most probably in antiquity any provincial Mediterranean village would have welcomed the foundation of a local sanctuary similar to the one at Dodona, if only because it would have attracted a regular stream of visitors, all needing to eat, drink and sleep somewhere and each one wanting to take home a bag of charms. The impact on regional economies must have been considerable.

In the *Iliad*, a work generally believed to have been composed at some time during the eighth century BCE, Homer relates that Achilles had made a pilgrimage to the oracle at Dodona expressly to offer a prayer to Zeus. This visit would have taken place some four hundred years before Homer made a record of it. Odysseus is reported to have undertaken the same journey not too long after Achilles. If the choice were made to trust these two accounts, it would mean that already in the second millennium BCE the oracular shrine at Dodona would have been in regular use. Its great

age was a matter of widespread repute and would certainly have contributed to the prestige associated with the site. "Dodona, the sanctuary of Zeus in Epirus, boasted of being the oldest oracle."[15]

As would befit its ancient origins, the shrine was initially dedicated to the Earth Mother, a character of primary importance in all the earliest European mythologies. The Earth Mother would eventually become associated with the figure of Hera, the goddess of women in the Greek Pantheon and by chance both sister and wife to Zeus. During a much later period, the Romans would worship her as the *Magna Mater*. At other times the Earth Mother would have been known alternatively as Ge or Gaia. It can be supposed that, under any of these guises, the wide recognition and respect enjoyed by her sanctuary must have come to the attention of Zeus because at a certain moment the god, probably jealous of her success, came on the scene and took her as his wife. After what can only be considered an early form of a palace coup, Zeus not surprisingly ended up assuming the mantle of principal deity at Dodona. Nevertheless, traditions have always died hard and the previous devotion to the Earth Mother would not have entirely disappeared right away. All the same the primacy of Zeus at Dodona would become fully established before too many decades had passed; it was to endure unchallenged until the beginning of the Current Era, when the oracle was shut down by imperial decree.

A legend of prodigious antiquity has been preserved to explain the founding of the oracle at Dodona. The story concerns two nameless priestesses who were attached to the lofty shrine at Thebes, an important city on the banks of the river Nile and an authoritative religious center since the earliest stages of Egyptian history. A group of mysterious strangers turned up one day and, without any warning, abducted the

two young women. Against all their pleas and loud protestations, they were taken away from the safe precincts of the great temple. Deeply traumatized by their ordeal, but nonetheless determined not to be subjected to any further indignities, in order to get away from their captors the two priestesses ingeniously decided to turn themselves into a pair of doves. The men must have been left dumbfounded and totally powerless to prevent the women's escape. The two birds flew away in different directions, one heading for the Mediterranean coast of Africa, but the other somehow managing to travel as far as distant Dodona, where she finally alighted upon the leafy branches of a large oak tree. She must have felt a deep sense of relief to put an end both to her long journey and to her ordeal. From the tranquillity of her refuge she ordained the establishment of an oracle, it could be presumed as a mark of gratitude for the miraculous nature of her reprieve.

It was soon discovered that during her long flight from Thebes the solitary priestess had been followed by a flock of doves, probably for reasons no more complex than simple avian instinct. These humble creatures would eventually assume the essential task of transmitting the signs which began quite literally blowing in from Zeus with frequent regularity. The wind would stir the leaves as it swirled around the branches of the oak tree, and as the leaves moved and brushed against each other, they made a soft rustling sound recognized at once by the birds as a projection of the god's voice. The doves' plaintive and repetitive cooing was their only way of communicating his messages to the world. In spite of their concerted efforts and all their good intentions, the unintelligible noise issuing from the feathered diviners would still have been in need of some degree of further decoding. This is the moment when the priestesses would have stepped in.

No other preserved example of the mediated transmission of a divine message appears to have involved so many different steps. Although there were four separate intermediaries between the deity and his intended audience, the possibility of misinterpreting or distorting his words does not appear to have been a concern. Writing in the fifth century BCE, Herodotus, commonly known as the Father of History, believed that the sound of the birds had simply been a metaphor for the speech of the priestesses. "The story which the people of Dodona tell about the doves came, I should say, from the fact that the women were foreigners, whose language sounded to them like the twittering of birds."[16] It would seem that both the doves and the priestesses had arrived at the oracle from faraway lands. Over the centuries waves of other foreign visitors would follow them there in ever-increasing numbers.

Although these accounts of the foundation of the sanctuary clearly indicate that priestesses had been in charge of the very first proceedings at Dodona, in his report of the visit paid by Achilles to the oracle, Homer records the presence of priests in attendance, a development most probably imposed by a few fanatical followers of Zeus. In this particular case the change would not have lasted very long. By the time a stone temple dedicated to Zeus was finally erected at the site, the men's tenure at the oracle had come to an end and women had been invited to come back.

Majestic oaks once used to grow in great profusion over the entire region of Epirus and the important role that these trees played at Dodona is documented by a wide range of literary evidence. The Theban dove had come to rest on the branches of an oak and when Zeus arrived he chose to settle within the confines of a patch of forest overgrown with trees of the same type. The poet Hesiod, who is thought to have

lived around the same time as Homer in the eighth century BCE, had already noted the key presence of an oak at the oracle. Walter Burkert offers an instructive illustration by observing that Odysseus had gone to Dodona "in order to learn the plan of Zeus from the oak of lofty foliage."[17] Together these various accounts would certainly give the impression that it was primarily the rustling sound of the oak leaves which relayed the words of Zeus to the legions of pilgrims who made their way to the oracle in search of enlightenment. By general consensus it would appear that this was indeed the most widely accepted practice and the one reported by chroniclers in classical times with the greatest frequency. Nonetheless, in antiquity there would never be any prophetic practice which followed an entirely straightforward pattern. It would seem to be the case that at Dodona there might have been other techniques which bypassed the use of birds and rustling oak leaves, and which now and then would be employed by the celebrants in order to discern the meaning of Zeus's advice to the world.

It is Michael Wood who once again provides an interesting perspective by noting the details of a ritual, fundamentally identical to the simple traditional practice of cleromancy, which was performed by the priestesses with possibly some degree of regularity. "Questions were written on lead slips and placed in an urn. The priestess took a question out of the urn at random, and then, equally at random, took a lead slip with an answer out of another urn. No room for maneuver or manipulation here, although of course there would still be plenty of room for interpretation."[18] More than anything else, what this account would appear to reveal is that every one of these venerable methods of divination had deep antecedents and continued to enjoy extraordinarily long periods of faithful acceptance in the ancient world. One

further practice recorded at Dodona seems to have required the consultant to sleep at the temple after first presenting to the god whatever troubling question needed to be considered and then performing, with both precision and great devotion, all of the rites officially prescribed. At some moment during the night Zeus would provide the consultant with the right answer. If the god's words were to prove insufficiently clear there would always have been someone in attendance to help out.

In spite of this potpourri of miscellaneous customs, or quite possibly just because of it, the oracle at Dodona retained its fame and prestige beyond the advent of the modern era. The temple dedicated to the omniscient Zeus, which by then had stood in place for half a millennium, had been razed to the ground by Roman soldiers in the middle years of the second century BCE. However that exercise of force was almost certainly less an example of religious suppression than a boastful affirmation of Roman political and military power. The fact that Emperor Augustus placed the reconstruction of the temple at the top of his agenda is a sign of the prestige still enjoyed by Dodona a hundred years later. In one of his first official acts after finally taking control of Rome and her dominions, Augustus appears to have temporarily set aside all other matters of state and ordered the project to commence without delay. With full support at this high level, a new temple quickly went up over the ruins of the old one; appropriately solemn celebrations would have marked its completion. Nevertheless, and despite all signs of benevolent imperial favor, by the second century CE, when the traveler and chronicler Pausanias would have been beginning to set out on his systematic exploration of the Greek mainland, just one solitary tree sadly remained where at one time there had been an entire forest of lofty oaks believed to be sacred to

Zeus and therefore inviolable. Only a few generations earlier, the almost complete obliteration of the sacramental grove would have been as inconceivable as it later turned out to be fatefully irreversible.

MODERN SCHOLARS WOULD HAVE NO DIFFICULTY RECOGNIZING the unambiguous signs that the venerable activities at Dodona were nearing their end, but that would not have been the case among the band of hopeful believers who continued to cling to the old ways. The flow of visitors to the oracle of Zeus might have slowed down somewhat, but there is abundant evidence to show that it had not quite yet come to a complete stop. Emperor Julian, who held the throne during the middle years of the fourth century CE and who is most frequently remembered in history as Julian the Apostate, is known to have taken time during his brief two-year reign expressly to make the long and demanding trip to Dodona. The Emperor wielded tremendous power and would have automatically commanded considerable respect. His gesture would have been perceived by everyone in the Roman Empire as a definite sign of official support for the old religious traditions. Certainly the few priestesses who were still to be found around the temple, and probably to an even greater degree their loyal and steadfast followers, must have felt sustained and encouraged by the unexpected and consequently all the more welcome visit from the emperor and his grand retinue.

There are reports that long after Christianity had taken over as the principal religion of the Roman Empire, determined pilgrims were still making the trip to the shrine at Dodona. "Traditional cult did not simply vanish into the back alleys, basements, and mountains of the Mediterranean

world when Constantine crossed his spiritual Rubicon and became a Christian."[19] The respected temple and its oracle were permanently closed down in the year 391 CE only after the Christian and perniciously pious Emperor Theodosius the First, remembered by his dogmatic admirers as Theodosius the Great, finally managed to proscribe every possible manifestation of traditional pagan religious beliefs and practices throughout the whole of his empire. Well after this implacable ban was imposed, it still remained the case that all those who arrived at Dodona would be struck by what must have been the intrinsic spirituality of the venerable site. The surviving historical evidence shows that, possibly as early as the period of still unfettered pagan activity, the first leaders of the recently established Christian Church had become aware of the existence of an undeniable supernatural power at Dodona. The ultimate source of this phenomenon may well have been cause for debate among these simple provincial clerics, but the reality of its presence there was tacitly acknowledged when Dodona was selected as the center of a newly created Christian bishopric.

In the modern world this move might not seem like a mark of such great distinction, but it needs to be kept in mind that at that precise moment neither archbishops nor cardinals had yet come into existence. The Bishop of Dodona held an office of the very highest rank within the hierarchical structure of the early Christian Church, an institution which by then was beginning to assume an increasingly influential role in imperial society. An insignificant village in the middle of a remote and mountainous hinterland and, to make matters worse, one that had only its connection to a pagan deity to back its single claim to fame, had unexpectedly become an episcopal see worthy of respectful recognition among all of the Christian faithful. Of course, by then the very legitimacy

of the deity had been dismissed by the new hierarchy as nothing more than useless superstition.

In the middle of the third decade of the fourth century CE Emperor Constantine, known to many as Constantine the Great and to some others as Saint Constantine, summoned all the bishops in the Christian world to join him at Nicaea, a city not far from Constantinople, his imperial capital. Nicaea, which is known as Iznik today, is located in northwestern Anatolia in the Asian part of what is now Turkey, and therefore would have been easily accessible to all of the bishops from Asia Minor and the Levant. It was in this area of the Mediterranean that the largest numbers of the faithful were to be found at that early stage of Christianity. Precise records were not kept, but it would appear that only a fraction of the eighteen hundred bishops who had been invited by the emperor actually turned up in Nicaea, most prominent among them Bishop Eusebius of Caesarea, the first historian of the Christian Church. According to him, only slightly more than two hundred bishops were in attendance, although other reports indicate a somewhat higher number.

Within the ranks of those who answered the emperor's call, there would have been some men very similar in background and temperament to the provincial Bishop of Dodona. There is not much that is known about the life or even the identity of the first few men who held this episcopal office. However, if any one of them had actually grown up in Dodona, he must have been a regular visitor to the Temple of Zeus, by far the most interesting attraction in the entire region of Epirus. There would have been precious few other ways for a restless young man to pass the time in a small town, and now and then he must have gone to the fabled old building with his friends, if only just to take a look around.

Small groups of recalcitrant priestesses might still have been in attendance, and if, by chance, he encountered any of them, he might have politely offered to give them a hand with their routine tasks.

A large number of the earliest Christian bishops must have spent their formative years in isolated provincial villages that would have retained at least some traces of their earlier pagan traditions in many comparable ways. In all likelihood, many of these bishops would have been brought up in the bosom of conventional pagan families. It is known with complete certainty that during the early stages of the Christian Church the vast majority of all but the very youngest of her members would have been recent converts from other religious traditions. That is one aspect of the bishops' background which they would have shared with most of the people who descended upon Nicaea by imperial command. Their numbers would have been substantially increased by the multitude of priests, deacons, secretaries and other various ancillary figures who would have accompanied the prelates on their travels.

Although Constantine was the first Roman ruler to become a Christian, he did not attempt to impose the new religion on his subjects. By the terms of the Edict of Milan, promulgated by him in the year 313 CE, tolerance of all religious practices was ordained throughout the Roman Empire. Constantine decided to bring the bishops together in Nicaea not in order to find effective ways to evangelize the pagans but simply in an effort to define and subsequently codify the fundamental principles of the Christian faith, which until that time had remained ambiguous and therefore uncomfortably subject to discordant and potentially divisive points of view. The issues were complex and contentious, but for the purpose at hand it will be sufficient to observe that

the final resolutions of the Council of Nicaea have been succinctly but quite adequately encapsulated in the words of what is known to every Christian as the Nicene Creed. For the last seventeen hundred years this proclamation of faith has been recited every Sunday in practically all Christian churches. Anyone who takes time to examine the text with care will recognize that the words reflect simply the outcome but not the process of deliberation of the momentous theological issues which the bishops were in Nicaea to study and discuss.

It needs to be emphasized once again that significant numbers of these men had been brought up in a pagan tradition which accepted the immanent presence of a divinity with the power to influence the world and the willingness to communicate with humanity through mysterious signs needing to be sought out and interpreted. Pockets of their most personal experiences, some as profoundly important as the language their parents had spoken when they were told bedtime stories in their early childhood, and others as simple and possibly frivolous as the treasured memory of the choice treats their grandmothers would have prepared on special occasions, each one represented significant aspects of their lives which had gradually shaped them into the individuals they had become. None of the bishops could have eradicated any of these moments from their consciousness any more than they would have been able to leave their early religious upbringing behind them. The deeply ingrained beliefs they had acquired in their youth would inevitably have had an effect on the way the episcopal delegates at the council were to conduct their discussions. "There is a great deal to be said for the notion that the needs met by traditional cults reformed Christianity every bit as much as Christianity reformed pagan practice."[20]

The early Christian bishops who met at Nicaea would have been the principal conduits through whom the immemorial voices of the prophetic traditions of antiquity gained their first hearing in the post-pagan world. This transmission might well have remained entirely imperceptible to those who witnessed it in person, but, all the same, it did take place and it did have an effect on what happened at Nicaea, and far more importantly on what continues to happen in the world today. The fate of the sibyls did not need to follow such a tortuous route. As will become evident in the following chapters, the gradual establishment of Christianity as the official religion of what once had been the mighty Roman Empire surprisingly served only to heighten the respect accorded to the sibyls and their pronouncements. The seamless and comprehensive overhaul of their collective persona from their traditional image of visionary priestesses in the service of pagan deities to authoritative conveyors of Christian prophecies would have guaranteed the remarkable survival of their reputation and authority. The *Dies Irae* section of the liturgical text of the Roman Catholic requiem mentions the name of the Erythraean Sibyl. Saint Augustine considered both her and her Cumaean counterpart exemplary Christian prophets. In the end it would seem to be the case that the ways of the classical world have proved beyond the powers of anyone to prophesy.

2

WOMEN AND PROPHECY

The people who raised the mysterious stones of Carnac were certainly not without Sibyls. Prophetic Druidesses were common in the most ancient Gaul. The Cathedral of Chartres, for instance, is said to stand on the spot where in the hoariest antiquity was the oracular grove and cavern of a priestess who prophesied that in the fullness of time a Virgin should conceive and bear a Son.

RICHARD LAWSON GALES,
Old World Essays: On the Sibyls

Both the existence of numerous visionary women and their regular participation in religious rituals have been consistently recorded over the centuries. If only for that reason, it should not be surprising that at various times the cave of a sibyl and an attendant prophetic grove for the use of her followers have been reported once to have stood on the lofty summit of a hill southwest of Paris. Starting in the late twelfth century a large Christian church, dedicated to the Virgin Mary perhaps not entirely by coincidence, would eventually be constructed at precisely this imposing location. For eight hundred years the Cathedral of Our Lady in Chartres has been one of the best loved and most frequently visited historical monuments in all of France. The incalcula-

ble number of Christian workers who spent many lifetimes building it would have chosen its location for the same reason the sibyl would have had for selecting it for her sanctum: it is the place closest to heaven in the entire expanse of countryside around it. The spot has a gentle but undeniable unearthliness about it.

Perhaps even the cavernous and dimly lit interior of the Cathedral of Chartres could be said to somehow reflect the sibylline shrine which might have once preceded it. On first coming into its vast meandering spaces, modern visitors will experience feelings of reverence and awe identical to what their remote pagan ancestors almost certainly would have felt at the moment they entered the cave of the mysterious sibyl. The air would have been heavy with the smell of incense or various types of fragrant herbs while the soft murmuring voices of the anxious visitors would have drowned all other sounds. Many of them would have come from far away places in search of guidance and spiritual support. As their eyes gradually began to adjust to the dimly lit spaces, their minds would have been preparing for the reassuring message they would have fervently hoped to receive. The worshippers and the consecrated space around them would have confronted each other in a moment redolent of tradition and pregnant with expectation, just as it is still the case at the cathedral today.

Despite the colorful chronicles and all the extravagant amount of effort and archaeological attention which over the centuries have been consistently devoted to the hilltop at Chartres and its venerated sanctuary, not a single scholar has ever been able to discover any concrete physical evidence that either a sibylline cave or a prophetic grove would have been previously found anywhere around this site. On the other hand, abundant signs of pre-Christian religious practices are

still to be seen in other parts of France today. The small and sleepy village of Carnac, situated in the middle of Brittany, is geographically and culturally a world away from the rarefied circles of Chartres or Paris, but in what the erudite British cleric and poet Richard Gales has called "the hoariest antiquity," this place had been the center of a highly sophisticated pre-Christian culture where women once played an active and meaningful role in society.

In and around this peaceful and otherwise entirely ordinary setting, modern visitors still continue to marvel at the sight of literally thousands of colossal freestanding stones meticulously arranged in what appears to be an endless number of parallel rows. For many centuries this bewildering complex has drawn the attention of curious tourists and earnest historians alike, but the original purpose behind its creation has not yet been established with any convincing degree of certainty. In contrast to this lingering mystery, the extraordinary antiquity of the site has never been a matter open to speculation. Most modern scholars generally agree that the towering stones at Carnac were laboriously cut and put into place with painstaking accuracy over countless decades at some point during the course of the fourth millennium BCE, in all probability just a few hundred years prior to the construction of the more widely known great circle at Stonehenge. Although the group of monoliths in Wiltshire has been studied by scientists for generations and is considered one of the most remarkable human creations in all of Great Britain, its original purpose has also remained a mystery.

Carnac is located on the southern coast of the massive Breton peninsula, facing the wide expanse of the Bay of Biscay and yet safely set back from its notoriously treacherous currents. Almost directly south across the open expanse of water lies the mountainous Cantabrian shore of Spain where,

starting in the late nineteenth century, prehistoric cave paintings have been periodically discovered in a number of successive locations. The first groups of murals were found by accident in the Cave of Altamira, west of the city of Santander, which since ancient times has been the principal Spanish port on the Bay of Biscay.

There would appear to be almost no doubt that for a very long time before the regularly spaced rows of monoliths would eventually come to be raised at Carnac, numerous waves of settlers had been arriving on the rugged but nonetheless sporadically hospitable stretches of sandy flatland along the bay. Certainly by the time the now quiet Breton village would have attained the peak period of its social and technical development, already for hundreds of generations there had been pockets of human beings living all around the extensive shoreline bordering the sea. The painted hunting scenes found on the southern side of the Bay of Biscay would have been in place for many thousands of years by the time the impressive tiers of stones at Carnac were erected. It is sobering to consider that when the builders of Carnac finally managed to complete their monumental complex, the cave paintings already were considerably older than the Carnac monoliths are today.

By any calculation, the building efforts of the ancient inhabitants of Carnac represent some of the earliest surviving examples of stone construction anywhere in the Western world. In addition to that distinction, the artful thoroughness of the general scheme, and even more the meticulousness of its execution, could justifiably be considered to be the very first systematic application of urban design principles anywhere in Europe. The decision taken by these incipient city planners to undertake their ambitious scheme would indicate that, already by that stage, their community must have attained

a highly advanced degree of collective organization and social cohesiveness; if that had not been the case their project would have gone nowhere. The massive stones still to be seen at Carnac needed to be quarried, cut, transported and finally put in place with the greatest care and precision. Every step of the process must have followed a master plan that necessarily must have been fully understood and approved by the majority if not actually by the totality of the population before the work actually got started. The people who would eventually be entrusted with the long and strenuous task of carrying out the project over several generations were not forced labor: they were driven by a spiritual conviction that they were working for something far greater than their own personal gain. On that count alone they would have had a great deal in common with the workers who many thousands of years later would build a cathedral on the summit of a hill at Chartres.

The highly motivated character of these people is made abundantly clear by the complexity of their final achievement; the sophistication and confident monumentality of their plan would appear to demonstrate with the same degree of certainty that the builders of Carnac were a spiritual breed. Their collective nature must have been inherently reverent, and the solid evidence offered by the results of their hard labor would appear to confirm that fact. It seems entirely too obvious to need clarification that the complex of monoliths they created must have been conceived as a backdrop to a specific type of cyclically recurring ceremonial activity. Their rituals must have been of sufficient significance within their social and religious structure to demand a setting of this scale and grandeur. It logically follows that the regular performance of these ceremonies, in their proper setting and according to a specifically prescribed manner, would have been of the

greatest importance to both the definition of their communal identity and to the public affirmation of their shared fundamental principles. In this sense the people who raised the monoliths would have been true spiritual heirs of the primeval communities that recorded their hunting rituals on cave walls. What still remains a frustrating uncertainty is the precise nature of the ceremonies at Carnac.

Historical evidence almost invariably shows that in the majority of cases ambitious artistic projects have been undertaken either by individuals or by groups of people intent on putting forward the terms of the particular ideologies which defined and sustained them. This would appear to have been the case in the most distant past as much as it has been in more recent times. When the remote precursors of the builders of Carnac set about painting the walls of their caves, quite probably they did so in order to affirm what they had come to recognize as the presence of an intrinsic spiritual side to the natural constitution of human beings. They must have felt in some way that this particularity would have bound them together as a group and deserved recognition. At that point their views were too raw and elemental to be considered either a religion or a political manifesto, but over the passage of time these beliefs have proved to be remarkably durable. Every generation to have succeeded these primeval humans has held the same conviction that all living men and women are in possession of a spirit; if the visionary builders of Carnac had held views different from this fundamental pattern, it certainly would have been a most unusual aberration. Their communal festivals and celebrations continued to be staged around their complex of proudly standing monoliths for thousands of years, until their distant descendants were eventually displaced by groups of foreign invaders who would start arriving in large numbers from the East.

THE CELTIC TRIBES THAT CAME TO OCCUPY THE VARIOUS AREAS comprising modern France may or may not have been aware of the original role played by the Carnac monoliths, but it seems that somehow they managed to find a way to incorporate the carefully arranged stones into their own communal ceremonies and cultic rites. The Celts would remain the primary cultural force until the Romans appeared on the scene. These later arrivals imposed the name of Gauls on the native population they found living across the lands lying west of the Rhine; for this reason the civilization that gradually emerged from the amalgamation of Celtic and Roman societies has traditionally been known as Gallo-Roman. It is to Roman chronicles that posterity owes what few details have been preserved regarding the Celts or Gauls and their activities, both before and after the Roman conquest, but not very much specific information has survived about their spiritual practices.

One characteristic of their religious ideology which would appear to have been reasonably well established is that to a considerable degree Celtic beliefs were shaped by animist principles. Reportedly the oak tree was held sacred by them, almost certainly because of its unusual strength and tremendous longevity, a view the Celts would have had in common with a great many other societies in ancient times. It has been recorded that they venerated a large number of gods and goddesses, many of them with quite specific connections to surrounding natural phenomena. Pliny the Elder was one of several observers to have been captivated by the widespread use of mistletoe in Celtic religious rites. The celebrants who guided them in worship were known as Druids, a name many people have come to apply to their group in its entirety. Vincenzo Bellini's opera *Norma*, based on a play by Alexandre Soumet, is set in Roman Gaul and the eponymous heroine is

an authoritative Druid priestess who acts as the supreme religious leader of her community, despite the fact that her father was still alive. Although various similar references to other Druid priestesses are not uncommon, it is regrettable that no contemporary accounts have been preserved to document the actual role women might have played in Celtic religious rites.

In contrast, when we turn our attention to secular activities the available evidence appears to indicate that in Celtic society women regularly held a rank equal to men, and that as a result both genders were entrusted with the same duties and enjoyed the same rights. At one stage during the early period of Roman occupation of Britain, a proud and fiercely independent Celtic tribe came under the rule of Queen Boudica, a name also recorded as Boadicea. She bravely led her people in revolt against the invading armies and for generations the British have considered her a symbol of patriotism and selfless courage. So great did her renown eventually become that the figure of Boudica would serve as the inspiration for Britannia, the traditional emblem of the British Empire. Other contemporary Roman chronicles confirm that in Celtic society women routinely took an active part in both governmental and military activities. According to Plutarch, it was not at all unusual for wise and mature Celtic women to be regularly entrusted with sensitive diplomatic missions. Were this indeed to have been the norm among the Celts, and there is every reason to believe that it was, then it would seem only logical to conclude that Celtic women would also have played a similarly active role in the religious rituals of their local communities and therefore that, as Richard Gales has suggested, "prophetic Druidesses were common in the most ancient Gaul."[1]

The introduction of the principle of gender egalitarian-

ism into Celtic culture is a matter which deserves our consideration. It is a well-known fact that in early Christian times groups of converts from paganism would regularly assume control of Roman buildings, both religious and secular, and turn them into Christian churches. Much earlier but in exactly the same manner, the Celts had appropriated existing structures in whatever regions they would establish their settlements. When they first came in contact with the mystifying complex of monoliths at Carnac, they definitely did not hesitate to take it over and find a way to assimilate its unique structural features into their own traditional ceremonies and rituals. However, it is not very likely that the architecture of their forerunners was the only feature the Celts admired and chose to adopt for their own use. It is entirely plausible that the Celts would have been introduced to the concept of gender egalitarianism by their industrious and spiritually minded predecessors at places like Carnac. A forthright adoption of these specific social principles and practices might easily have accompanied the takeover of the carefully aligned monoliths that had so smoothly taken place. If it is accepted that this transmission of ideas might have happened, it would mean that at Carnac, as well as at a great number of other similar places, powerful women might have been leading their communities in worship for a period of time lasting as long as five or perhaps even six thousand years, until the Roman occupation of Gaul would finally put an end to this practice. By comparison, the Christian Church has been in operation for only about a third as long as that.

THE SIMPLE COMMONPLACE FACT THAT *MOTHER NATURE* remains a term regularly used by people in the twenty-first century amply illustrates the significant place which women

have occupied in all mythological traditions and religious ideologies since the very beginning of recorded history. It may be hard to explain why, but the important role women have traditionally played in religion is quite frequently underrated. The study of the numerous carved figurines of women discovered in far-flung locations throughout Europe reveals that they were stylized representations of the Earth Mother, a powerful presence who has been known as Ge, Gaia, or other variants of that name. From the earliest times *Ge* has been the designation most commonly applied in Greek mythology to the personification of the earth. In Greek the meaning of *Ge* is quite simply *earth*, which is why it forms part of words like *geometry* and *geography*.

The figurines representing the Earth Mother invariably exaggerate her plumpness in a naive but clear attempt to convey her tremendous fecundity. Women most likely clasped them close to their chest when giving birth, but it is possible that men also might have considered them potent sources of vitality and even clutched them in their hands during mating rituals. The small size of these figurines would mean that they were meant to be portable; in Roman times similar small sculptures representing the deities held in the highest esteem by each family would accompany them to every important function to impart their blessing on the proceedings and to serve as silent but mindful witnesses to their outcome. The Roman tradition almost certainly had its roots in the power attributed to the portable Earth Mother figurines in much earlier times. The large number of surviving examples would attest to their prevalent ritual use within a wide variety of Western cultural traditions. Generally they have been dated to a time around 30,000 BCE which would make their creators nearly exact contemporaries of the cave painters who lived along the southern coast of the Bay of Biscay.

HISTORICALLY THE PRESERVATION AND CONTINUATION OF A COMmunity has always been its primary concern. "Fertility was the main preoccupation of religion in the Old World."[2] For glaring reasons, women's supreme role in the process of ongoing renewal was universally recognized. Ge was the Ur-Mother, the figure believed to have been the ancestress of every living creature and consequently the ultimate source of all life and, by extension, the fount of all power. By tradition the first Greek oracles were consecrated to this most venerable and fundamental of all deities. At these sanctuaries it would always have been a woman who played the essential role of relaying the message of the Earth Mother to the community in worshipful attendance. "Clearly her chief ministrant would be a woman and if, as alleged by our authorities, Ge had issued prophecies it would have been through a woman's mouth."[3] Here would appear to lie the beginning of the sibylline tradition.

The precious and rare ability to serve as the mouthpiece of a deity and be in a position to proclaim the future would normally be considered a privilege most people would want to enjoy. Throughout history, however, it has not always been the case that prophets have been fulfilled and content with their destiny. Probably the earliest documented example of a visionary woman is the unfortunate figure of Cassandra. She was the daughter of Priam, the last king of Troy, and therefore she would have been alive around the second half of the twelfth century BCE. Helenus, the man who would later exhort Aeneas to pay a visit to the Cumaean Sibyl, was her brother, and the traditional story has always been that, when they were still very young, the two of them jointly received their prophetic faculty directly from Apollo, the god of prophecy. Boccaccio, however, must have had access to other sources. He observes that "the ancient writers tell us that she

possessed the art of prophecy, but we do not know if she acquired this by study or through God's bounty or, as is more likely, because of some trick of the devil."[4]

Another version of the alleged course of events picks up on Boccaccio's intimation of possible malevolent forces at work. According to this more elaborate explanation, the young Cassandra and Helenus had acquired their prescient gift while they were happily playing innocent children's games inside a temple dedicated to Apollo. In a uniquely curious and almost obscene manner, the two of them had been unexpectedly interrupted by a snake that did not bite them but rather licked them all over their bodies. The latent sexual connotations of this unprecedented account would be impossible to ignore. An alternative and certainly much less perverse version of what took place suggests a sexual maneuver of a more conventional nature. By this account, the pretty Trojan princess simply caught Apollo's roving eye and, exactly as he would do in a different place and at a different time when dealing with the young Cumaean Sibyl, the god decided to grant the adolescent girl the gift of prophecy as part of his efforts to seduce her.

At that stage of her life, Cassandra might have been too inexperienced to have caught on to what Apollo actually had in mind, but a different and quite as plausible scenario could have her decide that a quick one-night stand with the handsome god was not likely to lead to anything but trouble. Whatever her real reasons would have been for refusing his advances, Apollo was most certainly furious when she firmly turned him down. He took his revenge on Cassandra not by withdrawing his gift, which supposedly at that stage not even he as a divine being would have been able to do, but instead by maliciously decreeing that although her prophetic vision would always remain sharp and her pronouncements would invariably prove accurate, she would never find anyone to

take her seriously. She was doomed to become a prophetess with neither a receptive following nor a trusting audience. "The god knows just what he is doing. He continues to lend his powers to Cassandra because he knows that those powers will become a torment, that possessing them in vain is worse than losing them."[5] The perpetually frustrated Trojan princess was to become one of history's most tragic figures.

Cassandra went on to make increasingly more urgent predictions about every successive stage of the Trojan War, particularly regarding its gruesome end, but Apollo would always make sure that every one of her warnings would go unheeded by all those who heard them. She must have been driven to delirium by the constant humiliation of her daily encounters with disdainful skeptics and mocking disbelievers. After the death of her father and the complete annihilation of Troy, she was taken prisoner along with the rest of the remaining survivors. When the time came for the spoils of war to be distributed, lots were drawn among all the soldiers and the forlorn princess fell to Agamemnon as just another part of his share of the booty; the victorious warrior simply took her as one of his concubines. On their way back to his native Mycenae, she warned him that his unfaithful wife, Clytemnestra, was involved in a plot to have him killed. With what would prove quite soon to be ruinous consequences, Cassandra's prophetic vision was once again treated with derision and ignored. In the end both Agamemnon and Cassandra were murdered not too long after their ship had reached the shore. "Agamemnon was killed through Clytemnestra's treachery, and Cassandra had her throat cut at the latter's order."[6]

LARGE NUMBERS OF OUR DISTANT ANCESTORS APPEAR TO HAVE been entirely comfortable in an environment where women

regularly occupied positions of authority. Sarolta Takács makes the observation that in ancient Rome the virginal priestesses who were in charge of the Temple of Vesta openly enjoyed religious powers which ordinarily would have been expected to be wielded exclusively by men. The goddess Vesta was the patroness of the home and the family, which were normally considered a woman's primary sphere of influence. The Roman name of the goddess had been derived from the Greek word *hestia*, which means *hearth*. In acknowledgment of this connection, a fire was always kept burning in the temple hearth, and one of the quainter and less demanding duties of the Vestal Virgins was to make sure that the flames would never be allowed to go out.

The performance of their other responsibilities would have guaranteed that as long as they remained in office, the priestesses were held in the greatest professional regard and accorded the highest social recognition. Vestal Virgins were normally selected among young girls from good families who ranged in age from six to ten years. Their position was so important and supremely respected that when the time came for the new initiates to take up their assignment, they were paid a very substantial amount of money in spite of their extreme youth. "A Vestal received a sum upon entry and a yearly stipend for her services. The entry sum reached two million sesterces in the time of Tiberius. At the time a senator received one million."[7] Regardless of rank, no religious figures within any recognized denomination have ever been known to be so generously remunerated for the performance of their professional duties at any other time in history. It would seem to have been the case that, in many if not in all religious matters, equality between the sexes was routinely considered by the Romans to be a question that mostly depended on individual circumstances. The available evidence distinctly suggests that

in the classical world a noble nature, a righteous disposition, and a dispassionate intellect were decidedly not always perceived by the majority of the population as character traits associated exclusively with men.

Contrary to what many people automatically assume to be the case, one of the greatest of all Christian churches, the basilica of Hagia Sophia in Istanbul, which was built by order of Emperor Justinian, is not dedicated to a saintly woman named Sophia but rather to Holy Wisdom, *sophia* being the Greek word for *wisdom*. It is significant that this word is feminine in both Hebrew and Greek, the respective languages of the Hebrew and Christian Bibles, or Old and New Testaments. If at any time over the centuries this practice had been found unsuitable, it would have been simple enough to amend it. Before the invention of the printing press, all works of literature were copied by hand and many words were regularly changed by scribes as they went about their work, most frequently as a result of simple human error. All the same an objectionable word or idea could have been intentionally replaced at any time by a scribe, either of his own accord or at someone else's command. It would have been not only possible but easy to alter the conspicuous choice of gender, but it appears that this never happened, and that no cleric of any rank or denomination ever ordered it done. To this day the womanly characterization of wisdom in the Bible has remained firm and unchallenged.

The first philosophers and theologians to articulate the feminine concept of wisdom, in whichever language might have been their own, must have been moved to do so by their personal acquaintance with either a few or perhaps many wise women who in their lifetime had been recognized by their contemporaries as possessing the ability to make sound judgments. Some of these women might have been ordinary

local figures well known for their power of divination, but whether or not any of them actually practiced prophecy would not have been nearly as important as their reputation for wisdom. In antiquity the majority of the population was illiterate, which means that most people would have become familiar with any works of literature, religious or secular, only by hearing them read out loud in either a public place or a private setting. As they were recited, whenever these texts referred to wisdom, those present must have made an immediate connection between the words being spoken and the women who had served as their inspiration.

Several women prophets are mentioned in the Hebrew Bible. The prophet Isaiah is reported to have married a woman who is identified simply as "the prophetess," although this designation might have been intended more as a courtesy title extended to a prophet's consort than as a factual reflection of her own gifts and faculties. In the case of the prophetess Miriam, a much fuller picture of her personality can be gleaned through the few surviving fragments of the story of her life. She was the daughter of a Hebrew family living in Egypt and the older sister of Moses and Aaron. Moses came into the world at the extremely unfortunate moment when it had just been decreed by the pharaonic authorities that all male infants born to Israelite women in Egypt would have to be put to death. In order to avoid this fate for Moses, his family placed him in a basket Miriam then quietly concealed in between the plants growing along the banks of the Nile.

Not too long thereafter, the Pharaoh's daughter chanced upon the boy. Miriam, who all along had been unobtrusively keeping an eye on her infant brother, took advantage of the opportunity and bravely stepped out of her hiding place to approach the princess. Ignoring all protocol and at the risk of being taken away in chains by the palace guards,

Miriam explained that in the event that the princess might have been considering the possibility of keeping the baby, there was a woman living close at hand who would make an excellent nurse for him. The princess was absolutely delighted with the suggestion and Miriam wisely did not mention that the nurse, who was engaged at once, was actually the baby's mother. In the end, and entirely as a result of the resourceful intervention of his caring sister, the young Moses was given the chance to grow up in the splendor of the Pharaoh's palace and eventually go on to fulfill his destiny as the one who would deliver his people out of their bondage in Egypt. After crossing the Red Sea Miriam would be among the first to lead her fellow Israelites in worship, and not too long thereafter her younger brother Moses would begin his epochal journey to Mount Sinai, where he received the Ten Commandments directly from the hands of God.

The story of the prophetess Deborah might perhaps be considered slightly more dramatic and exceptional because, in addition to being the one who presciently announced the ultimate victory of the Israelites over the Canaanites, she was also the only woman reported in the Hebrew Bible ever to have served as a judge. In those days, and almost certainly to a much greater degree than is the case in modern times, a judgeship was a position of the highest civic responsibility and consequently one which would have been awarded only to individuals with a known record of making sound moral decisions. If Deborah was appointed a judge, clearly it must have been because her credentials had been considered more than sufficiently adequate for the job. However, during the early stages of her tenure she would have been undermined in the performance of her duties by the presence of the occupying troops of a foreign power. Decades earlier the land of Israel had been conquered by

the Canaanites, a neighboring people whose king had appointed an army commander named Sisera as his local satrap. By all accounts Sisera was an arrogant and merciless tyrant, and he eventually came to be feared as much as he was profoundly detested by the entire Israelite population. Until Deborah came into the picture it had never been possible to find a way to end his brutal oppression.

At that time the top Israelite military leader was a brave and able man named Barak. It was Deborah's inspired decision to approach him with a concise plan to mount an attack on the Canaanite army and rid the land of Israel of the despised invaders once and for all. Eager enough as Barak was to proceed, he was not yet prepared to risk the lives of his faithful soldiers, mainly because of the vastly superior numbers of men and equipment that he knew to be under Canaanite control. Nonetheless Deborah was clearly not a woman to be deterred quite that easily. She announced that despite the obvious and singularly unfavorable disparity between the two armies, she was certain not only that the Israelite forces would eventually prove victorious, but also that the hated Sisera would meet his death, and not in combat with the Israelite soldiers, as normally might have been expected, but rather at the hands of a single ordinary woman. Against all odds, Deborah's prophecy came to pass exactly as she had assured Barak that it would.

At the most decisive moment of the battle, a stream unexpectedly overflowed its banks and the heavy Canaanite chariots became impossible to maneuver in the suddenly waterlogged terrain. Somehow Sisera escaped the carnage of his troops and managed to make his way to a nearby tent, where he begged to be granted temporary refuge. He was met by a woman named Jael who, unfortunately for the Canaanite leader, knew both his identity and his reputation. Neverthe-

less she agreed to take him in for the night. Probably she would have given him something comforting to drink and perhaps even bathed his wounds. Then she would have retired to a quiet corner of her own to collect her thoughts and carefully plan her next move. Sisera's day had been difficult and more than usually tiring, and Jael would not have had to wait too long for the sheer weight of his weariness to overtake his senses. As soon as he had gone to sleep she killed him, effectively if unknowingly fulfilling the final detail of Deborah's prophecy. In cold blood she had taken a heavy metal stake and silently pummeled it into his temple. For some reason this grisly episode has captured the imagination of European artists over the course of many centuries. The death of Sisera has been depicted in various degrees of lurid detail by a number of accomplished painters, among them Artemisia Gentileschi, a woman who in recent times has herself become something of a feminist heroine.

The prophetess Anna was another prescient Israelite woman, and although she is known to have lived in pre-Christian times, it is not anywhere in the Hebrew Bible but rather in Saint Luke's Gospel that her name is mentioned. The evangelist describes her as a woman of such advanced age that she had been a widow for eighty-four years by the time Jesus was born. So great was her faith that allegedly she devoted all of her waking hours to prayer, a habit which would explain why she happened to be present at the temple in Jerusalem on the day when Jesus was taken there for his sacramental presentation, as was prescribed by rabbinical law. The evangelist also reports that Anna had lived with her husband for seven years before his death, which means that she would have been well into the eleventh decade of her life at the time of her encounter with Jesus. When the aging visionary woman gazed upon the child, she must have had a

sudden prophetic revelation because at once she thanked the Lord in a resounding voice. From that moment onward, Anna spent the rest of her days proclaiming to all those she would encounter in every corner of Jerusalem that she had met the Messiah.

It is curious that of the four canonical evangelists, Luke is the only one who takes time to mention the existence and activity of prophetic women, not just Anna but also the four daughters of Philip the Evangelist, who are identified in the Acts of the Apostles as women who prophesied. Luke, unlike the other evangelists, had been brought up in the Greek and not in the Hebrew cultural tradition, and this background might explain his more broad-minded point of view. He was born in Antioch, a large and bustling Greek city on a stretch of the Mediterranean coast now belonging to Turkey. Along with Alexandria on Egypt's northern shore, Antioch was one of the two most important cities in the ancient Near East. In that cosmopolitan setting, Luke would automatically have become acquainted with the traditional figures of the sibyls from the earliest days of his childhood. Possibly of even more marked significance is the fact that he had trained as a physician and that, as a result of his profession, he necessarily would have been given a more comprehensive and wide-ranging education than his three fellow evangelists. As a result of his medical practice, and to an infinitely greater degree than the average person, Luke would have come in regular contact with a much more inclusive sample of the multicultural population of the Roman Empire. In modern terms, Luke would be defined as a sophisticated man of the world and, for him, the figure of a prophetic woman would certainly not have been any more unusual or threatening than an ordinary fig tree. The other evangelists, coming from a more provincial background, might not have felt the same way.

In his authoritative and highly regarded Epistle to the Romans Saint Paul makes it clear that prophecy was nonetheless an accepted part of everyday life in early Christian times. "Because the gifts that we possess differ according to the grace given to us, each of us is to exercise them accordingly: if it happens to be the gift of prophecy we should prophesy in proportion to the degree of our personal faith."[8] This forceful and straightforward Pauline exhortation has been heeded by many gifted men and women over the course of centuries, but without any doubt it is evident that Michel de Nostredame, the man better known as Nostradamus, has to be regarded as the most influential of all practitioners of inspired divination since the time Saint Paul wrote his letter to his fellow Christians in Rome. Nostradamus's book of prophecies has consistently remained in print since its first publication almost five hundred years ago, but he is hardly the only one to have written down his own personal vision of the future.

A great number of women have also played a visible and quite significant role in the perpetuation of the art of prophecy in the Western world. Approximately at the same time as Nostradamus, a clairvoyant woman was active in the north of England who would eventually come to be known first as Mother Shipton and in the course of time as the Yorkshire Sibyl. A number of her prophecies have been preserved and at a certain stage her fame must have attained such considerable proportions that her wax effigy was installed in the hallowed precincts of Westminster Abbey. The model of the sibyl remained in place, surrounded by the sundry tombs of great monarchs and numerous other respected public figures, well into the nineteenth century, when it was mysteriously and inexplicably removed from view.

Nowhere is the ubiquitous presence of women in prophecy more evident than in the contemporary practice of

astrology. The respected star-sign correspondent for the British newspaper *The Telegraph* is Catherine Tennant, and for decades Shelley von Strunckel has been writing an astrological column for both the London *Evening Standard* and the *Sunday Times*. In an interview Ms von Strunckel gave in 1999, she explained that what had originally attracted her to astrology was the cyclical nature of human activity and the possibility of being able to understand the implications of that cycle ahead of time. In her opinion the twelve signs of the zodiac represent nothing more than twelve different points of view, "each with its own individual perspective." There is actually an extraordinary and quite pertinent precedent for Ms von Strunckel's intriguing theory. In the year 378 CE the emperor Valens, who had been the ruler of the Eastern Roman Empire, was slaughtered, his soldiers massacred, and his authority obliterated in the course of a single but ferocious battle between Roman and barbarian forces. The confrontation had taken place at Adrianople, a Thracian city now known as Edirne, located near the Bulgarian frontier in what is now the European part of Turkey. When the news of these terrifying events finally reached Rome they would cause tremendous anxiety among the population.

The general state of mind was certainly not improved by an unsettling report, involving a group of no less than one hundred Roman judges, which began to make the rounds at the same time as the possible consequences of the Adrianople disaster were still being considered and discussed. Each of the distinguished magistrates had independently reported a deeply distressing dream that, as far as it could be determined, all of them simultaneously must have had on the same night. The matter was deemed to be of such significance and gravity that eventually the decision was taken by the Senate to request the Tiburtine Sibyl, who conveniently lived and

practiced prophecy not too far from Rome, to travel to the imperial city in an attempt to explain the meaning of the mysterious dream and thereby help to ease popular fears and concerns. "It is then said that when the Sibyl came to Rome, everyone came to see her, and the hundred judges came to her asking that she interpret a dream that they had all had. She took them up to the Capitol and asked them to report the dream. They told her that they had seen different suns. These, she tells them, represent nine ages of man."[9]

All those who were present at the Capitol to hear the views of the Tiburtine Sibyl would have understood that her interpretation of the perplexing dream suggested the existence of separate but individually valid perspectives inherent to each of the successive periods of a person's life. It is likely that in modern times a practiced astrologer would not necessarily link these contrasting frames of reference to the different stages of human existence, but much more probably connect them to the signs of the zodiac. Placed in an alternative interpretive context, the vision of nine different suns could be understood just as reasonably as a reference to any series of particular points of view or to any number of divergent individual perspectives. In every one of these cases, the principle at work would have remained precisely the same over the last sixteen hundred years. Ancient sibyls and modern astrologers would appear to be united in their approach.

THE ERYTHRAEAN SIBYL

*There is a rocky crag rising above the ground where
the people say that the Sibyl Herophile stood to sing
her oracles; I discovered that this earlier sibyl was
amongst the most ancient in the world. The Greeks
claim that she was the daughter of Zeus by Lamia,
daughter of Poseidon, that she was the first woman
to sing oracles and that she had been accorded the
name of Sibyl by the Libyans.*

PAUSANIAS, *Guide to Greece*

This intriguing if perhaps not entirely reliable account
was written by a man who can be said to have had
something quite significant in common with the
woman who had so clearly captured his interest and piqued
his curiosity. By remarkable coincidence Pausanias and
Herophile are the first recorded practitioners of their respec-
tive professions. Although many hundreds of years separate
their lives, they each broke new ground in their own chosen
fields, she as the earliest sibyl and he as the first travel writer.
The existence of previous examples of this particular literary
genre have been reported, but the *Guide to Greece* by Pau-
sanias is generally considered to be the oldest surviving work
by someone who wrote primarily about his travel experi-
ences. If it had ever been possible for the author and the sibyl

to meet each other, there is very little doubt that they would have had a great deal to talk about. We can readily picture the two of them exchanging stories and drinking a kylix of good Chios wine to toast their innumerable adventures.

Pausanias was an intrepid doctor from Greek Asia Minor who lived, traveled widely and wrote extensively in the second century CE. It is almost certain that he would have been inspired to explore the world around him by the example of his near contemporary, the Roman Emperor Hadrian, who famously had made a point to visit just about every corner of the immense territories under his control. Naturally Pausanias covered a much smaller area, but nonetheless he was extraordinarily well travelled for a man of his time. In addition to their wanderlust the peripatetic physician and the mighty emperor shared another passion: they both had an unquenchable interest in classical Greece and a fanatical devotion to Greek culture. It was his committed philhellenism which must have moved Pausanias to embark on what would turn out to be the longest and most fruitful of all his journeys.

The tentative early wanderings of the first travel writer had taken him to Syria, Judea and eventually all the way south along the Levantine coast to Egypt. On another occasion he traveled west to the Greek settlements in Sicily and southern Italy and subsequently paid a visit to Rome, the seat of imperial power. If at that point Pausanias had decided to stop traveling, certainly his name would long ago have been forgotten, but instead he resolved to visit the places that all his life had interested him most. He set off on a thorough exploration of mainland Greece and the long and meandering coast of the Anatolian peninsula which today makes up Asian Turkey but in those days still remained very much a vital part of the Greek cultural world. Pausanias must have been suffi-

ciently prosperous to be able to take a good ten or twenty years off work for his travels. Clearly he preferred travel to medicine, and he did not have a wife and children to keep him close to home. Whatever his personal circumstances might have been, all along throughout his journeys he never failed to keep a detailed written account of everything he saw and heard. His published notes easily fill a thousand pages.

There can be no doubt that Pausanias and any of his like-minded contemporaries who enjoyed traveling must have felt extremely fortunate to be alive during Emperor Hadrian's two-decade reign in the middle of what is commonly known as the Golden Age of the Roman Empire. By the time Hadrian assumed the imperial throne, the *Pax Romana* had prevailed for generations. The tremendous amount of wealth accumulated by the state had made it possible to construct an extensive network of excellent roads, all of them leading to Rome from every remote corner of the empire. This unprecedented combination of peaceful conditions and superior highways gave to all those who undertook a journey through the vast territories under Roman control the possibility of moving around more speedily, comfortably, and in considerably greater safety than ever before in the history of humanity. The ease of travel enjoyed by Roman citizens during Emperor Hadrian's reign would never again be equaled anywhere else or at any other time before the introduction of the railway system in Europe some seventeen hundred years later.

The account of Pausanias's life is considerably more straightforward and uncomplicated than the story of the sibyl Herophile. Because of the long-established tradition that she had her shrine in the Ionian city of Erythrae, it is as the Erythraean Sibyl that she has been firmly and most consistently known over the centuries. Nonetheless, it would be naive and wildly optimistic to believe that there is any real certainty

about the location of her oracle, or even less about the place of her birth. Michelangelo's frequently reproduced image of the Erythraean Sibyl presents her as a solidly built young woman clearly and quite peacefully at her ease. She is seated on a flat and unadorned stone bench with her right leg crossed lightly over her left knee in a relaxed and casually unstudied manner. She might have felt that her status as the first woman ever to have practiced her chosen profession underpinned and justified her authority. Perhaps for that reason she looks supremely confident and serenely self-possessed.

The viewer chances upon her at the moment when she is just beginning to turn her head gently in the direction of a small table placed directly to her side. On its velvet-covered top a large book has been propped open to the page which has momentarily caught her attention. In the square niche behind her hangs a simple oil lamp which one of her two attendant putti is assiduously trying to light. His companion is not offering any help; he rubs his eyes as if he had just been awoken from a long and very deep sleep. The Erythraean Sibyl gives no indication of being aware of either their presence or their movements; her mind appears to be focused solely on the lines she is about to consult and nothing disturbs her concentrated gaze upon the page. Her girlish and artless facial features are shown in profile and display a dignity and poise which entirely belie her youthfulness. Her lustrous, dark brown hair has been fastidiously braided and bound tightly around her head in a simple and unaffected fashion. Only the highly defined musculature of her pale arms suggests a tremendous inner strength and imperturbable determination. Michelangelo's Erythraean Sibyl is a young woman who commands the viewers' respect in spite of her tender age and gentle simplicity.

By the second century CE, when Pausanias would have

been starting off on his long and comprehensive journey through Greece, the presence of a sibyl in Erythrae had been firmly documented for many generations. Writing half a millenium before Pausanias, the historian Callisthenes of Olynthus had been the first chronicler to leave a written record of her name. Today this man is mostly forgotten, but at one point he served as historian to Alexander the Great and was considered a figure of some distinction. His account of the Erythraean Sibyl would have been read with great interest and taken very seriously by his contemporaries. The story of her origins which Pausanias had heard so attentively in Delphi and then proceeded to carefully transcribe into his travel journal would not have had a source as distinguished as Callisthenes, but all the same it was one which must have been making the rounds for a considerably long time. Herophile was reported by the Delphians to have been the daughter of Zeus by a mortal woman named Lamia who had been the daughter of Poseidon, a brother of Zeus and the god of the sea. Immediately after recording these details, Pausanias races ahead of himself to quote from a hymn, allegedly composed by the sibyl Herophile herself, where she reveals that Apollo was her brother. This claim would appear to corroborate her divine descent because Apollo was another of Zeus's numerous children, albeit from a different mother. All Greek deities were believed to be children of Zeus and Apollo's parentage would not have been considered in any way unusual for a god.

The report that Herophile's mother, Lamia, was a bewitching Libyan queen whose irresistible beauty and charm had swept Zeus off his feet lends a certain degree of credibility to the Delphians' claim that it was the Libyans who had originally bestowed the name *sibyl* on Herophile. Regrettably Lamia did not enjoy a happy life in spite of her good looks,

high birth and enviable connections. The goddess Hera, who was Zeus's official wife and consort as well as one of his sisters, became fed up with her husband's frequent infidelities and decided to seek revenge by having Lamia's children, presumably including the infant Herophile, taken away from their mother. Thrown into utter desolation, the young and beautiful North African queen tragically lost her reason and in a fit of irrational self-destruction tore out both her eyes. Zeus must have felt compelled to do something to compensate Lamia for her grievous misfortune and he decided to grant her the gift of prophecy, one that she logically might have eventually wanted to share with her daughter Herophile. In her final years Lamia became notorious for her demoniacal cruelty. The classical scholar Peter Levi reports that the unfortunate blind woman ended up living all alone in a barren cave somewhere near Delphi, where she would meet with a violent death.

To confuse the story still further, in a later passage from the same hymn already quoted by Pausanias, Herophile unexpectedly presents an entirely different version of her parentage. She completely ignores the report that she had been born from the union between Zeus and Lamia, as the residents of Delphi had informed the traveling doctor, and this time around she states that she had been not Apollo's sister but actually his daughter. In view of the numerous incestuous connections among the various members of the Olympian family, it would be entirely possible for Herophile to have been both a sister and a daughter of Apollo, but immediately thereafter she goes on to reveal that she was the offspring of a nymph and an ordinary man, not at all a divine personage. Pausanias does not appear to take the matter too seriously and he dismisses the sibyl's different allegations simply by explaining that she had probably come up with all

of these stories "when raving and possessed by the god."[1]

Still other divergent claims have been made about the time and place of the sibyl's birth. The Roman author Lucius Caecilius Lactantius, who served as adviser to Emperor Constantine in the first decades of the fourth century CE, drew most of his information on the sibyls from the catalog compiled by Marcus Terentius Varro some four hundred years earlier. Exceptionally not quoting from Varro's writings on this particular occasion, Lactantius reports that the Erythraean was the only one of all the sibyls to have added her name to her written oracles and explains that she was called Erythraean "despite being born in Babylon."[2] A thousand years later Boccaccio would make the same assertion. The Tuscan humanist went on to add the significant detail that her birth was believed to have taken place before the Trojan War.[3] By some accounts, the sibyl's father is reported to have been Berossus, a respected historian from Chaldea, the area around the confluence of the Tigris and Euphrates Rivers in southern Mesopotamia. Several mentions of a Babylonian Sibyl actually exist in ancient texts, but it is more likely that they refer not to the Erythraean but rather to the Persian Sibyl, a nebulous figure who nevertheless was portrayed by Michelangelo on the ceiling of the Sistine Chapel. On occasion this particular sibyl has also been called Chaldean, which is certainly more than strongly suggestive of a Babylonian connection. It has been recorded that the Persian Sibyl bore a Semitic name, Sambethe, and that she had been active such a long time ago that she had been chosen by a son of Noah to become his wife. A prophetess who was known by the same demonym was included in the foundational list of sibyls compiled by Varro.

These contradictory versions of the Erythraean Sibyl's origins could have sprung up quite easily over the centuries

from the independent accounts of two separate women who both happened to have practiced prophecy in Erythrae but who would have done so at different times. The authoritative Greek geographer and historian Strabo had testified to the existence of two Erythraean sibyls, one ancient and one modern.[4] The seventeenth-century Spanish historian and author Balthasar Porreño writes that one of them, almost certainly the one Strabo called the modern one, had flourished half a millennium after the Trojan War at the time of Hezekiah and Numa Pompilius. Porreño was faithfully following the fairly accurate dates recorded by Saint Augustine twelve hundred years before him. Hezekiah was king of Judah and Numa Pompilius was king of Rome; both lived in the eighth century BCE. The possible existence of two successive sibyls in Erythrae is also mentioned by Pausanias. "Herophile was younger, though she seems to have been born before the Trojan War even so, and to have foretold [to] Helen in her prophecies how she [Helen] would be reared in Sparta for the ruin of Asia and of Europe."[5] With his customary acuity, the eminent sibylline scholar Herbert Parke observes of Pausanias that "in view of the fact that he evidently accepted the theory of a multiplicity of Sibyls, it would be odd if he did not apply that explanation to such conflicting quotations."[6] Significantly more helpful is Herophile's subsequent assertion, in the same hymn cited by Pausanias, that she had been "mountain begotten by a mother from Ida."[7] At last the sibyl seems to be getting somewhere.

This incidental reference pointedly introduces a definite link to Mount Ida in Anatolia, an extraordinarily fitting place of origin for the sibyl and her mother because, from the time of the earliest Greek foundational narratives, it appears to have been closely connected to the primary mythological figure of the Earth Mother. Mount Ida was the name given in

Greek antiquity to the rocky massif separating the rest of the Anatolian peninsula from the area around Troy, which was commonly known as the Troad in classical times. Throughout the centuries the Erythraean Sibyl has most consistently been thought to have spent her adult life not too far south of Mount Ida. The settlement of Erythrae was started by the Greeks in the small region along the western coast of Anatolia known in antiquity as Ionia. Lydia, the area where Pausanias is believed to have been born, almost entirely surrounds Ionia, which faces the islands of Samos and Chios lying in the Aegean Sea directly to the west.

According to Strabo, who lived and wrote in the first century CE, Erythrae had been founded by a son of the last king of Athens who crossed the Aegean Sea with a group of his companions for the purpose of establishing Greek settlements along that stretch of the Aegean coast. These pioneering communities cannot realistically be dated to any period earlier than the eleventh century BCE, which means at least a century and a half not before but after the fall of Troy. Unfortunately this chronology would make it impossible to reconcile the dates of the Erythraean Sibyl with Varro's frequently quoted assertion that before the Trojan War had started she had forecast a Greek victory and the complete destruction of Troy.

The simplest and most obvious explanation for all of these confusing discrepancies must be that the birth of at least one of the women remembered as the Erythraean Sibyl had predated the arrival of Greek settlers in the region of Ionia. Although Apollodorus of Erythrae unequivocally affirmed that Herophile had been his countrywoman, it is not impossible that she had traveled to Ionia from her native Babylon in her infancy or adolescence, either on her own or with her family. Regardless of where she might have been born, it

seems likely that Pausanias was correct when he wrote that the sibyl had been alive and busy with her prophecies before the Trojan War. If this time frame is accepted, then the next premise that needs to be considered is the heady and provocative possibility that the Erythraean Sibyl might actually have witnessed at first hand the Greek fleet sailing north along the Ionian coast on its fateful way to Troy. The same claim could never be made either for Homer or for any other chronicler of that epic conflict.

By the time Pausanias traveled through this area many centuries had passed and Troy had long disappeared from the map. The doctor does not record having visited Erythrae but, all the same, he managed to find evidence of the Erythraean Sibyl in the course of his unhurried and meticulously documented journey along the eastern coast of the Aegean Sea. One of the principal cities in the entire region would have been the busy port of Alexandria in the Troad. During his stay there Pausanias was informed by the local residents that at one time the young sibyl Herophile had been attached to a venerable Alexandrian temple dedicated to the cult of the Sminthean Apollo. It appears that *sminthean* was a word taken from the form of ancient Greek used by the Aeolians, a separate group of people who spoke their own distinct language and occupied the small coastal region which lay immediately south of the Troad and north of Ionia. The learned Varro believed that also the word *sibyl* had derived from Aeolian antecedents. Surviving reports indicate that *sminthean* meant *mousy* in Aeolian, which makes it rather difficult to understand why the term ever became appended to the name of one of the handsomest and most elegant of all classical gods.

The highly unusual cult of the Sminthean Apollo dated back to the time when colonists from Crete had first started

arriving in the Troad. According to Ovid's colorful account, by means of an oracle a group of these adventurers had received a direct admonition from Apollo to establish a settlement at the spot where they would find their enemies emerging from the ground. That very night they pitched their tents somewhere in an empty field outside a modest village. The men were probably sitting around an open fire, peacefully exchanging stories and singing songs, when one of them perceived a slight movement barely noticeable in the soft moonlight. A large number of hungry field mice had started to leave their subterranean nests in search of food and they were chewing the edges of the men's leather shields which had been left lying on the ground. This occurrence was immediately interpreted as an obvious fulfillment of the divine oracle. The troops at once agreed to build their settlement just where they were; not too long thereafter a statue of Apollo with a mouse at his divine feet was raised in commemoration of the event. Peter Levi has observed that the casting in bronze of life-size votive figures of mice would become common in the Troad. Examples of the curious metal rodents can be found today in a number of museum collections. Eventually Alexandria in the Troad became the only center of this peculiar cult. During the Trojan War the priesthood of the Sminthean Apollo stood firmly on the side of Troy against the Greeks. Not surprisingly, this whimsical group never managed to gain a foothold in mainland Greece.

Another report found among Pausanias's travel notes refers to the time, even then already submerged in the depths of history, when Poseidon had paid a visit to Chios, one of the Aegean islands lying immediately off the Ionian coast. This is an amusing but minor episode peripherally relevant to the story of the Erythraean Sibyl only because it establishes that Poseidon, who was believed by at least some of the Del-

phians to have been her grandfather, had once paid a visit to a place separated from Erythrae by only a narrow stretch of water. The reason why Poseidon made this trip has not been preserved, but what has survived the centuries is the report that in antiquity Chios was famous as the place that produced some of the best and most highly valued wines in all of the Hellenic world. Poseidon may well have gone there in search of outstanding vineyards, but he evidently found more than just oenological pleasures to keep himself entertained. He remained in Chios long enough to father three children with two different nymphs he met on the island during what can only be described as a fruitful stay.

Perhaps the only puzzling feature about Pausanias's chronicles is that it was not in Erythrae, or even somewhere else nearby, where he first heard about the sibyl's practice of standing on a rocky crag to sing her prophecies. Pausanias actually came upon this tale during his visit to Delphi in central Greece, the site of the most respected Apollonian oracle in the classical world but one which was located at a considerable distance from Ionia and lacked any traditional connections to that part of the world. As Peter Levi has pointed out, Pausanias wrote "sometimes carelessly." In his account of his visit to Delphi, the doctor appears to have been particularly confused if not entirely overwhelmed by the number and variety of reports coming his way. His own wry observation is that "there are a lot of different stories about Delphi, and even more about Apollo's oracle."[8] It is significant that Pausanias recounts at least four different versions of the city's beginnings. There was indeed a very famous rock in Delphi, found below the Temple of Apollo and considered by the residents of the city to mark the very center of the world. For that reason it was known as the *Omphalos*, a Greek word which literally means *navel*. However it was not

while she was standing on this rock that the priestess of Apollo declaimed her prophecies, but rather as she sat on a three-legged stool placed over a deep fissure in the rocky ground. It is not impossible that in his frustration Pausanias mixed the stories of the Erythraean Sibyl with those of the Pythia, as the Delphic high priestess was known. Despite all the apparent confusion, for the purposes of this study the name of Herophile will be used in all cases to refer to the sibyl of Erythrae alone.

Undoubtedly it would seem more logical to expect to find Herophile's rock closer to the city where she plied her trade, but sibylline stories nearly always follow convoluted plotlines. Of course there is the occasional report that some of the sibyls had an itinerant practice, and this would mean that, at least in principle, Herophile could have traveled back and forth between Delphi and Erythrae. Charles Kahn identifies the sibylline link between the two cities when he writes that "authors spoke of an eighth-century Sibyl named Herophile, from the Ionian city of Erythrae not far from Ephesus, whose oracular wanderings had left a clear trace at Delphi."[9] Nevertheless this explanation does not seem entirely satisfactory, and not just because in antiquity commuting between the two cities on a regular basis would have been insurmountably difficult. An equally substantial obstacle would have been presented by what David Stone Potter identifies as "the rivalry between cities that laid claim to a particularly famous Sibyl as a fellow citizen."[10] Such civic pride would have made it very unlikely, if not entirely impossible, for any two recognized sibylline oracles to portion out a single sibyl between them. "Each place had its own technique, sanctioned by long practice, and there was no point in an established shrine's trying to bring itself into line with other places."[11] Both Delphi and Erythrae had their own proud and

independent prophetic traditions and it does not seem very probable that they would have been willing to share them with the competition.

It might well be the case that when Pausanias was told about the sibyl and the rock he had simply run into an early example of the inventive manipulation of historical facts for promotional purposes, not that the doctor gives the slightest indication that he took notice at the time. The story the Delphians related to Pausanias, and almost certainly to all of their other visitors, might have been nothing more than the second-century equivalent of the "Napoleon slept here" tale plainly intended to keep the tourists arriving in great numbers. If it reveals anything at all, it has to be that the Erythraean Sibyl was still a celebrity of the first rank, even as late as the second century CE when Pausanias visited Delphi. At the dawn of Christianity, a moment when she might easily have been forgotten, she evidently remained a figure so widely known and profoundly respected in the Hellenic world that the residents of Delphi, whose own oracle by then was beginning to fall on hard times, were hoping to impress the few pilgrims who continued to arrive there by claiming some kind of direct link to the Erythraean Sibyl and to her authority. Lactantius reports that "she is considered more celebrated than the rest, and more distinguished."[12] In his discussion of oracles, Walter Burkert writes that among the ancients "the most famous sibyl was connected with Erythrai."[13] Along the same lines, Herbert Parke points out that, beginning around the fourth century BCE, her fame and reputation attained ever-growing recognition. Parke goes on to share his conclusion that, of all the sibyls, the Erythraean "is the one most often mentioned."[14] The Delphians had cleverly managed to find a way to profit from the Erythraean Sibyl's universal celebrity.

There can be no question that her great fame had been one of the prime reasons why copies of the last remaining books of her prophecies were taken from Erythrae to Rome. Centuries before this scheme was set into motion, King Tarquin had paid a great deal of money to get his hands on an earlier group of prophetic writings. Since the day they had been acquired, directly from the Cumaean Sibyl, these books had always been kept in the inviolable precincts of the Temple of Jupiter Optimus Maximus, the paramount sanctuary in Rome and by extension in the whole of the Roman Empire. It was superbly located at the summit of the Capitoline Hill and the sacred sibylline writings were locked away in their own separate storeroom under constant guard. The books were made accessible only on special occasions and just to a small number of select attendants. It is fully documented that the great temple had stood proudly for four hundred years before burning down in a matter of a few hours one terrible day some eighty years before the birth of Christ. All of King Tarquin's Sibylline Books would go up in smoke during the conflagration.

The news of the destruction of the Temple of Jupiter Optimus Maximus spread very quickly to every corner of the classical world. Its loss was such a demoralizing and deeply felt tragedy for the residents of Rome that its reconstruction was started almost the moment the last of the flames had been put out. It took just fourteen years to finish a nearly exact replica carefully built along the same lines and in the same majestic scale as its predecessor. Finding satisfactory replacements for the Sibylline Books would prove to be a much more difficult task. For years after its inauguration the reconstructed temple continued to lack even a single example of any type of sibylline pronouncement. Finally a Roman consul took matters in hand and presented a proposal to start

an official search for other books of prophecies to replace those which had been lost. At some time during the last decades of the first century BCE the Roman Senate officially decreed to dispatch a number of distinguished men all the way to Erythrae in an effort to locate whatever sibylline documents might still have been preserved there and arrange to have them transported to Rome. Some reports indicate that fifteen envoys were sent off to Erythrae. If this was indeed the case they would have been the same number as the distinguished Roman citizens known simply as the *quindecimviri* (the fifteen men) who had once been entrusted with the protection of King Tarquin's Sibylline Books. Parke curtly observes that "it is interesting, but not surprising, to notice that Erythrae was evidently regarded as the original home of Sibylla."[15] Nonetheless, everyone believed that only in Rome could the prophecies be correctly interpreted for the general benefit of all the citizens of the empire.

Unfortunately it is likely that the meager group of sibylline material the Romans managed to come across in Erythrae might not have been originally composed or even put together there. The more probable scenario is that at some point a handful of isolated documents would have made their way to Erythrae from Gergis, an otherwise mostly forgotten city in the Troad but one that in antiquity was famous as the place where a substantial collection of prophetic books had been assembled over countless generations believed to go back as far as the seventh century BCE. Certain respected scholars have suggested that the original Apollonian cults could well have been started in the Troad, and there is much evidence to support this view. The main temple in Gergis was dedicated to Apollo, as would have been the case in the various other cities in the Troad where prophetic cults had long been part of the local tradition. In addition to its important

Apollonian shrine, the city of Gergis possessed other concrete and unimpeachable sibylline connections. The local mint regularly produced coins stamped with an effigy of the sibyl which would have circulated freely, not only locally in Gergis and its immediate surroundings but also beyond the boundaries of the Troad and throughout the classical world; examples of a few types have survived.

At the end of the day the expedition to Erythrae does not appear to have been the unqualified success which had been hoped. If by that date any type of sibylline material had actually remained in the city, the local authorities successfully kept it under wraps. By most accounts, whatever documents the commissioners managed to discover had been tracked down in the possession of private Erythraeans. The individual owners agreed to grant their visitors merely the right to make copies but not to take away the originals. In this slow and laborious manner the total number of verses salvaged by the scribes would not have exceeded a thousand. It was thus that the books of the Erythraean Sibyl found their way to Rome.

The gradual acceptance of Christianity as the primary religion of the Roman Empire a few centuries after the arrival of her books in Rome in no way diminished the fame or reputation of the Erythraean Sibyl. Writing at the end of the fourth century CE, the canonical Saint Augustine of Hippo declared his conviction that "this Sibyl of Erythrae certainly recorded some utterances which are manifestly references to Christ."[16] Saint Augustine was perhaps the most eminent but certainly not the only or even the first Christian scholar to express this point of view. Three generations earlier Lactantius had written that "all these Sibyls, then, proclaim one God, but the Erythraean one does so pre-eminently."[17]

A thousand years after Saint Augustine, at the begin-

ning of the Renaissance, Boccaccio would take a similar position when he proclaimed the belief that the Erythraean Sibyl had not actually received the gift of prophecy from either Zeus or Apollo, but that "through attentive study and divine generosity she earned the skill of prophesying the future. This she did with such clarity that she seemed to be less a prophet than an evangelist."[18] What Boccaccio considered the evangelical dimension of her vision had already been noted centuries earlier by the great Saint Isidore, Archbishop of Seville, a man universally considered to have been the last major scholar of antiquity. In the late sixth century CE, Isidore expressed precisely the same opinion and declared his view that the Erythraean had been the most famous of all the sibyls "by virtue of her Christological prophecies."[19]

The Erythraean Sibyl's prophetic announcements were originally written down on dry leaves. This practice might well appear eccentric or even bizarre to modern observers, but the use of foliage for writing purposes was so commonplace in antiquity that it would not have caught anyone's attention. So widespread was the practice that to this day a sheet of paper in many European languages is called a *leaf*. The French use *une feuille* to write down their thoughts, whereas the Spanish use *una hoja* and the Germans *ein Blatt*. Although paper as we know it was already being manufactured in China more than two thousand years ago, the surprising fact is that it remained a commodity completely unknown in the Western world until the late Middle Ages. Before its introduction in Europe, any kind of formal writing meant to be preserved had to be done either on parchment, which was laboriously processed and stretched calfskin, or still more frequently on papyrus, which was made from the pressed pith of a reedy Mediterranean plant. The manufacture of both types of products was extremely time-consuming and hugely

expensive. In any case the rarity and cost of these luxury goods would not have been of any concern to a predominantly illiterate population. Most people would not have even suspected the existence of such extravagant and esoteric articles, and probably would have remained ignorant of their intended purpose.

According to Homer and several other sources, a form of tablet covered in wax was regularly used for written communications, but the select few who were able to read and write would normally have reached for whatever scraps they had at hand to jot down their daily shopping lists, brief thoughts and memoranda. Dry leaves, empty shells and even discarded fragments of broken pottery vessels would all have been commonly used for this purpose. Biblical exegetes have proposed that either Saint Paul or the scribes working under his guidance are likely to have followed the identical practice to write down his epistles as they were being composed. Like many of her contemporaries, the Erythraean Sibyl, along with her most trusted attendants, would regularly have done precisely the same without giving it a thought. What the sibyl did differently from all the others, including most pointedly her counterpart from Cumae, was to arrange her leaves in a pattern deliberately composed and very carefully worked out.

The word *acrostic* is believed to have been first applied to the pronouncements of the Erythraean Sibyl to denote her personal method of beginning the jottings on each leaf so that the first letter of every opening word, when read in the correct order, would form a new message conveying an independent but nonetheless relevant meaning. At the start of the fourth century CE, Bishop Eusebius of Caesarea, the author of the first history of the Christian Church, wrote about the "Erythraean Sibyl, who pointed in a Prophetic Acrostic at our Lord and his Passion."[20] A hundred years later Saint

Augustine revealed that a learned Roman proconsul by the name of Flaccianus had brought this acrostic to his attention.[21] By early Christian times these stanzas would have become thoroughly familiar to all the faithful. The short phrase formed by the first letters of the relevant lines invokes the name of Jesus Christ, followed by his descriptive attributes: *IESOUS CHREISTOS THEOU UIOS SOTER*, Jesus Christ Son of God and Savior. Eusebius ends his commentary by declaring that "it is evident that the virgin uttered these verses under the influence of Divine inspiration."[22]

The awareness and eventual appreciation of the Erythraean Sibyl, her message and its significance have also found expression in the field of music. There are ancient documents in numerous libraries which reveal that, starting in the eighth century, a musical setting of the Song of the Sibyl used to be performed in every corner of the Christian world before the celebration of Holy Mass on Christmas Eve. This moving ritual was inexplicably halted by the Council of Trent in the middle years of the sixteenth century; despite this abrupt suppression performances appear to have been quietly resumed just a few decades later, probably at the insistence of local communities determined to preserve their treasured ancestral traditions.

The words of the Song of the Sibyl are based directly on Saint Augustine's Latin translation of the Erythraean Sibyl's apocalyptic verses. The original eighth-century musical setting has not survived, but it is remarkable that a later version, which is the one in regular use still today, appears to have changed very little over the last thousand years; this newer setting has been recorded and is widely available on compact discs. Performances of the Song of the Sibyl have continued to take place without interruption in several areas of the Mediterranean world until the present time and con-

tinue to this day, principally in Majorca but allegedly also in Sardinia. In 2010 the United Nations Educational, Scientific and Cultural Organisation (UNESCO) proclaimed the Song of the Sibyl to be one of the Masterpieces of the Oral and Intangible Heritage of Humanity.

The *Dies Irae* is another text associated with the Erythraean Sibyl which has been set to music, in this case with much greater frequency and by considerably more celebrated composers. By convention this thirteenth-century hymn has been attributed to Tommaso da Celano, a Franciscan friar who is otherwise remembered for having been asked to write three separate early biographies of Saint Francis of Assisi, a man he knew personally. The name by which the hymn is generally known is taken from the words of the beginning verse, *Dies irae, dies illa solvet saeculum in favilla, teste David cum Sibylla,* or as can be rendered in English translation, "on this day of wrath the world will be consumed in ashes, as foretold by David and the Sibyl." The *Dies Irae* forms part of the liturgical text of the Roman Catholic mass for the dead and it is normally sung just before the Gospel. In the course of time it has been set to music by some of the best-known and most highly acclaimed composers in the Western world, from Palestrina to Mozart, Berlioz, and Verdi, to mention but four. One of the most recent settings was done by the renowned British composer Andrew Lloyd Webber, someone who is perhaps more commonly recognized for works of a lighter nature. Wherever it is that she might be buried, the Erythraean Sibyl certainly would have every reason to feel proud of the quality of the music she has inspired over the centuries.

Boccaccio's account of the Erythraean Sibyl ends succinctly with the report that the time and place of her death had long been forgotten. Pausanias, however, is much more

informative on the subject. He relates that in her later years the sibyl had traveled extensively but that as she grew older she had eventually decided to return home. He had found concrete evidence that she had spent her final days in the Troad. The enterprising doctor actually discovered the location of her grave and had paid a respectful visit to it, a quiet but probably poignant excursion he must have enjoyed. With his customary attention to detail, he carefully noted down the proud and defiant words of her epitaph.

> I, *Sibylla, Apollo's wise woman,*
> *lie unseen under this stone.*
> *As a virgin I once spoke but in these shackles*
> *I am now silenced by the strength of fate.*
> *I remain close to the Nymphs and to Hermes;*
> *I have not lost my sovereignty.*

The sybil's funerary monument was appropriately placed within the tranquil and undisturbed confines of the sacred forest of the Sminthean Apollo, the prescient yet ever-playful god of nocturnal mice. In a rare departure from his usual practice, Pausanias failed to record its precise location.

THE CUMAEAN SIBYL

*Virgil himself indicates that this verse was not simply
his own invention when he says: "The final age fore-
told in Cumae's song has come." From this, it appears
beyond question that the verse was dictated by the
Cumaean Sibyl.*

SAINT AUGUSTINE OF HIPPO, *The City of God*

The masterful woman identified by Saint Augustine in such generous terms as Virgil's source and inspiration was one of the most consistently successful and longest-serving practitioners of the venerable art of prophecy. For a long time before she would come to the attention of the Bishop of Hippo, the Cumaean Sibyl had been a trusted and respected figure throughout every layer of the extensive and widely diverse pagan populations of the Mediterranean world. Augustine himself has enjoyed an almost equal degree of recognition: the saint is generally considered to be one of the key seminal figures of early Christian theology. For more than three decades he held the important episcopal see at Hippo, a prosperous city in the north of Africa and a main political and cultural center during the period of highest development of the Roman Empire. In the course of his tenure as bishop, the theological importance of his sermons

was recognized by all who heard him preach. He is officially acknowledged as one of the Fathers of the Church; his works remain highly esteemed and continue to be part of the curriculum in universities and seminaries everywhere. Why the chimerical pagan sibyl ever came to attract the attention and support of the studious Christian bishop is a long story; it might help explain the surprising process through which certain pagan figures would gradually become integrated into traditional Christian beliefs.

It had been widely reported in antiquity that the Cumaean Sibyl held her virtue in such high regard that all through her life she consistently refused to submit to any man. When she was in the prime of her youth Apollo became infatuated with her and on an impetuous whim he granted her the prized gift of prophecy. The budding sibyl must have been deeply pleased, and perhaps even flattered, but it would appear that nonetheless she was not quite yet entirely satisfied. After carefully considering all her options, she resolved to ask the god for one more gesture as proof of his devotion. Her reaction demonstrates that she must have been a woman of considerable audacity: the additional gift she requested was to be granted as many years of life as the number of grains of sand she could manage to contain in her cupped hands. In the hope of gaining her goodwill, the smitten god readily agreed to her immoderate request, but it would not have taken him long to realize that she actually had no intention of yielding to his designs. Apollo was sent packing as soon as she was given what she wanted. To what certainly must have been her extreme consternation, she realized only too late that she had failed to ask her suitor for the gift of perpetual youth to complement her longevity. Eventually the Cumaean Sibyl would outlive all other mortals but, with the passage of time, she inevitably grew more and more wizened and haggard.

Over the course of many centuries her renown would come to rest equally on the twin pillars of her old age and her prophetic vision. The prodigious number of years she had spent on earth became a matter of such common knowledge that, when Petronius wrote in the *Satyricon* that her greatest desire was to finally go to her grave, he seems not to have seen any need to explain to his readers the reason why the sibyl should have felt that way. A silly rumor began to make the rounds among Roman quipsters that she had become so shrunken with age that her body could have been quite comfortably contained inside a glass jar, a bizarre tale repeated by T. S. Eliot at the beginning of *The Waste Land*. In Imperial Rome the Cumaean Sibyl was generally considered the epitome of longevity, a singular distinction that she would continue to hold for more than a thousand years. Her age had become the yardstick by which all other lives were measured. The poet Ariosto, writing at the beginning of the sixteenth century, would compare her to the wicked sorceress Alcina, who was said to have lived to an even more advanced old age.[1] By such literary means the legendary story of the Cumaean Sibyl remarkably survived beyond antiquity through the Renaissance and well into present times.

Boccaccio declares that she had been the daughter of a simple fisherman named Glaucus who is now almost completely forgotten but who at one point had undergone a sensational metamorphosis as magical as it had been unexpected. The fisherman was suddenly transformed into a merman with prophetic powers and from that moment onward he lived in the sea. His newly acquired gift must have been so considerable that he became Apollo's mentor. The report has survived that the god had learned all that he knew about the art of prophecy at Glaucus's knee. If Boccaccio's account of her parentage is correct, then the Cumaean Sibyl might easily

have acquired at least some of her prophetic skills from her father. However no real certainty exists about the identity of the sibyl's forebears, or even about her given name. She has been identified most frequently as Amalthaea but occasionally as Demophile and only very rarely as Deiphebe.

The demonym by which she has been most consistently remembered derives from one of the many settlements founded along the Tyrrhenian coast of southern Italy by colonists from Chalcis on the Greek island of Euboea. It is evident that the majority of her contemporaries believed that the sibyl had been a native of a village northwest of Naples which had been given the name of Cumae by the Greeks. This conviction was shared by Boccaccio, who wrote with some assurance that she had been born "in Cumae, an ancient city of the Chalcidians."[2] Nonetheless the persistent suggestion that she had come to Italy from somewhere in Asia Minor would become widespread at a later time. Regardless of where it was that she was born, or what her actual given name might have been, it was certainly in a windy Cumaean cave overlooking the sea that she lived, prophesied, and ultimately died. By the middle of the second century CE visitors were being shown the bronze urn in which her desiccated remains had been carefully preserved. For at least half of the next millennium her barren cave would remain a tourist magnet.

Michelangelo's depiction of the Cumaean Sibyl on the ceiling of the Sistine Chapel presents her as an aged but somehow ageless woman almost overwhelmingly aware of her personal authority. The hardened features of her aquiline nose and jutting jaw are shown in profile while the titanic proportions of her muscular arms are portrayed with arresting realism. Michael Wood accurately points out that "if it were not for her large breasts and assertive nipples, she might be taken for a man. She wears a complicated white head-

dress, and her face is hard and gnarled like an ancient tree."[3] Certainly the skin on her broad and sinewy shoulders appears as husky as weatherworn bark. "Because of her mannishness, she has been associated with the weird sisters in *Macbeth*, and there is something about the traditional European witch about her—or perhaps simply of the woman who has survived long hard times."[4] All the same no less discerning an art critic than Giorgio Vasari, who had known Michelangelo in Rome and would later go on to become one of the earliest of all art historians, found her beautiful. She is seated majestically on a marble throne, facing her viewers but not casting her eyes in their direction. Her head is turned away as she leans across her right knee to consult with intense concentration the large and unwieldy volume she holds in her massive hands. She appears utterly oblivious to the presence of others, lost in thought and fully absorbed in her own divinations.

By far the richest source of information on the life and activities of the Cumaean Sibyl is Virgil's *Aeneid*, a work written in the first century BCE at a time when she would have been alive for a thousand years. In vivid and colorful detail Virgil relates the story of the sibyl's dealings with Aeneas, a valiant warrior who had fought in the Trojan War and who at that moment was on his way to Italy in order to fulfill his divinely ordained destiny to found the city of Rome, the second Troy. It would have been the clairvoyant Helenus, son of the last king of Troy, who had first urged Aeneas to find the Cumaean Sibyl. Under the influence of a visionary spell, Helenus had told his compatriot that it was imperative for him to go to Cumae directly upon his arrival in Italy. Helenus would have made it clear that nothing could be allowed to delay or much less prevent this visit. Only at Cumae would Aeneas find "an ecstatic, a seeress, who in her cavern communicates destiny, committing to leaves the mys-

tic messages. Whatever runes that virgin has written upon the leaves she files away in her cave."[5]

From all accounts it has been established that the sibyl routinely used dry foliage collected by her attendants as what is normally called "scrap paper" in the modern world. She shared this practice with most of her contemporaries, notably the Erythraean Sibyl. Whenever she was seized by prophetic visions, her usual practice was to use these leaves to write down each utterance as her revelations gradually unfolded. Eventually her prophecies would have been individually recorded one by one on separate leaves. As soon as her visions had come to an end her attendants would quickly assemble all the leaves in tidy heaps which the sibyl herself would then arrange in strict sequential order. The leaves would remain undisturbed on the ground along the walls of her cave, but only until the door was opened and the unrelenting wind rushed in. At that moment they would scatter everywhere, but to everyone's dismay the Cumaean Sibyl would not attempt to catch any of them as they swirled around the cave. Virgil reports that after the leaves had all come to rest she would make no effort to "restore their positions or reassemble the runes: so men who have come to consult the sibyl depart no wiser."[6]

The image of the sibyl's words flying aimlessly in the wind and alighting on the ground at random presents a most evocative account of her prophetic methods. It is well known from a great many reliable sources that her pronouncements did actually fly around like leaves in the wind throughout every corner of the classical world. It is also well known that the precise meaning of these prophecies was not always immediately apparent to those who first received them. In the sixth century CE, the author Procopius of Caesarea, official historian at the court of Emperor Justinian, observed that it was

quite impossible for anyone to fully discern the true meaning of the sibyl's divinations. Even to her contemporaries the Cumaean Sibyl had been known for the enigmatic nature of her prophecies. People would begin to grasp their full significance only after they had actually come to pass. Time alone would offer the ultimate validation of her prophetic visions.

In order to avoid such useless confusion, Aeneas had been advised to come to the sibyl with great reverence and to ask her in a deeply prayerful manner to "graciously open her mouth and prophesy."[7] The cautious Helenus had assured Aeneas that, if he were to take this approach, the sibyl would enlighten him about events in the future and be ready to offer him guidance. "She will tell you of wars to come with the tribes of Italy, how to evade, or endure, each crisis upon your way."[8] Aeneas certainly would keep these words very much in mind when his ships dropped anchor off the coast of Italy and at last he and his men landed near Cumae. This would have been a moment Aeneas had been anticipating for a long time, and understandably he might have been a little apprehensive about his encounter with a strange old woman who was notorious for her unpredictable behavior. He would have been wise to take a few moments to gather his wits and prepare for the meeting. "The god-fearing Aeneas made for the shrine where Apollo sits throned on high, and that vasty cave—the deeply-recessed crypt of the awe-inspiring Sibyl, to whom the god gives the power to see deep and prophesy what's to come."[9]

Not even a trace of the sanctuary of the Cumaean Sibyl would have been visible from the coast of the Tyrrhenian Sea. Trying to find the way to it could never have been an easy task for anyone starting out from the shore. Aeneas and his companions would have needed to climb a steep cliff before coming across any signs that they were anywhere near the

mysterious cave. For a moment they might have thought that they had lost their way. Only when they reached the summit would they have caught first sight of their destination, but nothing could have prepared them for what they found. Squarely in front of them stood "a huge cave hollowed out from the flank of Cumae's hill; a hundred wide approaches it has, a hundred mouths from which there issue a hundred voices."[10] Through each one of the openings they would have heard the distinctively shrill voice of the sibyl. The scene must have unnerved even this group of hardened men who had fought and survived many fierce battles.

When she finally made her appearance the Trojans would have faced a frenzied creature with disheveled hair and heaving breast, her clairvoyant heart swollen in ecstasy. Aeneas's brave companions shirked in terror at her sight. Virgil reveals that "larger than life she seemed, more than mortal her utterance: the god was close and breathing his inspiration through her."[11] Unlike his men Aeneas managed to stay calm. He quietly began to pray as he had been counseled to do, first to Apollo and then directly to the sibyl. "O most holy Sibyl, foreseer of future things, grant—I but ask for the kingdom owed by my destiny—grant that we Trojans may settle in Latium."[12] As a gesture of his respect and obeisance he then went on to make her a solemn promise. "You too shall have your holy place in the realm to be, where I shall deposit the oracles, the mystic runes you utter for my own people, ordaining a priesthood to their service, O gracious one."[13] As it turned out these were words that the Cumaean Sibyl would never forget.

Aeneas continued with a passionate plea to cease her habit of entrusting her divinations to mere leaves, "lest they become the sport of whisking winds and are scattered: speak them aloud, I pray."[14] All at once the sibyl began to run

around her cave in a raging madness as Apollo "exhausted her foaming mouth and mastered her wild heart."[15] What must have seemed to Aeneas an unbearably long time would have passed before she finally regained her composure and was able to speak coherently once again. With terrifying conviction, she then warned Aeneas that, although his troubles at sea might have been over, he could expect to encounter many more and much worse disasters on land. Along with various other calamities, she declared that she had visions of "wars, dreadful wars."[16] She could see the river Tiber "foaming with torrents of human blood."[17] By then the Trojan warrior had had enough. He had not come this far just to hear a long line of gloomy predictions.

The traditional story had been that Aeneas was the son of Anchises and the goddess Aphrodite. Both the father and the son survived the fall of Troy but Anchises died not too long thereafter. What Aeneas really wanted from the sibyl more than anything else was to be taken to the underworld to have one last meeting with his father, a journey which he knew only the Cumaean Sibyl had the power to arrange. Getting there would be easy, she sensibly pointed out to him, since the gates of Hades were always open to everyone who arrived there; it was the return trip that would present a problem. "To retrace your steps, to find the way back to daylight—that is the task, the hard thing."[18] After some deliberation she eventually agreed to lead Aeneas both to the underworld and back, but just on his own and not in the company of his troop of skittish soldiers. The men must have felt deeply relieved to be sent back to the safety of their ships. Together the sibyl and the warrior set off on their perilous adventure. Aeneas would have been all eyes.

The underworld was inhabited by the spirits of humans who invariably went there only after they died. At the moment

of arrival the spirits would be taken either to Tartarus, the area where all those who had displeased the gods would meet the eternal punishment they had earned by their impious behavior, or to Elysium, a more distant corner of the underworld which was reserved for the virtuous others who had led righteous lives. Virgil describes Elysium as a place of eternal spring so peaceful and agreeable that a sun of its own had been advisedly put in place by the gods to light its evergreen meadows. The arrangement was clear and the spirits would not have moved around once they had settled in their assigned location. The underworld was not a place for casual visits or leisurely strolls; there was no need for road signs and those reckless enough to travel there had to know what they were doing.

Straightaway Aeneas would have recognized how important it was for him and the sibyl not to make a wrong turn. "Here is the spot where the way forks, going in two directions."[19] The road leading to the right could take them to Elysium, but the one on the left might just as easily be there to lead "the wicked to Tartarus, their own place, and punishment."[20] Despite all the difficulties, from the very beginning of the journey the Trojan warrior must have realized that he was in safe hands. The sibyl was a resourceful travel companion who could find her way around the underworld without hesitation. She knew which paths to follow and which to avoid, and could identify all the curious characters they would meet, all along explaining to Aeneas each one of the puzzling features they seemed to encounter at every turn. She was the one who talked her way around all obstacles and managed to get every door to open. In a moment of perhaps not entirely unintentional humor, Virgil reports that the sibyl cleverly produced a spiked treat to drug the dreaded three-headed dog Cerberus long enough to allow her and Aeneas

the chance to get past him without suffering injury or harm. The longer the two of them traveled, the more obvious it became to him that she must have been there many times before and had come to know the place like the back of her hand. "Side by side they went the twilight way."[21] At long last they arrived at their destination, "the Happy Place, the green and genial Glades where the fortunate live, the home of the blessed spirits."[22] It was there, in Elysium, where all along the two of them had been hoping to find the spirit of Anchises.

Aeneas would have wept with joyful satisfaction as he caught sight of his father and began to race in his direction. The distinguished old man, born a prince of Dardania, would never have expected to meet his son so soon and there can be no doubt that theirs must have been an emotional reunion. "Three times he tried to put his arms round his father's neck, three times the phantom slipped his vain embrace."[23] Nevertheless father and son would have taken time to sit down in the warm Elysian sun to review the many ordeals which Aeneas had endured on his way to Italy. It is possible that on first seeing his son Anchises might have assumed that Aeneas had met his death, possibly during a great battle: normally that would have been the reason for people to arrive in the underworld. Aeneas, however, was clearly very much alive and full of energy, and Anchises would have been astute enough to grasp the purpose of the visit. He had important information to convey to his son, and when he began to speak he chose his words deliberately. With the sibyl standing supportively by his side, Aeneas would learn his destiny and that of twenty-two future generations of his family. Among his progeny would be the future rulers of Rome, a city that at that stage had not yet been founded. Aeneas's head must have been spinning. "Anchises escorted his son and the Sibyl

as far as the ivory gate and sent them through it. Aeneas made his way back to the ships and his friends with all speed."[24] The Cumaean Sibyl would have had a great deal to think about when she returned to her cave that night.

The abrupt end to the account of Aeneas's epic visit to the underworld has troubled more than a few readers of the *Aeneid*. "Aeneas, after his tour with the sibyl, leaves the underworld by the gate reserved for false dreams. The standard interpretation of this strange exit is that Aeneas, being still alive, is not a true shade, but this reading doesn't entirely clear things up, and a little cloud of trouble clings to the image."[25] As he left the underworld Aeneas was still alive, most definitely not a true shade, as is correctly pointed out, but this was merely an objective phenomenon which made him fundamentally different from his father, whose departure from the underworld through any of the available gates would have been totally impossible. Most probably Anchises led his son and the sibyl to that particular exit simply because it was the one closest at hand. The gods would not have organized the layout of their underworld with the possibility of a convenient withdrawal in mind.

The gate Anchises chose might well have been known as the one reserved for false dreams, but if Aeneas was aware of it he does not give any indication that this knowledge slowed him down in any way. Perhaps on an instinctive level he already understood that, in his case, such an ominous designation would not apply, that all the dreams he must have been dreaming as he went through the gate, his brain teeming with the images of glory that his father had planted in his imagination, would ultimately not turn out to be false, regardless of any warning. Any other outcome would have negated the sincerity of his father's revelations and the sibyl's own prophetic powers. The inescapable and most significant detail

about Aeneas and his departure from the Elysian Fields is that every one of his father's prophecies would eventually come to pass, and Virgil's readers, all of them familiar with the history of Rome, would have known that. Perhaps the intended message is simply a reminder that death is not reversible, that everyone who arrived in the underworld would have been forced to stay there forever. Only those who harbored false dreams would have been deluded enough to think they could somehow escape, that they would be able to simply walk away and leave death behind. There would never have been a way out, and any gates that might have suggested otherwise would have been reserved for false dreams. Aeneas, Odysseus, and a handful of others were the only few exceptions history would allow. It could well be that Virgil was just reminding himself and his readers of that fact.

Six hundred years after these stupendous events, the Cumaean Sibyl made the long trip to Rome to meet with King Tarquin, a remote descendant of the man she had led through the underworld so long before. She arrived at Tarquin's palace and must have been brought into the royal audience chamber by a court official who presented her to the king with the prescribed formalities. At the time of her visit the sibyl must have been at least seven hundred years old, and her pressing journey through the vast and dusty coastal plains of central Italy would have left her emotionally spent and physically worn out. Nevertheless she would have cut a dignified and authoritative figure when she appeared in the august presence of King Tarquin and his extensive retinue. It is not unreasonable to suppose that she had taken time to change out of her traveling clothes and do something about her hair. Surely she could not have forgotten the impression that her disheveled appearance had made on Aeneas and his companions all those years earlier when they first turned

up at her cave. Regardless of what she looked like when she made her entrance, what is certain is that her great fame would have preceded her. Every one of the officials and courtiers in attendance to the king that day would have been curious and excited to put a face to a name so well known to all Romans since their early childhood.

Once the customary polite salutations had been exchanged, perhaps the sibyl was offered a glass of wine or other light refreshments; after her long and tiring journey she would have accepted happily. This was the first time she had ever been part of such a grand occasion and, despite her nervousness, she was most likely enjoying the show. In marked contrast to her customary surroundings, the walls of the luxuriously appointed hall would have been lined with rows of imposing marble statues of various gods and goddesses, but she was probably the only one there taking time to look at them or admire all the splendor. The eyes of everyone else must have been focused on the famous old woman who had so unexpectedly landed in their midst. The room would have been buzzing as everyone tried to engage her in conversation. Those who could not get near enough must have been talking about her as they waited for a chance to push through the crowd and approach her. The sibyl, however, would have felt uncomfortably out of her element and she would have been eager to get down to the serious business which had brought her to Rome. At the first available opportunity she would have made her way to the king. We can easily imagine the dense crowd parting silently to let her walk through.

Certainly Tarquin must have welcomed the chance to become acquainted with someone who had actually rubbed shoulders with Apollo and other legendary figures. The sibyl would have been happy to regale him with stories about that encounter and all her many different adventures. A few pleas-

ant moments might have passed this way, with the crowd straining to hear every word she spoke. It must have been the details of her encounter with Aeneas, his illustrious ancestor, that the king would have wanted to hear most of all. Undoubtedly at that point the Cumaean Sibyl was the only living link between the king and his Trojan forebears, and he must have delighted in every revealing detail she could provide. An hour or even two would have easily passed before the sibyl finally started to run out of stories. By then Tarquin must have been wondering exactly what it was that had brought the venerable old woman all the way to Rome. Immediately she would have brought the conversation around to the real purpose of her visit: she reached into her traveling sack and produced nine books of her prophecies. She would have explained to the king that she had taken them with her thinking that he might well want to buy them after having seen them. She would have mentioned a price of three hundred pieces of gold, quite a large sum of money in those distant days. Her sudden proposal must have caught him entirely off guard.

King Tarquin's reaction was quick but clumsily unconsidered: with a complete lack of foresight, he refused the sibyl's offer in a brash and imperious manner. The Cumaean Sibyl had been undiplomatically rejected in front of the entire court. Everyone must have been wondering what she would do next. They probably expected her to meekly accept the monarch's decision, make a quick exit with as much dignity and grace as she could muster, and take her nine books back home to her cave. Her immediate response to this humiliating and completely unanticipated affront, however, would have defied all the expectations of the court. So tremendous was her self-esteem that before the king's very eyes she calmly proceeded to set three of her books on fire. She paused for a

moment to let the flames rise and then, with monumental audacity, she proposed to sell him the remaining six volumes for precisely the same price. Every person there would have been shocked and horrified at the sight of the burning books which only a few minutes earlier had been offered to the king for what amounted to a small treasure.

At that moment King Tarquin foolishly chose to add insult to injury by ridiculing the sibyl for her age and dismissing her savagely as nothing but a raving lunatic. It would appear that he had colossally underestimated both her determination and her amour propre. The woman who had turned down the advances of the handsomest of all the gods and who had literally been to hell and back more than once was not about to be deterred by any man, not even one as powerful as King Tarquin. Once again her reaction was as immediate as it was completely unexpected, and three more of her books went up in flames in front of him. The crowd would have been left speechless but agog with curiosity. While the king watched in disbelief, the sibyl nonchalantly turned her back on the smoldering pile of prophecies and, without saying a word, moved away. The entire episode could not have lasted much longer than twenty minutes. By then clouds of acrid fumes would have spread through the audience chamber, but every single smoke-filled eye would have followed her as she slowly made her way to the door. The curtain had come down on the first act, but the performance would not yet have reached its conclusion.

The sibyl's behavior must have appeared unimaginably irrational to the king, an act of unpardonable lèse-majesté. He would have felt confused if not completely stupefied. Kings were not used to being challenged, most particularly not in public, and he would have needed a little time to compose himself. After the sibyl had left his presence, his first

move would have been to send everyone else away. Only the most trusted courtiers and advisers would have remained behind at his personal behest. They would retreat to a quiet room somewhere in the palace where they could sit in private to consider the implications of the day's events. Probably at first they all would have agreed with the king that he had been right to dismiss an old woman who had behaved in a manner so defiant of all conventional propriety. Eventually, however, they would have got around to a discussion no longer of her actions but of the books themselves, a compilation of prophetic pronouncements which went back a few centuries. The sibyl obviously valued them so highly that she had been willing to destroy them rather than take the chance that they would remain underrated and unrecognized.

Finally all of them together would arrive at the inevitable realization that the Cumaean Sibyl would be perfectly ready to sacrifice everything when pushed to her limits. If her terms were not met, she would have been quite capable of destroying the last three irreplaceable books of her prophecies and this was an outcome that the king and his counselors were not prepared to consider. The next day a royal servant was dispatched to the sibyl with the message that King Tarquin wished to see her once again. She would have arrived at the palace, defiant and uncompromising as ever, for what she must have known would be her final audience with the king. Without a hint of hesitation, she offered him the surviving three books for the same amount she had originally asked for all nine. Tarquin had been expecting her proposal, and this time around he would accept it with alacrity, swallowing his pride and almost certainly breathing a deep sigh of relief. The last of her prophecies had been spared and the sibyl would have gone back to Cumae feeling vindicated, triumphant, and richer than she had ever been in all of her long life.

Michael Wood presents a poignant analysis of a trans-
action whose eventual outcome should have become clear to
everyone the moment the wise sibyl set off from her cave to meet
a fatuous king. "This is a striking cautionary tale, although
I'm not sure whether it's about oracles or money in the first
instance. The most important implication, in the context of
communications and wisdom, is that whatever use the Romans
made of their three books—and they made much, well-
documented use of them, consulting them formally, carefully,
whenever times were bad or unusual events occurred—they
were six books short of the full set. If the emperor had not
been so skeptical (or so stingy) they might have known every-
thing, and ruled the world forever."[26] The intimations of
these provocative lines demand to be considered.

The unassailable reality is that thus far in history nobody
has ever had access to a full set of guidelines to the future,
and consequently that the most we can do is to speculate
about what might have happened if anyone ever had. It could
easily be concluded that if the Romans failed to rule the
world forever it was because they were six books short of the
full set, but if we were to do that then we would also have to
apply the same conclusion to the case of each one of the mis-
guided and blundering dictators sprinkled throughout human
history. The terrifying prospect that if Hitler had only pos-
sessed an extra six books of prophecies to consult at his wan-
ton leisure, he might have decided not to attack Russia and
would have gone on to rule the world forever, is one which
most rational people would prefer not to contemplate.

Matthew the Evangelist wondered why people would
always seem ready to notice the speck of sawdust in their
neighbor's eye while ignoring the wooden beam obstructing
their own vision. Modern thinkers might be ready to denounce
the insufficiency of sources in the past, although in our own

times we have an almost total absence of sources *from* the past. It is true that the Romans possessed only one third of the Sibylline Books, but today we have access to a much smaller fraction of the total corpus of important literary works from antiquity. Almost all of Aristotle's writings were irretrievably purged in the early modern era, and the production of the majority of other classical authors has met with the same implacable fate. These were texts which had influenced Western thought for many centuries, and would still continue to do so in the modern world if only they had not been willfully destroyed. What is left to us from our classical past has to be considered much less than a third of the full set. Heraclitus was right to observe that nothing endures but change.

In a complete reversal of his prior indifference, King Tarquin celebrated his acquisition by commanding a great public ceremony to be held in Rome. It is doubtful that the Cumaean Sibyl ever heard of all the fuss that was being made over her books, but if any reports actually managed to reach her in her cave she probably would have chuckled with gleeful satisfaction. Excited crowds would have watched the formal procession that conveyed the three surviving Sibylline Books to the Temple of Jupiter Optimus Maximus on the very summit of the Capitoline Hill, the nucleus of Roman power. It was in this exalted place, the most important shrine in all of the Roman Empire, that the prophecies of the Cumaean Sibyl finally came to rest under guard, exactly as Aeneas had promised to her when he had first shown up at her cave six centuries earlier. It had taken a very long time for his pledge to be fulfilled, but at last her books had arrived at what was to be their final resting place. It is documented that they remained there for more than four hundred years until they were devoured by the great fire which obliterated the temple eight decades before the beginning of the Current Era.

Access to the Sibylline Books was a privilege which had been very strictly controlled. As long as King Tarquin remained alive he would have held the right to appoint the guards who kept constant watch over them. The scholar David Stone Potter gives a clear account of the process as it gradually developed. "The oracles themselves were consulted by a board of priests who acted on the orders of the Senate. In the earliest period this was a board of two patricians, in 348 BC it was expanded to a board of ten (five patricians and five plebeians) and in the first century the college was expanded to fifteen. Membership of this board, the *quindecimviri sacris faciundis*, was one of the most cherished positions in the state."[27] An approximate translation of the Latin designation might be "the fifteen men in charge of devotions." Exactly as this grandiloquent title suggests, this was a prestigious public office, but by no means a simply honorary one. For their trouble all of the fifteen men were excused from any other civic obligations. Writing in the fourth century, the Christian apologist Lactantius explains that the Sibylline Books were classified as "Roman state secrets and no one has the right to see them except the *quindecimviri*."[28]

In normal practice the books were not disturbed unless serious and pressing matters would demand their examination. Potter offers the example that "at the end of the consular year 218/7 BC Livy records that there were a number of prodigies which he says caused great excitement and that the rites which the Sibylline books ordained greatly eased popular concern. They were consulted again when a great number of prodigies were reported at the beginning of the next year."[29] It was generally understood that these unusual events served as warnings or, if not, signals of how the gods felt about humanity. Cicero offers a long list of examples of

these prodigies: the sighting of several suns or moons or the appearance of the sun at night, meteors or breaks in the sky, landslides or earthquakes. "After all of these prodigies which warned the citizens of Rome about wars and revolutions, the response of the diviners would be in agreement with the Sibylline Books."[30] Whenever it was found advisable and necessary to consult the sacred writings only the *quindecimviri sacris faciundis* were believed to be qualified to understand them and to properly interpret the meaning of their message for the welfare of their fellow Romans.

However the clarification of sibylline pronouncements was not their only duty. In addition to that infrequent task, each one of the men was held personally responsible for making certain that the secrecy of the books would never be violated. On one occasion the shocking discovery was made that a member of their group had illicitly made a transcription of a few portions of the sacred writings and this transgression was considered so heinous and vile that he received the death penalty. While still alive the condemned man would have been thrown into a sack which was then stitched closed and transported all the way to the coast to be unceremoniously dropped into the deep waters of the Tyrrhenian Sea. This was a brutal and excruciatingly prolonged type of execution which customarily would never have been inflicted upon anyone except those who had murdered their parents or committed the most monstrous criminal offenses against the state. All the deferential awe and mysterious secrecy that surrounded the Sibylline Books in the classical world would certainly have contributed to the respect accorded not only to their authority but, by extension, also to the figure of the Cumaean Sibyl.

The stories of her legendary association with Aeneas and her masterful handling of King Tarquin would have

remained in continuous circulation at every level of Roman society for many generations. Almost certainly it would have been the picaresque nature of her exploits, together with the canonical status granted to her prophetic pronouncements, that served to promote her prestige among the general population of the ancient world. Although these factors must have continued to play an important role in sustaining her reputation, it would be above all to the few words Virgil wrote about the Cumaean Sibyl in his fourth *Eclogue* that the greatest credit must be given for the survival of her name and authority into modern times. Not surprisingly, these have been called the most widely discussed and intensely analyzed lines in all of Latin poetry.

Virgil was born a decade after the destruction of the Sibylline Books and he composed his series of ten pastoral poems when he was in his mid-thirties, a generation before the beginning of the Current Era. The *Eclogues* or *Bucolics* are the earliest of his known works, predating the *Aeneid* by about ten years. The fourth of the *Eclogues* is an account of a shepherd's prophetic vision concerning the imminent dawn of a golden age. The beginning of this optimal phase of human history would be marked by the appearance in the world of a miraculous boy whose birth would be ordained by the gods and who would himself come to be recognized as divine. Virgil's shepherd describes this new era that at any minute would begin on earth. Justice would return and humanity would be freed from the wickedness of the past. Eventually this child would come to rule together with his divine father over a world finally at peace. The poem ends with the shepherd's keen exhortation to the boy to commence his reign at once. "Oh baby boy, begin!"[31]

The similarities between this story and the Christian narrative are too striking to have escaped the notice of any

post-pagan reader. The divine child in the fourth *Eclogue* would soon come to be seen as a definite prefiguration of Jesus Christ, while the shepherd in whose voice the poet speaks, and who persistently urges his companions to befriend this exceptional child, was perceived as clearly foreshadowing the character and life of John the Baptist. In spite of the numerous references in the poem to pagan deities like Saturn, Apollo and Jove, many exegetes, most particularly those in early Christian times, would come to the conclusion that Virgil's fourth *Eclogue* was nothing but an inspired prediction of the birth of Jesus the Savior and the promised coming of the Kingdom of God.

It would seem only reasonable if the scholars who have given their support to these interpretations at the same time would have acknowledged Virgil as a prophet in his own right; most curiously, however, that has not been the case. It has been instead the Cumaean Sibyl to whom the full prophetic vision recorded in the fourth *Eclogue* has been traditionally ascribed. Virgil's role had been reduced to having merely written down the sibyl's words. The line which delivers the most convincing endorsement of the sibyl appears to be "the final age foretold in Cumae's song has come."[32] It was concluded from this straightforward proclamation that the visionary scenes immediately following it had been divinely revealed to the Cumaean Sibyl, who had subsequently shared them with Virgil. It was decided that the poet's only function had been to record her revelations. The fourth *Eclogue* would come to be considered quite literally the sibyl's song.

Saint Augustine, writing about these matters in the fourth century, was among the earliest Christian authors to wholeheartedly adopt this point of view. In *The City of God* he maintained that "Virgil himself indicates that this verse

had not been his own invention."[33] With Saint Augustine's support the stage was set for the Cumaean Sibyl's elevation to the hallowed rank of a Christian prophet. Within a short time the apocryphal *Sayings of the Great Sibyl* would appear in circulation to enhance her new standing. A thousand years later Boccaccio expressed his conviction that her gifts had come to the Cumaean Sibyl not at all from pagan sources but directly from the one and only God. It had been her chaste nature "that earned her the light of prophecy from that true Sun which enlightens everyone who comes into this world. Thanks to this gift, she predicted and described many future events."[34] In Boccaccio's view, the authority and respect that the Cumaean Sibyl rightly commanded were not due just to her visionary pronouncements but in fact to her exemplary virtue. By that stage her apotheosis would have been complete.

At the end of the day we are left with the disconnected pieces of a large puzzle. "Sibyl-stories show us a knowledge that was perfect in its original condition but is now lost or broken, a matter of fragments or remnants."[35] It is only through such fragments and remnants that we can try to make sense of the life and activities of the Cumaean Sibyl, a woman of seemingly irreconcilable attributes. She has managed to be remembered both as a terrifying pagan seer and as a gentle proto-Christian prophet. In her dealings with Apollo she chose to be a coquettish tease, but when her negotiations with King Tarquin demanded it, she would prove to be just as capable of becoming a calculating, manipulative and hard-driven businesswoman. Above all else, she must have possessed an extraordinary degree of personal magnetism. At different times authors of such significance as Virgil, Petronius, Ariosto and Boccaccio were all drawn to her story. One attribute she certainly must have had in great abundance

was the ability to draw a crowd. Even as late as the twentieth century figures of such divergent interests as Roberto Rossellini and T. S. Eliot would become intrigued by the details of her life. Ultimately this mutating image becomes a tentative but perhaps not entirely inappropriate reflection of what can only be surmised to have been her personality and singular achievements, at least as far as it is possible to single them out. The Cumaean Sibyl has been frequently called prophetic, but not even once has she ever been found predictable.

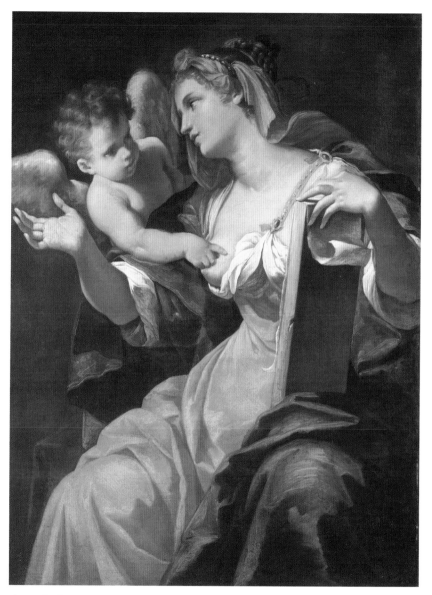

The *Budrioli Sibyl* by Lorenzo Pasinelli, second half of the seventeenth century.

The Pérez-Simón Collection, Mexico City.

This scene of a sibyl assisted by her attendant illustrates the strength of both her physical attraction and her mental acuity. The putto points to a passage in the book but she corrects whatever observation he has made, gently but nonetheless with her usual discernment. The dual nature of a sibyl's magnetic presence and unquestionable authority is made quite clear.

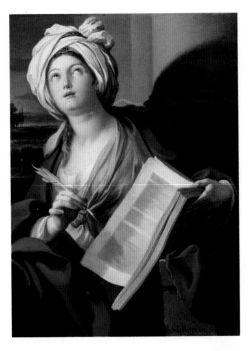

A Young Sibyl by Sebastiano Conca, early eighteenth century.

The Museum of Fine Arts, Boston.

We come upon a sibyl at the moment the god speaks to her. She looks up to heaven, the source of her revelations, and holds a quill pen as she debates whether to write down what she hears. Her turban adds a touch of exoticism to the scene. The artist has portrayed her as a fey romantic heroine: ethereal, otherworldly, and as bewildered as we are by what is happening to her.

The Erythraean Sibyl by Michelangelo, early sixteenth century.

The Sistine Chapel, Rome.

The totally self-possessed image of the youthful but supremely confident Erythraean Sibyl is quite possibly the result of her status as the earliest among all the sibyls. She might have witnessed at first hand the Greek fleet sailing north along the coast of the Aegean Sea on its way to fight the Trojan War; reports survive that she accurately foresaw their ultimate victory.

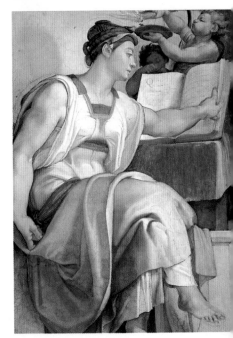

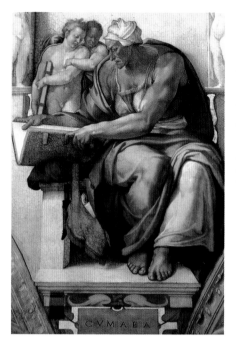

The Cumaean Sibyl by Michelangelo, early sixteenth century.

The Sistine Chapel, Rome.

The hardened features of her aquiline nose and jutting jaw, the titanic proportions of her muscular arms, and the toughened skin on her sinewy shoulders all combine to make the image of the Cumaean Sibyl almost frightening as a concentrated expression of power. Here is a woman who had been to hell and back more than once during the course of her long lifetime.

The Delphic Sibyl by Michelangelo, early sixteenth century.

The Sistine Chapel, Rome.

In one of the most famous images in Western art, Michelangelo depicts the Delphic Sibyl as a young woman holding a long scroll where the revelations from the god had been inscribed. Her pale blue eyes, however, are unexpectedly cast in the opposite direction. This enigmatic sidelong glance might well indicate that she knew the beginning of a new age was imminent.

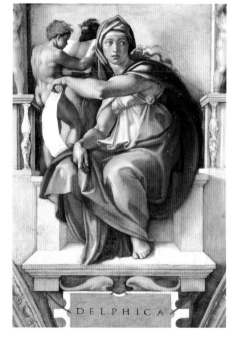

The Cumaean Sibyl Leading Aeneas Through the Underworld by Jan Breughel the Elder, early seventeenth century. *Private collection, courtesy of Johnny van Haeften Ltd, London.*

In this scene of their journey to find his father's spirit, Aeneas appears to be guiding rather than following the Cumaean Sibyl as they go through the underworld. She warned him that getting there would be easier than going back. Monsters surround them as they tread a rocky path while the red glow of an erupting volcano adds a sense of urgency to their mission.

The ruins of the Temple of Apollo at Delphi.

By courtesy of the Greek National Tourist Office.

Today just a few fallen blocks of marble survive as a reminder of its former glory, but for many centuries the oracle of the Delphic Sibyl was regarded as the most trusted religious institution in all of the classical world. Only the mountainous surroundings have remained as they must have been when the traveller Pausanias described Delphi as "a steep slope from top to bottom."

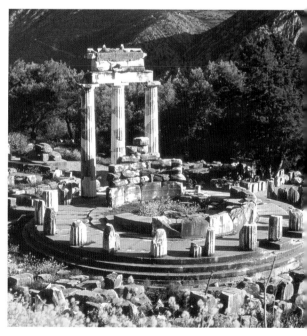

The Meeting Between the Tiburtine Sibyl and the Emperor Augustus by Antonio da Trento after Parmigianino, first half of the sixteenth century.

Summoned to Rome by her emperor, the sibyl led him outdoors to feast his eyes on the miraculous sight of the infant Jesus resting in the lap of His Virgin Mother. At once he realized the meaning of the vision and rendered homage to the baby. The scene of a mighty emperor being humbled by a newborn child ignited the imagination of the Christian faithful.

The Waterfalls at Tivoli by Claude-Joseph Vernet, early eighteenth century.
The Cleveland Museum of Art.

Anyone coming upon the dazzling sight of the majestic cascade would have been struck by a formidable natural force which somehow transcends its own overwhelming physical expression. From the earliest antiquity the falling waters were perceived as the dwelling place of a mighty spirit and the ultimate source of the Tiburtine Sibyl's prophetic powers.

The *Apollo Belvedere*, a Roman work probably after a Greek prototype dating from the fourth century BCE and attributed to Leochares.

Pio-Clementine Museum, Rome.

The god originally held a bow in one hand and an arrow in the other as he prepared to fight the Python of Delphi. The killing of the monster marked the beginning of Apollo's predominance at the oracle and the period of its greatest glory. Until Nero sacked the city many similar artistic treasures embellished Delphi's temples and treasuries.

THE DELPHIC SIBYL

> *She whirled through the empty spaces, knocking down*
> *the tripod that stood in her way and seething fiercely*
> *with inward fire as she bore the terrible force of*
> *Apollo's fury. He not only goaded her and whipped*
> *her, and darted flames through the inward parts of her*
> *body, but also he curbed her: knowledge was given en-*
> *tire, but not the permission to divulge all that she*
> *knew. All time was crowded together, the ages weighed*
> *on her tortured breast, and all events in the future*
> *struggled towards the light, as destinies vied with each*
> *other striving for utterance. Nothing was absent, not*
> *the beginning, not the end of the world.*

<div align="right">MARCUS ANNAEUS LUCANUS, Civil War</div>

In this passage of nearly overwhelming intensity, the Roman poet Lucan presents a vivid description of the moment when the god Apollo takes ritual possession of one of his high priestesses at his oracle in Delphi. The effect which the god has had on the woman's mind is made immediately clear: she has been given limitless knowledge but at the same time she has been denied the freedom to divulge it in its totality. Over the course of history other women too numerous to fathom would have faced similar and equally frustrating circumstances in their own private and professional lives. Meanwhile the frenzied god is in command of the priestess's

body as much as he is in absolute control of her mind. Before sharing his prophetic vision with her, Apollo would have aroused her physically by teasing her and spanking her, and after she had become hopelessly out of control and was literally knocking into the furniture, Lucan reports in a stunning metaphor that the god released burning darts inside her body. The inescapable erotic allusions, flagrantly graphic and explicit as they are, should not shock even the most prudish or sensitive of readers given the fact that a fair number of her fellow priestesses at Delphi would have considered themselves permanently wedded to the god.

In almost every recorded instance, the relationship between Apollo and the different women he periodically selected to act as his spokespersons or channels was highly physical and openly sexual: in his case bodily and spiritual communion would appear to have been inseparable. Walter Burkert observes that definite sexual overtones would be found in the god's dealings with the Trojan prophetess Cassandra and that "there are hints of a similar relationship between the Pythia and Apollo, even if it was only Christians who first elaborated this with sexual details."[1] Despite a firmly established connection between intellectual and sexual knowledge which can be dated all the way back to the story of Adam and Eve, the early followers of Christianity had already started to show signs of their unease in dealing with any issues having to do with sexuality. Nonetheless "wisdom comes with age" has been an accepted adage for countless generations and, if the premise it offers can be acknowledged, then sexual awakening would logically be accompanied by the emergence of mental and prophetic powers. At Delphi the principal priestess would be chosen from a group of experienced matrons; notwithstanding their maturity they would have been required to appear in public wearing the clothes normally seen on young maidens, most likely in an attempt

to perpetuate the absurd fantasy that only girls of tender years would be able to attract the god's attention and receive his messages.

Whatever had been a priestess's age, the altered physical and mental state described so expressively by Lucan would never have surprised either those who were there to witness it at first hand or the others who would hear about it at some later time. Everyone in Delphi would have expected the priestess "to enter into an abnormal condition of trance for the purpose of uttering her oracles."[2] Wild but hardly uncontrolled fits of frenzy were part of a complex ritual which had gradually developed over many generations; by the time of Lucan's account they would have been followed with unchanging predictability and strict formality. The frenzy was undeniably real but it had been deliberately provoked, and all the participants and spectators would have been fully aware of it. Somehow everyone shared the conviction that the trance had been induced by the god for his own purposes.

Burkert remarks that "the words which the Greeks use to describe such phenomena are varied and inconsistent. An ancient name and interpretation for an abnormal psychic state is *entheos*: 'within is a god,' [one] who obviously speaks from [inside] the person in a strange voice or in an unintelligible way."[3] The word *entheos* is almost like a sign on the side of a busy highway, a warning to look out for something which, if we were to ignore, we would do so at our own risk and peril, something we need to notice and understand with care because it can alter the course of what is about to happen next in our lives. *Entheos* is the condition leading to *enthousiasmos*, "itself a form of suffering, a kind of spiritual rape."[4] The Greek word has obviously given us *enthusiasm* in English, which the Oxford Dictionary defines

quite simply as 'intense and eager enjoyment.' There is an alternative meaning, now considered archaic and derogatory, which all the same remains much closer to the Greek. It would appear that at one time the modern word could also be applied to a form of 'religious fervor supposedly resulting directly from divine inspiration, typically involving speaking in tongues and wild, uncoordinated movements of the body.' With his customary authority Burkert brings the discussion to an end by deciding that "the most common term is therefore *mania*, frenzy, madness. Frenzy is described as a pathological outburst provoked by the anger of a god."[5] From the evidence at hand it would appear that the oracle of Apollo at Delphi had been witnessing the anger of one god or another since the very beginning of recorded history.

The city which would become known as Delphi was built on the undulating southern slopes of Mount Parnassus. Pausanias complains that the steep road leading to it "gets more precipitous and becomes difficult even for an active man."[6] Despite the arduous terrain, the city nonetheless enjoyed a location as prime as could be found anywhere in the classical world. The protected waters of the Gulf of Corinth lay a few kilometers to the south, offering immediate access to the Ionian Sea and from there to the whole of the Mediterranean world. The city of Corinth, whose population in the early modern era was five times larger than that of Athens, was just on the other side of the gulf. The two, perhaps even three epistles Saint Paul wrote to the early Christian community at Corinth serve as evidence of that city's cosmopolitanism and multicultural diversity. Directly to the north of Delphi was the mountain itself, today the site of a popular ski resort but in ancient times covered in fertile groves and dotted with picturesque valleys.

Lying to the southeast of Delphi was another massive

peak, Mount Helicon, where the notoriously demanding Muses had chosen to take up residence. In antiquity these figures from Greek mythology were universally considered the eternal sources of artistic inspiration; significantly all nine of them were women. Each one had a singular area over which she extended her personal influence: Calliope was in charge of epic poetry, Clio had history as her preserve, Erato was the Muse of love poetry, while Euterpe looked after the musicians. Melpomene was the Muse of tragedy and Polyhymnia's sphere of influence extended over the production of sacred hymns. Terpsichore graciously took care of dancers and Thalia did the same for comedians. Urania was the Muse of astronomy, an area of human endeavor very highly respected in ancient times. The Greeks believed that the creative influence of all the Muses would be broadcast to the world from Mount Helicon where they lived in splendid isolation. In spite of all these fancy neighbors, the reputation of Delphi would be due not to the nearby Muses but rather to its traditional association with the god Apollo and his bucolic nymphs, creatures who had some claim to superhuman status and regularly mated with gods but who were themselves not entirely divine.

Pausanias reports that the "most ancient city here was built by Parnassos, the son of the nymph Kleodora. They say that the mountain and the Parnassian valley were named after Parnassos. The story is that Parnassos discovered the art of divination from the birds flying there."[7] The modern observer could be forgiven for thinking that the entire Greek population at that early period of their history must have considered every bird they spotted flying overhead to be a type of messenger pigeon carrying a small packet of divine revelations. The suggestion that the first people to settle in Delphi had been taught about prophecy by the indigenous

avian population is strongly evocative of the early myths surrounding the foundation of the oracle of Zeus at Dodona. The connection between the wild birds on Mount Parnassus and the doves in the oak grove at Epirus would appear too conspicuous to be merely coincidental, particularly if we consider that the similarities in the early history of both oracles do not stop with the winged soothsayers. It would appear that at Delphi, just as had been the case at Dodona, the oracle had initially been consecrated to Ge, the first name ever given by the Greeks to the eternal and omnipresent Earth Mother. "Such has been the strength of the tradition that many historians and others have accepted as historical fact the ancient statement that Ge and Themis spoke oracles at Delphi before it became Apollo's establishment."[8]

At some moment in its early history, the Earth Mother must have graciously consented to share her oracle with the god of earthquakes, water sources and underground streams, who inconveniently bore the same name as the figure much better known in later Greek mythology as the god of the sea, Poseidon.[9] This particular Poseidon was annoying in other ways. The Earth Mother was happy to do all of her own prophesying, but the vain Poseidon must have felt that the task was somehow below his dignity since he delegated it to one of his servants. The reliable Pausanias offers an illustration of the way power was shared between the two deities in those early days of the oracle. "Then the voice of the Earth spoke her wise words, and Pyrkon, the servant of the glorious, Earth-shaking god, spoke with her. Some time later they say Earth gave her share to Themis."[10] The beneficiary of this generous gift was her daughter, the goddess in charge of law and divine justice, who continued her mother's oracular practice without a break.

By that stage the oracle had become notorious as the

hiding place of a horrifying creature, variously described as either a serpent or a dragon, but generally known simply as the Python. The dreaded monster lived in an underground cave next to the sacramental Castalian Spring and from this convenient vantage point it would have kept an eye on everyone passing by on the way to the sanctuary. A stop at the Castalian Spring was required of all travelers who arrived in Delphi: before being allowed to approach the oracle, each visitor was expected to undergo a ritual cleansing in the sacred waters. In most instances a simple dunking of the head would be enough, but in the case of those guilty of serious offenses a more thorough full immersion would have been demanded. Pausanias reports that in spite of all of these ablutions, the water from the spring surprisingly managed to retain its delicious taste.

Some ancient sources offer the explanation that the Python was probably another one of the Earth Mother's many children and that originally it had moved into its lair at her personal command and only in order to protect her oracle.[11] With the passage of time the creature's presence would turn into such an established part of local lore that its name eventually came to be attached to the place itself, replacing the name of *Krisa*, which had been in use at an earlier stage. From then on and for a long time to come the sanctuary on Mount Parnassus would be generally known as *Pytho*. By a remarkable coincidence the later change of name from *Pytho* to *Delphi* would be the result of an unexpected association with another type of animal, the dolphin. The fierce Python would eventually be killed but its memory never entirely disappeared from Delphi. For the rest of the oracle's long history, the chief priestess in attendance would continue to be known as the *Pythia*. To this day the French use the silky word *pythonisse* to denote a woman prophet or diviner.

It would seem to be the case that humanity's most frightening monsters somehow manage always to occupy a haunting corner in our communal memory.

Apollo arrives on the scene for the first time at the head of a group of men in search of the Python. The god had been born on the island of Delos along with his twin sister, the goddess Artemis. The two had been the product of the adulterous union between Zeus and the Titaness Leta. The jealous goddess Hera viciously persecuted Leta over the entire world until the heavily pregnant woman finally found refuge in Delos, where she managed to give birth in relative peace. Artemis was the first to come forth and nine days of difficult labor followed before at last Apollo was born. By that point Artemis had become sufficiently mature to assist her mother at the birth of her twin brother. These divine offspring of Zeus grew up with an extraordinary degree of speed and efficiency. After merely a few days on earth the infant Apollo had already reached young adulthood, and at once he had become impatient to get away from the tedious provincial routine of life on a small island. His imaginative solution was to turn himself into a dolphin and swiftly make a watery escape. However a mighty wind unexpectedly blew up over the Aegean Sea, and in the ensuing storm Apollo noticed a boat struggling to stay afloat. Still bearing the form of a dolphin, he jumped onto the deck and directed the men safely to shore. To what must have been the total astonishment of the grateful crew, directly after making landfall the god shed his disguise and resumed his normal aspect. Faced with such a striking demonstration of his divine powers, at that point the men would have followed Apollo anywhere.

Without delay they set off on their way to Pytho, where they managed to trace the monster to its lair. It would have been clear to the god that his predestined mission was to kill

the Python. Just at that moment Apollo would have been less than a month old, but nonetheless we can suppose that he would have done his duty with at least some degree of the remarkable grace and aplomb for which he would later become renowned in the ancient world. The very first arrow ever shot by the young god miraculously managed to strike the Python directly in its heart. Apollo's followers were deeply impressed and without a moment's hesitation decided to stay with him on Mount Parnassus. For many generations to come the priests at the oracle would claim direct descent from this motley band of nameless Aegean adventurers.

When Themis was told about the slaying of the Python she immediately agreed to cede her half share of the oracle to Apollo. Pausanias points out that at this juncture "no record goes back to any other man, only to prophetic women."[12] Nevertheless the god still had to find a way to get his hands on the other half. He had received "Themis's share as a gift, but he gave Poseidon the island of Poros off Troizen in exchange for this oracle."[13] The glaring inequality of the trade must have been obvious even to Pausanias. The deal may not have been exactly fair, but it was definitely advantageous to the ambitious new arrival. His uncle and predecessor at the oracle had been dispatched to a small and insignificant island, a remote outpost where he would never offer any interference or even less present a threat. The name *Pytho* was supplanted by *Delphi* in recognition of the fact that Apollo had first arrived on the mainland while still bearing the form of a dolphin: the word for *dolphin* in ancient Greek is *delphis*. However an alternative etymology has been suggested for the oracle's new name. The word *delphys* might look very similar, but it means *womb*. If this were to be the correct source, then the name of the oracle would logically relate to the figure of the Earth Mother and not at all to the

dolphin, which would certainly suggest much greater antiquity. Whatever the antecedents may have been for its new name, the oracle was about to begin the period of its greatest splendor. "For a thousand years of recorded history the Greeks and Romans, sometimes as private individuals, sometimes as official ambassadors, came to Delphi to consult the oracle."[14]

Once Apollo had achieved complete supremacy at his new sanctuary he began to leave his personal mark on it. The touching story of Apollo and Daphne lies at the root of one of the most enduring traditions which would eventually gain currency at Delphi. In his *Metamorphoses* the poet Ovid relates the legend of the unfulfilled love the god had once felt for a young and very beautiful nymph named Daphne. The Greek word *daphne* actually means *laurel* or *bay laurel*. In an attempt to avoid Apollo's persistent advances, Daphne ran into a forest where her father, who knew of her distress, contrived to turn her into a laurel tree. The god was left frustrated and heartbroken at the foot of an inarticulate sapling that only moments before had been the object of his infatuation. With sincere regret and in the deepest sorrow, Apollo used his sword to cut off a single slender branch which he then tied securely around his brow as a tender memento of his beloved nymph.

Laurel leaves, on their own or shaped into wreaths inspired by Apollo's example, would gradually come into such widespread use at all stages of the sacred rituals in Delphi that it became necessary to plant a grove of laurel trees somewhere not too far from the city. By some accounts Apollo himself is given credit for being the first to cultivate laurel in Parnassian territory. It is said that the small sprig the god would plant at Delphi had been part of the laurel wreath he had crafted with such loving care after Daphne's unexpected

metamorphosis. The Delphians would tell their visitors that the first temple to Apollo had been built from laurel branches. In an amusing aside Pausanias comments that "this shrine must have been in the form of a hut."[15] Images of the god dating from ancient times nearly always show him wearing his laurel wreath; for the Romans, a wreath like Apollo's would become a symbol of victory. During the Renaissance it became a mark of great achievement: revered authors on the level of figures like Petrarch and Dante were regularly shown wearing one. The significance of laurel wreaths continues to be acknowledged in the modern world, and winners of the Nobel Prize are quite frequently identified as *Nobel Laureates*.

Apollo's oracle at Delphi would eventually come to be regarded as the most trusted religious institution in all of the classical world. This success story was almost certainly due as much to the god's prestige as to the parallel presence of a sibylline sanctuary at the site. Many students of the historical practice of prophecy have insisted on making a categorical distinction between the Delphic Sibyl and the Pythia. Despite these attempts, it is difficult to imagine that two prophetic women would have been active for generations at the same location, both drawing their inspiration from the same god, and yet still manage to avoid any type of collaborative activity. According to Charles Kahn, "the institution of ecstatic prophecy had been established at Delphi in the person of a regular priestess, the Pythia. We may think of the Pythia as a kind of sedentary Sibyl, a holy woman who has become a fixed appendage to a particular shrine. Whatever the historical connections may have been between the Pythia and the Sibyl, they represent prophetic phenomena of the same type."[16] The logic behind Kahn's conclusion cannot be disputed.

It is principally as a result of the high social, financial

and intellectual level of the pilgrims drawn to the oracle of Apollo at Delphi that any records at all have been kept about its activities. There are reports that Homer, Pythagoras and Herodotus all made the trip there, as did a great number of political dignitaries and at least two emperors. Plutarch actually lived in Delphi during the few years he spent as the chief priest at the temple. Such a distinguished roster of visitors would be the reason why so many details have been preserved about the regular practices of the Pythia. Because important people would have been expected to leave behind generous offerings, their regular presence at Delphi would also help explain the considerable wealth which would gradually accumulate in the city's treasuries.

In striking contrast to all the glamour surrounding the Temple of Apollo and its multiple attendants, almost nothing is known about the habits of the Delphic Sibyl. This almost complete absence of any historical material to document her activities has appeared to suggest, at least to some observers, that the Delphic Sibyl and the Pythia are likely to have been one and the same figure. "Both the Pythia and the Sibyl are women who serve as 'mediums,' who see the future in a trance experience, in the superhuman vision of the god. It is the woman's voice that speaks, but it is Apollo's word that is uttered."[17] Once we accept the fact that both women acted as channels for the same deity, then unavoidably we need to wonder why Apollo would have thought it wise or even necessary to use two different women living in the same place at the same time but with separate sets of vocal chords to proclaim his message. Perhaps he did not trust either one of them to get it right; it is much more likely that he was sexually involved with both of them.

The tacit duality of her identity is masterfully reflected in the representation of the Delphic Sibyl that Michelangelo

presents to us on the ceiling of the Sistine Chapel. Her stand-
ing among the other sibyls is quite clearly acknowledged by
the fact that Michelangelo placed her prominently close to
the main entrance, where everyone who came in would see
her image directly on arrival. He depicts her as a young
woman of strikingly beautiful features seated uneasily on a
plain marble bench. "She is close to us because of her surprise
and remote from us because of her calm."[18] The blue mantle
softly framing her perfect oval face evokes the garb of the
Virgin Mother. Under her expansive garments the precise
form and scale of her surroundings are almost totally con-
cealed; however it is evident that she and not the architecture
should be the focus of our attention. The sibyl is shown
holding a long scroll, but she is plainly not about to start
reading it because her pale blue eyes are cast expectantly in
the opposite direction. Behind her is the traditional pair of
attendant putti who would have been there to assist her with
her demanding and time-consuming work. One of the boys
is busy consulting a large book with vivid intensity, while his
companion looks over the edge of the pages in a puzzled and
inquisitive manner.

Michael Wood reflects that the responses the Delphic
Sibyl habitually offered would "include silent or implied
questions and silent or implied answers."[19] It is the haunted
look in her eyes which amply suggests this perplexing ambi-
guity. A suitably enigmatic illustration of her cryptic state of
mind is given by the story that at some point during the
fifth century BCE, a distinguished Athenian visitor named
Chaerephon asked the sibyl whether anyone alive was wiser
than Socrates; her snappy comeback had been a single mono-
syllabic negative. "When the answer was transmitted to
Socrates he, predictably, did not take this simple answer for a
simple answer. He said, 'I wonder what the god meant.' Did

Socrates think there was something confusing about the word *no*? No, but he did think that even the word *no* could be the start of a conversation, and more generally that even unequivocal monosyllables are signs—rather than emphatic speech or unbroken silence—and that signs have to be interpreted."[20]

There is definitely something of a helpless uncertainty about Michelangelo's Delphic Sibyl. The young woman "is not reading but staring out at the world. Even so, she is not staring at us, but away toward our right, as if aware of something approaching."[21] Her apprehensive sidelong glance would be interpreted by dedicated Christian exegetes as the unequivocal confirmation that the sibyl knew exactly what the nature was of whatever it was that was approaching. This has to be the moment when she recognizes that the hollow voice of the god who had always spoken through her would never be able to reveal the ultimate truth about the future of humanity. Certainly for Michelangelo and his powerful papal patron, the fundamental reason why the Delphic Sibyl ignores both the book behind her and the scroll she holds in her left hand could only have been that she was in possession of a full awareness of the imminent beginning of a new age. None of the ancient volumes of traditional pronouncements would ever have given her that knowledge, and much less the dusty voices that continued to whisper archaic messages in her ear. Yet still the sibyl in some way must have known that the Savior was on his way. It is only her precognition of the coming Kingdom of God that can justify the presence of her image among a group of trusted Old Testament prophets on the vaulted ceiling of a papal chapel.

The festival that would come to be known as the Pythian Games was held every four years to commemorate the slaying of the Python by Apollo. Three other sets of panhellenic festivals would come to be held in ancient

Greece, but of the four only the Olympic Games have been revived in modern times. The great popularity of the Pythian Games would become another reason for the great prestige enjoyed by Dephi throughout the ancient world. To most observers in postclassical times, Apollo's role as patron of the arts has always been one of the most appealing manifestations of his various powers. The god displayed a particularly keen fondness for music, an endeavor which by all accounts he considered his own personal domain. Along with the laurel and the tripod, the lyre was considered one of the attributes normally associated with him. Apollo's tremendous skill in playing this instrument was so well known by everyone in antiquity that Orpheus, who had the power to charm even the wildest of animals with his music, was generally believed to have learned this instrument directly from the god himself. In view of Apollo's known predilection it should not be surprising that the earliest Pythian Games were devoted not to athletics, as might easily have been expected, but to musical competitions. Pausanias confirms that "the most ancient contest the Delphic people remember and the one where a prize was first offered was for singing a hymn to the god."[22] In view of this fact it would be only reasonable to acknowledge the Pythian Games as the first example of what has by now become the fashionable tradition of European music festivals.

It is not at all the purpose of this study to discuss the traditional role of musical expression in the context of religious liturgies: this is an engrossing but highly complex subject which has been studied by many learned specialists. All the same it might be relevant to consider very briefly that the presence of music at Delphi would have had venerable antecedents. Burkert makes reference to an interesting connection between musical and oracular practices. "The Greeks

seem to have discovered ecstatic cults connected with flute music in northern Asia Minor."[23] It is significant that this particular corner of Anatolia is the place where many scholars believe Apollonian cults had first developed. According to one of the various ancient accounts of the founding of Delphi, the god had arrived not from Delos but "from the remote North."[24] Northern Asia Minor would have seemed remote indeed to someone living on Mount Parnassus. Evidently the connection between Apollo and music had been firmly established for a long time before the first Pythian Games were to get started.

One musical contestant at Delphi who would attain extraordinary renown was an able flautist named Sakadas. His standing as the first known virtuoso performer in the history of Western music cannot be challenged, obviously excluding mostly mythical figures like Orpheus. In one of his generous and invariably informative footnotes to his translation of Pausanias, the classical scholar Peter Levi discusses the music Sakadas composed and would have played at one of these competitions. "His Pythian tune was a bare, early version probably for dancing, of the fight of Apollo with the dragon, the Python of Delphi. An elaborate and fascinating later version which included trumpets and fifes and imitated the whizzing of arrows and the god's triumphal procession is described by Strabo. Sakadas's tune already had five movements."[25] We must not fail to keep in mind the mind-boggling fact that Professor Levi is describing program music written almost three thousand years ago. Sakadas must have been the Beethoven of antiquity. There can be no doubt that he fully deserves the lasting fame he has attained.

Nevertheless athletic events were eventually introduced as part of the competitions at Delphi. Pausanias reports that "the same Sakadas won again at the next Pythian games, and

again at the next. This was also the first time they gave prizes for athletes."[26] Every winner at the Pythian Games was fittingly honored with a wreath made from laurel branches freshly cut in Apollo's sacred grove. "The crown for a Pythian victory is a laurel wreath, so far as I can see because of the legend that Apollo was in love with Daphne."[27] In great detail Pausanias then chronicles the successive inclusion of various athletic events at Delphi. "In the twenty-third games they added a race for men in armour; Timainetos of Phlious won the laurel for this Olympic series after Damaretos of Heraia. In the forty-eighth Pythian games they established a race for chariot and pair; Exekestides of Phokis won. Four games later they ran foals in harness; the team that won belonged to Orphondas of Thebes. Many years later they took over from Elis all-in fights for boys, pairs of foals in harness, and racing with ridden foals: the all-in fights started in the sixty-first Pythian games."[28] The ancient Delphians definitely kept punctilious records.

Almost certainly at some point during their stay all of the contestants would have felt at the very least a mild compulsion to pay their respects to Apollo and the Pythia, even if only out of simple curiosity. The oracle at Delphi was undeniably the best-known tourist attraction in all of Greece, as popular in the classical world as the Sistine Chapel has proved to be in modern times. It would have been unthinkable for anyone who happened to arrive in the region not to take time to view these fabled sights which everyone since their youngest years had heard described in words of awe and admiration. The city covered a large area and it boasted many buildings of undeniable interest to those who were visiting for the first time. When Pausanias was there he had been determined to do the full tourist circuit but it is doubtful that many others approached their stay with the same vigor.

Unfortunately it would seem that the layout of the city had not been planned with the idea of easing the passage of worshippers and casual travelers through its narrow streets. "Delphi is a steep slope from top to bottom, and the sacred Precinct of Apollo is no different from the rest of it. This is huge and stands at the very top of the city, cut through by a network of alleyways."[29] Before reaching the temple the varied crowd of visitors would have had to struggle up the mountain. Along their long and tiring trek up and down the muddy paths, they would have passed a number of monumental shrines, lesser ancillary altars and various treasure-houses filled to overcapacity with the offerings left there by successive generations of rich and ever-hopeful pilgrims. The vast amount of wealth contained within the city would not have escaped Cicero's notice when he paid a visit to Delphi. The Roman author concluded that "the Oracle at Delphi never would have been so frequently visited, so renowned throughout the world and so overfilled with offerings from people and monarchs of every land if the centuries had not proved the truth of its prophecies."[30] By this reckoning, if Delphi had attracted such an overwhelming abundance of donations it had to have been because the predictions of the oracle had always proved authentic and dependable. It will be shown that not everyone in antiquity would have agreed with Cicero.

The acting Pythia would have been someone selected by the priests of the oracle from a tight group of experienced women of unblemished reputation who had been in attendance at the temple for a number of years. Generally the priestess chosen was a married woman in her middle years; from the day she took up her new position her whole life would be dedicated to the service of Apollo. All the Pythias were required to live away from their husbands for as long

as they were allowed to perform their sacred duties. In spite of their maturity they were expected to always dress in the garments usually worn by young unmarried girls. By tradition the oracle was consulted only on the god's birthday, which was celebrated on the seventh day of every month. Normally the Temple of Apollo was freely open to visitors at all times, but on the days when the oracle was to be consulted access to it was restricted. On those occasions the proceedings would be conducted along the lines of a prescribed formula unchanged for centuries.

A young billy goat would have to be burned and offered as a sacrifice to Apollo before anything else was allowed to happen. No doubt a few days ahead of time the animal had been examined by the priests with the greatest attentiveness and officially approved for the sacrificial pyre. Only after that rite had been performed would the Pythia and her attendants be expected to make their first appearance. It is tempting to speculate that the presence of the high priestess would not have been deemed appropriate at what surely in ancient times must have been a perfectly ordinary daily event in every village of the Mediterranean world. However the following stage of the proceedings would be precisely the same for the Pythia as what would have been prescribed for any regular visitor approaching the sacred precincts: she and her attendants would be required to begin their day by undergoing a sacramental cleansing in the Castalian Spring. That rule would never be broken for anyone, regardless of their social or ritual standing.

The Pythia would then proceed to an additional sacred fountain to take a goodly sip of its strange and mysteriously fortifying waters. This second source was known as the Cassotis Spring, and its waters were supposed to sharpen the Pythia's mind. After a few moments she would have started

her unhurried ceremonial ascent to the temple. Somehow or other her progress would have been followed by the chants and invocations shouted by the bystanders who lined the way up the mountain. On arrival the women would have found the sanctum already infused with the distinctive smell of burning barley. Since the beginning of time this grain had been considered essential to human sustenance, and therefore sacred to the Earth Mother, who of course was considered the fundamental source of all life. She was also the deity who had been the first to hold authority over the shrine at Delphi. Even after the passage of many centuries, barley flour was still being offered to the Earth Mother in worshipful recognition of her abiding presence.

As the Pythia made her way through the confined chambers which led to the inner area of the Temple of Apollo, the sharp, pungent scent of burning laurel would have become gradually apparent to everyone in attendance. Not just the leaves and branches but also the hearth itself where they were ritually burned had been consecrated to Apollo. The priests were in charge of making sure that nothing would extinguish the god's fire. From beginning to end, this second stage of the proceedings would have been an explicit proclamation of Apollo's supremacy at the oracle. The authority of his predecessor, the Earth Mother, had been granted respectful recognition at an earlier stage, but the god's ultimate sovereignty had to be reaffirmed. The image of barley and laurel smoke coming together in the stifling atmosphere of the crowded and overheated rooms could reasonably be seen as a metaphor for the mingling of the two traditions represented by the different fumes. On a more physical level the combination would have made an exhilarating blend for everyone there to inhale; this would certainly appear to have been the general idea. Beginning with the drink that the

Pythia had been asked to take at the Cassotis Spring earlier that morning, she had been exposed to various types of intoxicating substances all day. In a state of heightened excitement, the Pythia would next proceed to the *Adyton*, a primitive underground chamber located just below the temple. It was in these tenebrous surroundings that the final and most significant stages of the day's ritual proceedings would be enacted.

The *Adyton* was the oldest part of the sanctuary and it had been contrived around a bottomless fissure in the rocky surface of the mountain. Professor Levi observes that "the Delphic chasm was probably opened by an earthquake and undoubtedly affected by a later landslide."[31] It is obvious that nobody living in ancient Greece would have been aware of any of these scientific details. Everyone happily believed that the deep opening in the rock had been put there by Zeus as an explicit indication that it was the place where the gods would communicate with the human world. Certainly the group of priests who were waiting for the arrival of the Pythia would have been convinced that they were standing on sacred ground. A man as learned and sophisticated as Plutarch had been moved to report that he had personally experienced at first hand the manifestation of a supernatural presence at the *Adyton*. He wrote that on one occasion when the oracle was being consulted, quite suddenly and entirely without any other possible explanation the *Adyton* had been suffused with a potent and delicious perfume; Plutarch was certain that the phenomenon could only have been a signal from the god that he was in attendance.

As the Pythia entered the underground shrine the priests would have led her directly to the spot where a precarious three-legged stool had been installed over the narrow opening of the gloomy abyss. This was of course the very same tripod Lucan's priestess would have accidentally knocked over in

her frenzy. Just then one of the Pythia's attendants would offer her a small bunch of freshly cut laurel leaves for her to chew at her own pace. The taste would have been familiar to her but all the same its bitterness would always remain slightly jarring. Gradually her mind would become clouded and yet strangely more and more receptive as she began to feel the effects of the potent juices. Once the Pythia had settled down at her ceremonial place on the sacred tripod, the question to be presented to Apollo for his consideration on that particular occasion would be announced from the altar in a ceremonious chant. This important function would be entrusted to a different priest every month; no doubt those with the most resonant voices enjoyed the greatest popularity. The Pythia would be holding a branch of laurel across her chest as she eagerly waited for Apollo to speak. If the god took his time, she would shake the branch now and then as a gentle reminder of her presence. Everyone else in attendance at the *Adyton* would have remained standing motionless in complete silence.

Somewhere behind them in the darkest recesses of the *Adyton* stood a uniquely curious boulder as an inarticulate reminder of the immemorial power behind these proceedings. Because of its size and shape, this prehistoric relic resembled an extremely large petrified egg, and eventually it had become the tradition among the Delphians that Zeus himself had placed it there to mark the center of the earth. It would become known by everyone as the *Omphalos*, a word that still means *navel* in Greek. The exact location of this spot had been established by the god by letting two eagles loose into the air and commanding them to fly in opposite directions; after their long flights they had met again precisely over the *Adyton*. For generation after generation the residents of Delphi had taken pride in the fact that their

city and its oracle occupied the very center of the entire world around them.

"Seated over the chasm, enveloped by the rising vapours, and shaking a freshly cut bay branch, she falls into a trance. The Hellenistic theory that volcanic fumes rose up from the earth has been disproved geologically; the ecstasy is self-induced."[32] When at last the Pythia in her altered state would begin to hear the messages quietly arriving from Apollo she would repeat them in her own softly trembling voice. The largest part of the assembly would not have been near enough to be able to make out what she was saying. At this stage the priests would take over and the Pythia would leave the *Adyton*, by Plutarch's account feeling peaceful and composed. The transcription of her pronouncements would then begin. Most accounts indicate that the message conveyed by the Pythia would have been noted down by the attending priests and then set into Homeric hexameters. The simplest explanation of the Homeric or Greek hexameter is that it was made up of a succession of lines, each containing six metrical units combining short and long syllables, all of them arranged according to a strictly prescribed rhythmic pattern. It was the traditional literary form used by Greek and Roman authors in antiquity.

It would appear, however, that this elaborate process of mediating the god's message had not always been followed. Pausanias offers a short account of an earlier occasion when Apollo's message had been handled in a different manner. "Phemonoë who was prophetess at the time answered them in hexameters."[33] If Pausanias is correct, then the Pythia had once been allowed to speak freely, and not just in her own voice but in a highly controlled and sophisticated literary style. Greek mythological chronicles normally credit Phemonoë with the invention of the hexameter. Her message

would have been addressed directly to the people who were waiting to hear from her own lips exactly what Apollo had told her; by some accounts the god had been her father. Joseph Fontenrose asserts that "the Pythia spoke clearly, coherently, and directly to the consultant in response to his question."[34] Apparently her poetic pronouncements had not always been mediated by the priests.

It is possible that the change in the proceedings had come about as a result of what Germaine Greer describes as "the contempt expressed by literary men for literary women who took themselves seriously, who risked ridicule, exploitation and calumny because they thought they had something to say, and the contempt likewise meted out to the women who fooled around with poetry."[35] The observation is undeniably accurate, but in the case of the Pythia it is not likely that the priests at Delphi would have been all that clever. These men held their position only because in the distant past their ancestors had followed Apollo to Delphi, and perhaps after a few generations they could have grown disgruntled at having to play a secondary role in the prophetic proceedings while the Pythia received all the attention. The men could just have felt the primal need to mark their territory and assert what they would have considered their hereditary primacy. The reason for their takeover might come down to plain and simple jealousy, the strongest of all human emotions.

What is not open to any degree of conjecture is the admiration Pausanias felt for Phemonoë. His words make it very clear that he held her in the very highest regard. "The greatest and most universal glory belongs to Phemonoë: that she was the god's first prophetess and the first to sing the hexameter."[36] Regardless of whether it was the priests or the Pythia who announced Apollo's words, it is

a fact amply demonstrated time after time throughout Delphi's long history that even the simplest and most straightforward messages would become notoriously troublesome to interpret once they had been encoded in the lines of a formal hexameter.

Without any question the most famous example of the difficulty in making sense of oracular messages is the one offered by the visit made to Delphi by Oedipus, son of the king of Corinth. The young prince was deeply troubled and decided to consult the most respected of all Greek oracles, the Pythia, trusting that her pronouncements were invariably truthful and reliable. What the Pythia told Oedipus was not entirely straightforward but nonetheless deeply horrifying: his fate was to murder his father and then marry his mother, unspeakable actions which would have grave personal consequences and bring great turmoil to his native city. Oedipus was understandably despondent and decided that the best way to thwart the oracle and prevent the outcome the Pythia had foreseen for him was to avoid ever again seeing his mother and father. As the whole world surely knows, although Oedipus never went back to Corinth every one of the Pythia's predictions would eventually come to pass.

A later and much more distinguished ruler would consult the oracle at Delphi only to receive equally misleading answers. The reign of the Roman Emperor Augustus had marked the start of a long stretch of peace and relative tranquillity throughout the Mediterranean world. Augustus consulted the Pythia not in order to find answers to any pressing problems but simply because he wanted to discover exactly how long he could expect this propitious period of Roman history to last. The emperor was extremely pleased with the response he received since it led him to believe with considerable certainty that the existing peace would endure forever.

The difficulty in finding the right meaning behind even the most seemingly unequivocal oracular pronouncements has seldom been illustrated with greater clarity. What the Pythia had actually said to Augustus was that the long cycle of peace would come to an end only after a young maiden had been delivered of a child and still remained a virgin. Because it was considered totally impossible that such a series of events would ever come to pass, the emperor had jumped to the wrong conclusion. All the same Emperor Augustus went to his grave a happy man since the empire would stay peaceful under his guardianship until the day he died. As far as he ever knew, his interpretation of the Pythia's message had been entirely accurate.

It would appear that the activities at Delphi remained more or less as usual even after the advent of Christianity, although the tremendous wealth contained within its various temples and treasuries continued to attract mostly unwelcome attention. Pausanias informs his readers that "from the beginning there have been innumerable plans to sack Delphi. There was this Euboian bandit and the Phlegyan people some years later, then Pyrros son of Achilles attempted it, then a detachment from the forces of Xerxes, then the rulers of Phokis who made the longest and strongest attack on the wealth of the god, and then the Gaulish army. Delphi had also to suffer its share of the universal arrogance of Nero."[37] Pausanias is referring to the time, half a century after Augustus's consultation, when the Roman Emperor Nero paid a visit to Greece. There is no record of how much gold and silver he carried away from the treasuries at Delphi, but what is fairly well documented is the report that he removed no less than five hundred of the very finest statues from the city's temples. The emperor would have taken all of his booty directly back to Rome with him.

On arrival everything made of precious metals would have been melted down and turned into coinage straightaway, but the eventual destination of all the other objects can only be speculated. Few inventories were ever made in ancient times but it is to be hoped that the most admired works of art pillaged by Nero somehow survived the centuries and by now have ended up in modern museums. The celebrated marble figure of the Pythian Apollo that has been on view at the Vatican for the last five hundred years gives an excellent indication of what at least the most beautiful of Delphi's plundered treasures might once have looked like. This monumental statue, most commonly known as the Apollo Belvedere, had been buried for generations before it was fortuitously discovered very close to Rome in the sixteenth century; since that time it has been uniformly considered one of the finest examples of classical sculpture known to the world. Perhaps in antiquity there would have been many others of equal quality and beauty to be admired in temples all around Delphi.

Emperor Hadrian, who was famous for his devoted admiration of every aspect of Greek culture, with great magnanimity offered the Delphians complete autonomy from imperial rule. That noble gesture sadly did not manage to make much headway against the slow but inexorable onslaught of decline. The city and its ancient traditions were gradually winding down. There were more raids during the reign of Emperor Marcus Aurelius, but nothing would compare to the systematic looting of the city perpetrated by the zealous troops serving under Emperor Constantine, the first Christian ruler of the Roman Empire. Delphi's prospects might have begun to look more promising after the Emperor Julian the Apostate ascended the throne and reinstated the earlier religious practices throughout the empire. Nevertheless his reign would be too brief for any of his edicts to have a lasting

effect. When Emperor Theodosius finally enacted a comprehensive ban of all pagan rituals everywhere within the vast territory under his control, the move would have had no discernible effect on the activities at Delphi. Long before that time the oracle had already lost its authority, along with its once enviable wealth.

The most fitting recapitulation of the final chapter in the long history of Apollo's sanctuary might be offered by the sorrowful account of a visit made to the Delphic shrine by the close friend, confidant and personal physician of Emperor Julian the Apostate, a distinguished man of science who is remembered in history by the name of Oribasius of Pergamon. It is quite possible that Julian might have wished to offer assistance to the Delphians, but it is just as likely that he might have been seeking the sibyl's advice on a serious question of imperial concern. In either case the precise nature of the matter which the trusted doctor had been commanded by his emperor to discuss with the oracle has long been forgotten; only the reply he took back to Rome has been preserved. The message delivered to Julian by Oribasius was grim and implacable: the once splendid temple had fallen to the ground and Apollo no longer possessed either a house or the prophetic laurel. The fountain which at one time had spoken with such eloquence by then had been muted; even the water would no longer provide answers. The last recorded pronouncement of the Delphic Sibyl had been "a description of ruin more than a description of silence."[38] It would seem that alone the sibyl's fame had managed to survive.

THE TIBURTINE SIBYL

*At midday a golden circle appeared around the sun,
and in the middle of the circle a most beautiful virgin
holding a child in her lap. The Sibyl showed this to
Caesar, and while the emperor marvelled at the vision,
he heard a voice saying to him: "This is the Altar of
Heaven." The Sibyl then told him: "This child is
greater than you, and it is he that you must worship."
The emperor, understanding that the child he had seen
was greater than he, offered incense to him.*

JACOBUS DE VORAGINE, *The Golden Legend*

The dreamlike account of this miraculous and highly
significant episode has come down to us from the
hand of the Blessed Jacobus de Voragine, a devout
Dominican friar who late in the thirteenth century would be
appointed archbishop of Genoa, the largest and most impor-
tant city on Italy's busy Ligurian coast. In his own day the
learned Jacobus had been recognized throughout the whole
of the Christian world as a theological authority of some
distinction; Pope Nicholas IV himself had summoned the
respected cleric to Rome for his archiepiscopal investiture.
Among his various other scholarly writings the *Golden Leg-
end*, or *Legenda Aurea* as it would have been known for the
greatest part of its history, was to become the most consis-
tently read and widely distributed religious work of the late

Middle Ages, for a time surpassing even the Bible itself in esteem and popularity.

In France alone the book would appear in seven separate translations spread out over a period of two centuries. "Its popularity earned it the nickname the *Golden Legend*, with the implication that it was worth its weight in gold: the word '*legenda*' then meant simply a text to be read aloud, with none of the associations with fiction or fancy that the word 'legend' has since acquired."[1] Jacobus's entirely commendable intention was to preserve in one single volume a group of the most meaningful traditions which had given shape to the history of the Christian Church since her inception, along with inspiring but still entertaining details of the lives of a number of the major saints "as an aid for busy priests and preachers in need of a handy source of vivid anecdote, instruction, and edification to bulk out their sermons."[2] In time the work of the capable friar and archbishop would succeed beyond even his wildest hopes and most ambitious expectations.

After the printing press came into increasingly wider use in the second half of the fifteenth century, the circulation of the *Legenda Aurea* would quickly attain still greater proportions. The book "became as big a bestseller in the new medium as it had been in the old. Between 1470 and 1500, at least eighty-seven Latin editions of the *Legenda* were printed, as well as sixty-nine editions in various vernaculars, including four editions in English, considerably more than all the known printings of the Bible in any language during the same period."[3] As the book's reputation soared, so did the general recognition of the Tiburtine Sibyl's prophetic powers and personal authority. All through the Middle Ages the germinal Christian story of the nativity of Jesus enjoyed almost the same degree of popular devotion as it does in modern times. A good part of the chapter Jacobus devotes to the feast

of *The Birth of Our Lord Jesus Christ According to the Flesh* is taken up by the chronicle of the sibyl's encounter with the Roman Emperor Augustus. For hundreds of years this account would have been at the very least acknowledged by the priest from the pulpit during mass on Christmas day, if not actually repeated word for word to the assembled congregation. In the imagination of the faithful the Tiburtine Sibyl would become indelibly linked to the celebration of Christmas: it is principally as a result of this connection that her name has been kept alive over the centuries.

Not many concrete facts have been preserved about the movements and activities of the sibyl of Tibur; for that obvious reason very little can be gleaned about her personal characteristics, and still less about her background. Certainly not a single detail in the few surviving accounts of her life would have made anyone expect her place in history to be based mainly on having known precisely the time and circumstances of the birth of Jesus the Savior. Lactantius faithfully repeats Varro's assertion that her given name had been Albunea and that she had lived and practiced prophecy in the ancient settlement of Tibur, sited on the lower slopes of the Sabine Hills not very far to the east of Rome. The name of the city became *Tivoli* in modern times, but regardless of the change in official nomenclature, the local residents continue to refer to themselves as *Tiburtini* to this day, perhaps in respectful acknowledgment of their distinguished past. Even the main road from Rome still bears the name of *Via Tiburtina*, as it always has.

Although various other accounts fail to make the same specific claim, the studious Spanish historian Balthasar Porreño records that the Tiburtine Sibyl was actually born in Tibur.[4] Various reports would appear to indicate that the young Albunea might have first attracted the notice of her contem-

poraries as a river nymph or water sprite, which if true would logically suggest a possible cultic association with the river Anio, known today as the Aniene. The river and its spectacular cascade have always been the two principal topographical features of the city, even more so than its picturesque location overlooking the wide-open valley at its feet. As the Anio runs through Tibur on its way to join the Tiber, it creates a series of majestic waterfalls; the early explorers who would have been the first to lay eyes upon this marvel must have fallen on their knees at the mere sight of it. The flow of the river has now been adjusted to prevent flooding, and the monumental cascade is no longer as dazzling as it was when its appearance attracted multitudes of visitors and inspired legions of artists, but before that change was made the thundering sound of the falling water alone must have been awe-inspiring. It is not an exaggeration to suggest that it would have been quite simply impossible for anyone to come upon this natural phenomenon for the first time and not be struck by what can only be described as the presence of a formidable natural force which somehow transcends its own overwhelming physical expression; an animist would have felt at once that it had to be the dwelling place of a great and mighty spirit.

Accompanied by a wondrous roar, a forceful current rushes out of the rocky side of the Sabine Hills directly below an uneven patch of ground which at some point in the most remote antiquity would have become the first location of a precarious human settlement. The mighty stream bounces off the monumental boulders as it leaps and scatters all the way down to the bottom of the hill, each errant little drop reflecting the piercing light. Literally tens of thousands of images of the tumbling river Anio have been painted, drawn, engraved and photographed by the artists of every discipline and

nationality who have been coming to this place over dozens of generations. What all of them would have attempted to capture with various degrees of success is the potent yet ineffable magic of the falling waters; examples of their work can be found today in almost every important museum in the Western world.

The Grand Tourists who would have begun arriving here in the greatest numbers during the course of the eighteenth century would all have taken home a painting of the cascade as a souvenir of its magnetic power. For the majority of these visitors an excursion to Tivoli to stand before its celebrated natural wonder would have been one of the high points of their entire journey. It seems logical and particularly fitting that any hopeful water sprite would have wished to have her shrine near the river, most of all during the earliest periods of classical antiquity. As a minor provincial deity Albunea would have been revered in her own right by her fellow residents in Tibur, a gesture which would have been a high honor as well as a tremendously selective accolade. Lactantius maintains that she was actually "worshipped as a goddess at Tibur by the banks of the river Anio."[5] If indeed this was the local custom, then it would be entirely reasonable to expect a temple to have been built in the general area for her ritual practices to be carried out somewhere next to the water, the ultimate source of her authority and power, and perhaps that statues of Albunea would have been commissioned and installed in public areas for her followers to venerate.

No evidence of either waterside temples or early examples of monuments to the sibyl, however, appears to have survived anywhere in Tivoli to substantiate the reports of her cult or her perceived divinity, minor and brief as those might have been. The most substantial architectural vestige from

ancient times still to be seen at Tivoli is the round temple traditionally said to have been dedicated to the goddess Vesta; it abuts a boxy rectangular structure hesitatingly identified as the Temple of the Sibyl. The two buildings occupy the central area of the acropolis or forum of the ancient city, not far from the top of the waterfall but nowhere near the banks of the river Anio. There are reports that a sacred grove had once surrounded the Temple of the Sibyl, but if one had been there in antiquity it has disappeared without a trace. All the same the story of her cult cannot be dismissed out of hand.

No less distinguished a sibylline scholar than Herbert Parke follows Lactantius in pointing out that statues of the Tiburtine Sibyl had definitely been made in antiquity. One example, still holding a book of her prophetic pronouncements, had once been "miraculously recovered unharmed from the waters of the Anio."[6] Evidently one of her effigies had somehow fallen into the swiftly moving waters of the river, although it seems never to have been determined whether the figure ended up submerged because of an unfortunate accident or as a result of a deliberate act of explicit rejection of her divine status. Another matter which has also remained frustratingly unrecorded is how Albunea eventually managed to succeed in making the transition from a quaint river nymph with a restricted local following to a grand sibyl with direct access to the powerful ruler of a vast empire.

The Tiburtine Sibyl was the last of the ten women identified by Varro in his catalog of sibyls, a document generally believed to have been arranged in strict chronological order. However her place on the list should not be automatically interpreted as definite evidence that her activities had dated from a later period than those of any of the other nine figures mentioned by the Roman author. Reliable sources from antiquity indicate that Tibur had already been the site of a

flourishing Sabine community for at least half a millennium by the time Rome was eventually founded. The city on the banks of the Anio was considered by Virgil to be one of the five most important urban centers in the entire area. Traditional accounts appear to suggest that Tibur had been settled by a small group of Greek pioneers who had arrived in Italy much earlier than Aeneas and his troop of Trojan warriors. The word *Tibur* itself quite clearly shares a common etymological root with other words like *Tiberis*, which is the Latin name of the main river flowing through central Italy. Such a close linguistic similarity demonstrates the tremendous antiquity of both of these place-names.

The historical evidence suggests that, for many generations before the founding of Rome, separate pockets of Sabines had been peacefully inhabiting the regions both to the north and to the south of the river Anio. There can be little doubt that the most widely documented moment in the history of the Sabine people living on either side of the river must be what has always been quite dramatically called the *Rape of the Sabine Women*. Although the rape in question does not actually refer to an act of sexual violation, as most people appear ready to believe, but rather to a somewhat less aggressive abduction or takeover, nevertheless the event has quite often been the subject of colorful and occasionally strikingly vivid pictorial representation. The traditional story that Sabine women were taken away to Rome against their will dates back a few millennia and it is one of only a handful of tales from antiquity to have consistently captured the imagination of visual artists throughout the centuries.

Rome had been founded by a group of unmarried and adventurous Trojan soldiers who had been traveling on their own for years; in the earliest stages of its existence the city obviously lacked a sufficient number of resident women to

be able to reach and maintain the necessary level of urban growth and collective security. What almost certainly would have happened is that the inhabitants of those Sabine territories lying closest to Rome peacefully and probably almost imperceptibly became integrated with the less numerous more recent arrivals. This development would have benefited both groups, and eventually it would produce a composite population that assimilated both indigenous and imported social and religious traditions. The figure of the Tiburtine Sibyl is not the only Sabine example of this gradual process of cultural interbreeding: it is documented that Numa Pompilius, who had been born a Sabine, reigned uneventfully over the Romans as their second king very soon after their city was founded.

For quite a long time following the successful establishment of Roman hegemony over the complete area along the banks of the river Tiber, a small but resilient Sabine community remained active on the Quirinal Hill, holding on to its own particular cults and customs. The Quirinal is the highest of the traditional seven hills of Rome, and it is located well within the ancient walls constructed at a later stage for the purpose of protecting the residents of the city from their enemies. The truly gigantic papal palace, which since the end of the sixteenth century has occupied a large part of the summit of the hill, is today in regular use as the official residence of the president of the Italian Republic. The lavish formal gardens admired by visitors to Rome have all been planted over fields once tilled by industrious Sabine farmers. In a remarkable combination of persistent Sabine connections, an earlier occupant of the Quirinal Hill had been Cardinal Luigi d'Este, whose uncle would build the famous Villa d'Este in Tivoli, still to this day one of the greatest sights in all of Italy. The cardinal lived in Tivoli when he was not in resi-

dence on the Quirinal Hill, and after his death he was buried in Tiburtine grounds.

The city of Tibur was built some twenty-two miles (thirty-five kilometers) to the east of the Quirinal Hill at an altitude of approximately 325 feet (100 meters) above the level of the river Tiber. The incomparable long views from the ancient city across the vast expanse of the Roman Campagna, along with the noticeably fresher climate found among the thickly forested slopes of the Sabine Hills, would help establish Tibur with generations of Romans as one of the most desirable and highly agreeable spots where respite from the heat could be sought during the long Mediterranean summers. The poets Catullus and Horace both owned holiday houses in Tibur; in the second century CE the cultivated and remarkably well-traveled Emperor Hadrian started building directly outside the central part of the city a large complex of monumental structures, fountains and gardens. It can be stated without risk of encountering the slightest possible disagreement that the compound contrived by Hadrian at Tibur has remained since its completion the grandest, largest and most ambitious architectural retreat ever created or even conceived by any ruler anywhere in the world at any time in history.

Following in the much earlier and grander footsteps of the emperor, an aristocratic and enlightened Renaissance cardinal, Ippolito d'Este, chose Tibur as the location of a considerably smaller but only slightly less extravagant folly, the compact and yet exquisite complex of palace and surrounding gardens known as the Villa d'Este. The cardinal's decision is evidence that, even fourteen hundred years after Hadrian, the city at the foot of the Sabine Hills had retained much of its charm and time-honored allure. As part of the decorative scheme of his elegant Tiburtine villa, Ippolito thought it only

appropriate to commission a series of frescoes illustrating the story of the Tiburtine Sibyl. By the end of the sixteenth century, just about the time when the decoration of the Villa d'Este would have been nearing its completion, the name *Tibur* started to gradually become replaced by *Tivoli*. Under that far softer and more mellifluous name the city would become one of the drawing rooms of Europe, and consequently a magnet for all the studious young noblemen from every country north of the Alps who regularly set off on the Grand Tour in covetous search of cultural refinement.

As a result of the presence of its ancient ruins, and of many other far more recent but no less spectacular architectural attractions, Tivoli would gradually attain an exceptional degree of fame and popularity. The combination of its magnificent cascade and mild climate, perhaps helped to some degree by its traditional association with the famous sibyl, turned the city into one of the obligatory ports of call for any visitor to Italy. By the turn of the eighteenth to the nineteenth century, and for quite a long time thereafter, such was its fame and reputation that it would become an established custom for pleasure parks in every corner of the Western world to be named *Tivoli Gardens* in hopeful evocation of their Italian prototype. Sadly the ploy never really worked and all attempts to replicate Tivoli's unique enchantment away from its waterfall would invariably fall pitifully short of the original.

It would be impossible for modern observers to find an adequate explanation for this failure, but for sensitive people in classical antiquity these unsuccessful efforts would have been automatically understood in terms of the simplest of animist principles: there were gods present everywhere under the stones of the illlustrious city and the great waterfall was the most tangible manifestation of their existence. The immanent

spirit within the cascade would have been the reason why so many people from the whole of Europe had been drawn to this particular spot for centuries. Certainly if someone as wise and distinguished as Augustus, the first Roman emperor, had felt compelled to summon Albunea to his side it would have been in direct reaction to this tangible power. In its absence neither the magical charm nor the singular wisdom would have been in evidence anywhere else.

Without the achievements of the extraordinarily capable Augustus it is not very likely that Tibur would ever have attained the high level of distinction which has made it such a remarkable place. By the time Hadrian started the planning and construction of his villa in the Sabine Hills, the Roman Empire had not been involved in any major war for a century and a half. It was no doubt mainly due to the fact that Roman armies had been out of action for quite a few decades that there were sufficient funds sitting in the imperial treasury to be made available to the emperor for his extravagant building project on the outskirts of Tibur. The *Pax Romana* had started precisely during the first years of imperial rule under Augustus, and it was to him alone that traditionally credit has been given for the multiple benefits engendered by the long period of peace. "Augustus seems to have occupied a special position in popular memory as the bringer of peace to the Mediterranean world."[7] Jacobus de Voragine offers a more comprehensive explanation when he writes that the emperor "had brought the whole world under Roman rule, and the Senate was so well pleased that they wished to worship him as a god. The prudent emperor, however, knowing full well that he was mortal, refused to usurp the title of immortality."[8]

It would become apparent that the Roman Senate was not ready to accept the emperor's self-effacing decision. Despite

Augustus's firm and persistent refusal, the question of his divinity would not be left unresolved by the senators who finally put their foot down and insisted that the Tiburtine Sibyl be summoned to Rome. Just a few decades later, Emperor Hadrian would not hesitate to deify his dead lover, Antinous, in glaring contrast to his predecessor's unwillingness to accept divine status for himself. The question the sibyl would have been asked to arbitrate was whether or not it was likely that there would ever be born in the world any human being of greater distinction than Augustus. The emperor and the senate would soon get a clear answer.

Early on a chilly morning in late December an imperial chariot would probably have been dispatched from Rome to Tibur in order to convey Albunea to the imperial quarters. We know that the sibyl must have been given some kind of advance warning of her impending mission because Porreño reports that she had fasted for three full days in preparation for her meeting with the emperor. The journey from the Sabine Hills would not have taken longer than a few hours, but nonetheless it is not likely that the sibyl would have gone on such an important assignment entirely on her own. Most probably one or two of her handmaids or even a temple attendant would have accompanied her on her trip. All the same, whether or not she had someone with her when she arrived in Rome, she would certainly have been by herself when she met with Augustus. Jacobus writes that the two of them were entirely alone when they began their deliberations.

On an empty stomach her ride from Tibur would have seemed longer than usual, but at least the crisp morning air would have helped keep her head clear and her mind alert. Without any doubt the timing of her visit to the emperor was extraordinarily propitious. After one of her periodic visions,

the sibyl had already forecast that if a fountain were to suddenly start spouting oil instead of water, this entirely unprecedented occurrence would be a clear sign that the Messiah was about to be born. Just a few days earlier it had been reported that precisely such a curious episode had actually taken place in Rome. Jacobus relates "that a fountain of water turned to oil and burst into the Tiber, spreading very widely all that day."[9] The stage was being set for an event of epochal significance which, according to all signs, was about to unfold.

It seems surprising to the modern reader that for some reason there is nothing at all in the *Golden Legend* to indicate with any certainty where in Rome it was that the Tiburtine Sibyl had her extraordinary audience with Emperor Augustus. The place where the sibyl and the emperor met must have been considered by Jacobus a matter too trivial to be mentioned in his narrative. This may now seem like an inconsequential detail but, in view of later developments, it is one that would eventually come to acquire some importance. We can only speculate that Albunea was most probably dropped off at the main portal of one of the emperor's customary winter residences where she would have been greeted by a junior member of the imperial staff and taken forthwith to see Augustus. She probably felt colder being led down the marble corridors than she had been in the chariot on her way from Tibur. Jacobus clearly did not consider the location of their meeting nearly as important as he did its timing. When he came to address this question he took great care to point out that the interview between the emperor and the sibyl had been scheduled to take place precisely on the day that Christ was born. "On the day of Christ's birth, the council was convoked to study this matter and the sibyl, alone in a room with the emperor, consulted her oracles."[10] Whatever information

it was that she discovered must have been sufficiently explicit to prompt her to quietly lead the emperor outside and urge him to gaze upon the miraculous sight of the Child Jesus resting in the lap of His Virgin Mother, the two of them surrounded by a circle of light in an otherwise crystalline Roman sky.

Even before the day when the Tiburtine Sibyl arrived from Tibur to meet with the emperor, both of them must have already known pretty much what to expect from each other. They certainly would have prepared for their discussion and quite possibly they had more or less arrived at some idea of what the outcome of their interview would likely turn out to be. By that time Augustus had been on the imperial throne for almost three decades, and during those years the presence and prophetic activities of a sibyl at nearby Tibur would undoubtedly have come to his attention. Surprisingly he must have never had any prior reason to make direct contact with the sibyl; it would appear that the emperor finally felt compelled to seek a firsthand meeting with her only in reaction to the very specific nature of her prediction regarding the impending birth of a Savior. An event of such magnitude would have had profound personal and political consequences for him and for his sprawling empire, and Augustus must have agreed to ask the sibyl to come to Rome in order to explain her prophecy and not only to help settle the question of his divinity. From the standpoint of the Tiburtine Sibyl, her oracles had certainly made her aware that the birth of Jesus was about to take place in distant Palestine that very day. Her own prophecy about the water fountain would have been enough to tell her that much. Most amazing of all is the fact that the sibyl not only got the day right but that she evidently had the power to conjure up in the sky a *tableau vivant* to allow the

mighty ruler of the Roman Empire to witness the birth of the Savior just a few moments after it had taken place. The scene of Emperor Augustus and the Tiburtine Sibyl together looking up at the sky is one that inspired Christian artists for many generations.

Jacobus ends the story with the straightforward report that after looking at the heavenly vision Augustus once again decided to turn down the privilege of being declared divine. "The emperor, understanding that the child he had seen was greater than he, offered incense to him and refused to be called God."[11] According to Porreño's account, Saint Thomas Aquinas, a member of the Dominican order like Jacobus de Voragine and a formidable theologian in his own right, had interpreted the rejection of divinity by Augustus as a sign of a miraculously inspired humility that had been instilled in the emperor's soul at the very moment Jesus had come into the world. Augustus might have been divinely moved to reaffirm his own mortal status next to the greatness of the newly born Savior, but all the same he would not have set aside his own pagan religious beliefs in order to become a Christian, if only because it would have been impossible on that day for anyone to convert to a religion which at that moment had not yet come into existence.

In addition to the immediate if perhaps somewhat facile appeal of the report of an emperor being humbled by the sight of a newborn infant, the account of the exchange between Augustus and the sibyl has traditionally been perceived as conveying the deeper and more universal message that the birth of Jesus and the eventual establishment of Christianity would mark the collapse of a world which up to that moment had been ruled by pagan principles under Roman imperial control. Not just the iconic figure of the sibyl but also the emperor would be seen ready to acknowledge the authority

of the Savior. Still there are aspects of the saga which would appear to go both beyond and below any overarching Christological dimensions, undeniably valid as these might be in their own right, and if any of them are to be properly understood at all it would be useful to consider them in the general context of what happened.

On certain levels the story might seem to be solidly anchored in events and narratives which could easily go back to the earliest moments of organized human experimentation with communal ownership of land and resources, not just in this particular area of central Italy but everywhere else in the world where the arrival of a body of newcomers would result in the submission and subsequent takeover of the population that had been there before. Perhaps what might need to be considered is the *Rape of the Sabines* as the systematic cultural despoliation of one group of people by another, an event which, certainly in this case, must never be interpreted as a simple tale dealing mostly if not exclusively with the abduction of part of a community for the elemental purpose of mating and procreation. If the Romans ever raped any Sabines, it would have been done through the deracination of their primordial customs and ancestral traditions.

The cascade would appear to be the main protagonist in the unfolding of the story, with the sibyl and the emperor playing secondary roles. Because life in any of its forms cannot be sustained without it, water has figured prominently in the traditional mythologies and practices of every human society since the beginning of recorded history. If for at least a brief moment we could be willing to sustain the animist belief that an eternal spirit can reside within an inanimate object, then unavoidably the Tiburtine waterfall must be perceived as the dwelling place of a singularly dynamic su-

pernatural force. The spectacular display of this power may well be glaringly obvious to all observers who stand before it, but this concrete physical expression gradually disappears as the waters begin to settle down and flow away placidly on their way to join the broader currents of the river Tiber. The great waterfall both symbolizes and illustrates the transfer of the vital strength of the Sabines from Tibur, where the water roars with awesome primal energy, to Rome, where it drifts peacefully under control.

Although the sibyl did not actually play a direct role in the expatriation of this force, she was the channel through whom the sacred spirits immanent within the cascade made themselves manifest and intelligible to the world. Both the waters and the wisdom had flowed through Tibur on their way to Rome. In the end it was the Tiburtine Sibyl who conveyed to the emperor the message that the political and religious hegemony which the Roman Empire had held for so many decades was about to come to an end. She would have received this knowledge from the spirits in the great waterfall, the same source which provided her with her prophetic visions when she was at her own quarters in Tibur. Christianity would eventually prevail over the Romans just as the Romans had once triumphed over the Sabines, completing a cycle which already then certain people would believe had been predetermined all along.

The *Golden Legend* reports that on the day of his encounter with the sibyl Augustus decreed that from that moment onward the chamber where they had met was to be dedicated "to the honor of Holy Mary and to this day it is called Santa Maria Ara Coeli."[12] At this point it would have been helpful if Jacobus had taken the trouble to identify the precise location of the room in question, but fortunately other Roman sources reveal that it was somewhere

on the higher slopes of the Capitoline Hill, at that time as much as today the most important place in all of Rome. Anyone who has had the pleasure to ascend Michelangelo's superb *cordonata*, the generous staircase which takes visitors ever so gently from the bottom of the Capitoline Hill to the masterfully elegant square at the top, would not have missed seeing directly to its left a long and very steep set of shallow stone steps which lead to the plain and yet completely intimidating brick facade of a church that since time immemorial has been known to the people of Rome as Santa Maria in Aracoeli. *Ara Coeli* means *altar of heaven* and these are reported by Jacobus to have been the very words heard by the emperor at the time of his revelatory vision. There is no record that either Augustus or any of the other emperors ever lived in this part of the city; all the same an old tradition would appear to suggest that the spot where the emperor and the sibyl stood to gaze upon the miraculous vision evidently overlooked a temple dedicated to the goddess Juno located on the summit of the Capitoline Hill. Solid documentary evidence indicates with almost complete certainty that in antiquity such a temple occupied the very site where the church now stands.

The story of the emperor's vision and its connection to the Church of Santa Maria in Aracoeli was included in the earliest of the thousands of guidebooks written over the centuries by well-intentioned scholars and connoisseurs in order to inform and assist visitors to Rome. It was called the *Mirabilia Urbis Romae*, a title which means *The Wonders of the City of Rome*. This famous work first appeared in circulation some nine hundred years ago, but half a millennium earlier the site where the church now stands had been occupied by a Christian monastery, itself erected over the foundations of an older altar reportedly put up at the command of Emperor Augustus.

The nave of the Church of Santa Maria in Aracoeli as we see it today is lined with a disparate assortment of marble columns of varying heights, girths and colors, all of them salvaged from any number of different pagan temples, a sight which is certainly not an unusual one to encounter in a Roman church of this tremendous antiquity. In this particular case what makes the assembly of architectural elements different from all the others to be seen in the city is that one of the massive monolithic columns is engraved with an ancient inscription identifying it as once having been part of the bedroom of Emperor Augustus: *A Cubiculo Augustorum*. Fanciful portraits of the emperor and the Tiburtine Sibyl face each other across the arch over the high altar of the church. Most of the modern tourist guides proclaim with ostensible authority that nowhere else in Rome can the triumph of Christianity over pagan culture be experienced with so much clarity, but the reality is that the heady blend of pagan and Christian motifs is not always possible for most visitors to unravel. Quite probably the Tiburtine Sibyl would have felt comfortably at home in these surroundings.

Every year on Christmas Eve the Church of Santa Maria in Aracoeli comes alive in celebration of the blessed event which is popularly credited with its foundation. The normally unwelcoming stone steps leading up to its entrance door will be decorated with freshly cut branches and furnished with candles to softly light the way of those nimble enough to brave the long climb to the summit. All the way up the steps there will be musicians playing Christmas songs on ancient instruments for the purpose of enticing the faithful of the district to join in the traditional celebration of Midnight Mass. For the following twelve days a magnificently bejeweled sculpted figure of the Christ Child

will be placed on display as the focus of a pageant of public veneration of almost pagan opulence. This extraordinary ritual, faithfully preserved intact over the centuries, appears to have no parallel in any other corner of the Christian world. The contented shadow of the Tiburtine Sibyl will certainly be found poised somewhere in the background.

THE FUSION OF
PAGAN AND CHRISTIAN
TRADITIONS

*Oracles were to last for four hundred years after
Jesus Christ. There is no difference which can be
detected between those oracles which followed the
birth of Jesus Christ and those which came before it.*

BERNARD LE BOVIER DE FONTENELLE,
Histoire des Oracles

After they have been codified and established for
a period not necessarily any longer than merely
one or two generations, all religious systems
appear to become intensely conservative. The consequence
of this development is most frequently the onset of a sclerotic
resistance to any type of change. Not many records can be
found of comprehensive adjustments being made to the for-
mal religious rituals of any given group of people who had
lived together and worshipped as a community for a lifetime.
Very rarely throughout the preserved history of humanity
have societies abruptly altered the practices which up to that
point had been held sacrosanct by both their doctrine and
tradition. On the few occasions when it has become compul-
sory or even just merely politically expedient to adopt new

ways, almost always it has been the case that whatever changes were made would never take immediate effect. This would appear most conspicuously to have been what happened when Christianity gradually began to replace pagan polytheism as the primary belief system of the Roman Empire. The new religion had been introduced into an immensely complex geographical and political entity which, over the course of many centuries, had come to incorporate a confusingly large number of diverse cultural, social and religious practices. "Rome's political centre exercised supreme control over the periphery, but the periphery also contributed to the power of the capital. What made Rome successful was that the other, the peripheral, was integrated, adopted, or assimilated. Roman religion did as much."[1]

Despite the extremely important role played by the multitude of pagan gods and goddesses in the private and public lives of people at every level of ancient society, surprisingly little evidence has survived regarding the official measures put in place to regulate the practice of religion in the Roman Empire. What documents have been preserved would suggest that, with very few exceptions, most of the statutes enacted over the years had been inconsistently and sporadically enforced, if they were enforced at all. It would appear that under Roman law hardly any religious rituals were prohibited tout court. In general the activities of magicians and astrologers were singled out for somewhat stricter controls, and all attempts to forecast the time or manner of someone's death by any means were firmly forbidden. To a similar degree the use of love potions and incantations was officially subject to severe punishment. More than all other practices, any rite involving human sacrifice was forcibly proscribed throughout the empire. Otherwise it seems to have been the case that, as long as the supremacy of the Olympian gods remained

unchallenged, Roman society at the beginning of the Current Era comfortably tolerated the presence of a considerably broad spectrum of foreign cults and imported faith traditions.

Followers of fringe religious groups appear to have been relatively free to celebrate their rites and ceremonies, provided that some public gesture was occasionally made to show their respect for the traditional Roman pantheon, and most particularly for Jupiter. Unlike the members of all the other sects, Christians consistently refused to comply with this demand, even though in actual practice the requirement would have been met by merely burning a handful of incense at the foot of a sacred statue now and again. More frequently than not, these disparate factions would have had their roots in the more remote regions of the extensive imperial domains. Shrines ministering expressly to the numerous followers of recently transplanted Egyptian or Mesopotamian deities appear to have been routinely allowed to function literally side-by-side with older and much more conventional temples dedicated to pagan gods with a measurably longer and substantially better established presence in Rome. "Religion is inherently conservative, and fundamental changes occur rarely, although in Roman religion its polytheistic composition allowed foreign cults to be integrated."[2]

Notwithstanding the fact that these divergent religious practices would have been countenanced by the majority of the population of the empire, there can be no question that, at the highest levels of Roman society, they were all without exception considered superstitious, ineffective and reprehensibly crude. "Both Augustus and Hadrian are reported by their biographers to have despised foreign cults; and Suetonius also notes that, when in Egypt, Augustus declined to visit the Apis bull, and highly commended his grandson Gaius for

not offering prayers to Jehovah in Jerusalem."[3] Emperor Domitian, on the other hand, is known to have openly enjoyed foreign cults. This quirky personal predilection would have been considered highly unusual for a man in his position, and almost certainly it would never have met with the approval of his contemporaries. All of these various accounts would appear to suggest, more than anything else, that the Roman Empire was far too vast and its population much too numerous and culturally heterogeneous for a single religious standard to operate uniformly throughout the whole of society. "Rejection of foreign superstition created a sense of unity for the Roman élite in relation to the empire, though consistency was hardly possible given the expanding nature of the Roman Empire."[4]

Saint Paul's celebrated *Epistle to the Romans* most eloquently demonstrates that a sizeable and quite dynamic Christian community had been firmly established in the imperial city as early as the middle of the first century CE. If the Christians had not persisted in their unwavering conviction that theirs was the one and only acceptable way to worship God, there cannot be much doubt that with time their growing numbers would also have been welcomed into the officially sanctioned theological melting pot. At that moment "the growth of 'foreign superstitions' at Rome could be portrayed as a threat to the 'official' Roman system: so, at least in Tacitus' account, the emperor Claudius found the popularity of these alien cults particularly responsible for the neglect of the art of haruspicy among the great Etruscan families, and he took steps to revive the art."[5] *Haruspicy* was a time-honored method of divination involving the examination of the viscera of sacrificed animals; it had been practiced by the Etruscans for many generations before the Romans became familiar with it and decided to adopt it for their own use.

The emperor's decision to breathe new life into this arcane custom would seem almost certainly to have been nothing more than a reflection of the sentimental reverence indiscriminately felt by the Roman patriciate for every one of the most ancient and firmly established of their religious conventions. Emperor Augustus's greatest scorn appears to have been reserved for those foreign cults of recent standing. Despite this strong attachment to traditional ancestral practices, Roman religion, as it became defined and formulated, would not be forged into being through a simplistic and backward mix of resurrected archaic traditions like haruspicy, but rather as the direct result of a rational amalgamation of diverse doctrines and rituals. From the time of its earliest conception, the Roman system of beliefs had been shaped by a vigorous and inclusive syncretism, which was precisely what had made it possible to join together Greek and Etruscan mythologies and traditional practices in the first place.

This pragmatic open-mindedness would appear to have been a Hellenistic development. Certainly in earlier periods of their history, the Greeks had once had a markedly different approach to sacred matters. Surviving accounts reveal that their rigidly insular religious practices had become so hermetic and inflexible that their rituals and festivals were open only to those people who held Greek citizenship; all foreigners who found themselves in Greece were customarily excluded from any public form of worship. The peripatetic rule of Alexander the Great, and the subsequent expansion of Greek hegemony beyond the immediate region of the Mediterranean shores, would have made it inevitable that in time fundamental changes had to be made. "Roman religion was polytheistic and open, conservative yet flexible. Roman religion was not about faith, dogma or morality; it was about the proper performance of

prescribed rituals. The aim was a community's prosperity and, by extension, the continued success of the Roman state. In this, religion and politics were intertwined."[6]

It can only have been the presence of a political dimension to their religious thinking which would have shaped the Romans' inclusive approach to the individual mythologies and belief systems of all the groups of people who would come under their political control. The loyalty, and eventually the subsequent political and military cooperation of all these tribes and nations, would always have depended, to a large degree, on the toleration the occupying forces were seen to show for the native traditions they came across. As their empire continued to expand, it would have become evident to the Romans that they needed to respect all the regional deities, festivals and devotional institutions they encountered as they went about the world conquering their neighbors in increasingly greater numbers. The important role played in the daily lives of their new subjects by their religious practices would come to be acknowledged and ultimately accepted by Rome. The judicious policy enforced by Roman officials was to neither replace nor suppress local traditions, but rather to find a way to gently fit them into the general social and theological system of the empire. Just as the majestic gods and goddesses of Egypt and the Near East had been welcomed into the Roman pantheon, with the passage of time also the drab and frequently dour mythological figures worshipped by the Germanic and Celtic tribes in Northern Europe would be pragmatically adopted by the Romans in one form or another, all for the sake of political stability. The Teutonic Thor and the Olympian Jupiter would gradually come to be regarded as most likely representing the same deity under different guises. This was Roman religious realpolitik in its most comprehensive and efficient application.

It is widely documented that, during the earliest decades of their presence in Rome, Christian converts showed an entrenched aversion to any kind of contact with heathen practices. The meat of animals killed in the course of ordinary pagan ceremonies was openly offered for sale at all public markets. The meat would be routinely bought by the majority of the Roman population, who would then take it home and consume it without any misgivings. Nevertheless at a certain moment the Christian community would start devoting a great deal of thought to the question of whether or not one of their assembly would be guilty of idolatry by eating the flesh of a sacrificed animal. This seemingly trivial matter was eventually allowed to become a vehemently debated issue of divisive proportions. Saint Paul expressed the opinion that it would not have been idolatrous for Christians to consume such meat, but the elders in Jerusalem appear to have held the opposite point of view.

By any standards such fastidiousness would seem entirely out of place among a group of people who, merely two or three generations later, would not think twice about coming in regular contact with other types of relics from polytheistic rites and traditions. If a dead animal could be justifiably considered to be unclean because it had once been used as a brief and unwilling participant of a pagan ceremony, then logically it should have followed that the temple which had repeatedly served as the setting for these same rituals would have been contaminated to a much greater degree, and as a result shunned and proscribed. Perhaps surprisingly this would not turn out to be the case: at a later stage Christians would delightedly take over entire pagan buildings for their own religious purposes. Before that would happen, however, the tenacious persistence of the early Christian leaders in categorically rejecting every type of syncretic compro-

mise with the Romans and their religious practices would eventually grow to heroic and, in the end, tragically self-destructive extremes.

For a long time Christians had been forced to meet in secret hiding places, and it seems to have been the case that as soon as they were allowed to practice their faith in the open and without threat of persecution, they never missed a chance to raid an abandoned pagan building and make off with a marble pillar or two. Columns pillaged from Roman temples would be used in the construction of Christian places of worship as long as their supply lasted. Countless churches in Rome and in every other region of the Roman Empire would be constructed out of whatever elements could be removed from old temples and carted away to new building sites. Christians used this pagan material without any compunction in the creation of their own sacred spaces: on many occasions entire Roman structures would be taken over and hastily rededicated to Christian meetings and rites. The Pantheon in Rome has survived almost entirely undamaged only because at a very early stage it was turned into a church.

If they were to think about it at all, the majority of people in the twenty-first century would most likely consider basilicas to be a quintessentially Christian architectural creation; in fact such buildings have inherited both their name and their appearance directly from pagan antecedents. In classical times basilicas were built strictly for commercial purposes and, although at least a handful of statues of protective gods and goddesses would have been on display along their walls, the buildings themselves were never meant to be used for religious celebrations. The basilica built by Emperor Maxentius on the Roman Forum, large sections of which can still be seen today, might be considered a characteristic example of the type: it was designed to facilitate the everyday

activities of businessmen and bureaucrats and was provided with a semicircular apse at one end and a wide central nave flanked by aisles, a simple but serviceable arrangement which has been meticulously observed by Christian masons and architects over the last millennium and a half. It might come as a surprise to many of the faithful in the modern world, but even the holiest and grandest of Christian churches owe their design to the mundane office blocks put up by pagan Roman builders in ancient times.

It took the shedding of much blood and the passage of a great many decades for the Christians, their customs and their religion to become fully integrated with their pagan counterparts and together bring about the birth of a new society. In the middle of the second decade of the fourth century CE the Roman Empire was ruled by two separate monarchs. Constantine ruled over the western half of the empire and Licinius held sway over its eastern part. In the year 313 the two emperors jointly issued the Edict of Milan, and under its terms the practice of Christianity was at last officially accepted and legalized everywhere within the borders of their adjacent domains. To modern observers this might seem to be no more than a minor formality, but to a Christian community that just a few years earlier had suffered greatly during the reign of the Emperor Diocletian, the promulgation of the Edict of Milan would have been a tremendously significant advance.

What is commonly known as the Great Persecution had been started by Diocletian ten years before the Edict of Milan, at a time when numerous Christian communities had already been established in the western part of the empire for at least a dozen generations. Different reports of the exact character and severity of Diocletian's systematic brutality vary widely but, according to most traditional accounts, not

too long after the persecution started all Christian documents had been put to the torch and most Christian places of worship had been torn down. In addition to all this destruction, it is believed that whatever private property was suspected of being in Christian hands had been summarily confiscated by the state. The actual scale of the oppression, however, remains unclear. "Almost all the details—legal, political, religious, social—of the punishment (or persecution) of the Christians have been hotly and minutely disputed from Roman times until today."[7]

Under the terms of the Edict of Milan, Christian communities would enjoy a stable period of increasing social prestige and much greater political recognition; in the end these gains would turn out to be only temporary. After Emperor Julian assumed the throne, almost exactly half a century later, Christians would have had to deal with a different set of rules. The new monarch was a nephew of Emperor Constantine but, despite their close family connection, Julian did not share the Christian sympathies of his celebrated forebear. In a complete reversal of his uncle's official policy, the new emperor would make a determined attempt to revive traditional Roman religious practices while suppressing the growing acceptance the Christians had enjoyed within the system. His policies would earn him the title by which he has been most frequently remembered in history: Julian the Apostate. Nevertheless it seems likely that it had never been the emperor's intention to eliminate the presence of Christianity. It would appear that his principal aim had been the restoration of the syncretic pluralism typical of traditional Roman belief systems over the course of many centuries; the emperor was convinced that this had been at the root of Rome's spiritual vitality and, by extension, the principal reason for her political greatness.

Following Julian's unexpectedly early death after merely two years on the throne, the religious balance within the empire quickly returned to what it had been before his reign. Before too long Christianity would manage to recover its standing, if not as the principal religion, at least as one of the two most widely practiced in the Mediterranean world. Those extremists who were hoping for institutionalised supremacy would have to wait for almost another three decades before Christianity would be officially declared the state religion of the Roman Empire. This development would come about under the reign of Emperor Theodosius, a man who had been baptized a Christian only in the middle years of his third decade, and then apparently after surviving an unspecified illness which brought him perilously close to death barely a few months after he had assumed the throne. The reason for the emperor's relatively late conversion has never been established, but what has always been beyond discussion is the unrelenting piety and intransigent orthodoxy blighting the years of his reign. His intolerance is a trait Theodosius would have shared with many of the people who undergo conversion to a new religion in their full maturity.

If history remembers Theodosius at all it is only because of his colossal hatred of pagan religion and classical culture. Shortly after his baptism, in the year 380 CE, the emperor ordered all of his Christian subjects to toe the line of his fervently held but quite recently acquired Nicene Catholicism. A decade later Theodosius decreed that from that moment onward his own personal brand of Christianity would become the official state religion of the Roman Empire. This move, by itself, would not have had such disastrous consequences had it not been followed, almost immediately, by an order to demolish all pagan buildings and monuments throughout the imperial territories, and prohibit every type of polytheistic

rite and celebration. Not even the highly popular Olympic Games, which at that point had been a universally respected tradition for almost twelve hundred years, managed to escape the emperor's comprehensive and benighted bigotry. The final games to be organized in antiquity would be held in Greece barely a few months after Theodosius's ban on all pagan practices took effect; they would be reinstated only in 1894, fifteen hundred years after their senseless suppression.

It is the merciless and thorough obliteration of the famous Serapeum in Alexandria, however, that has been considered one of the blackest chapters in the long and shameful history of zealotry and unbridled religious intolerance. This immense temple had been dedicated to the worship of the gentle Serapis, a syncretic Greek-Egyptian deity whose very existence not only demonstrated the religious inclusiveness of Hellenistic philosophy, but also most eloquently proclaimed the harmonious coexistence of two ancient cultures. It had been raised on the highest point of the Alexandrian acropolis overlooking the city and its busy harbor. Chroniclers at the beginning of the Current Era would report that, since its completion half a millennium earlier, the Serapeum had been known throughout the whole of the Roman Empire as undoubtedly the paramount temple in all of Egypt and, next to the Capitol in Rome, as probably the most magnificent human creation in the entire world. The Serapeum did not stand on its own, but formed "part of the palace structure and housed the famous library of Alexandria. A sarcophagus containing the body of Alexander was said to have been in this temple-library."[8]

White marble of the greatest purity had been used for its exterior construction, and as a result the entire surface of the Serapeum sparkled in the bright Mediterranean sunlight with a distinctive but delicate golden glow. Its corridors were

lined with imposing statues of the greatest attainable perfection and long rows of columns chiselled from precious marbles. The monumental figure of the bearded Serapis, god protector of Alexandria, was kept in majestic isolation inside a vast chamber whose walls were said to be covered from floor to ceiling with sheets of the finest gold. Remarkable as it might seem today, all of this physical splendor would have paled in comparison with the literary treasures from the Library in Alexandria, by then preserved within the precincts of the Serapeum. At one time the *Bibliotheca Alexandrina* had held the largest collection of literary works in the ancient world; for the very first time in history it had included examples from all of the world's different cultures. Five decades before the birth of Christ the celebrated library had gone up in flames and no less than a staggering 40,000 hand-written works would turn to ashes on that day. It is recorded that, after this disaster, what was left of the collection had been transferred to the Serapeum for safekeeping. The remaining manuscripts would be kept there, in undisturbed tranquillity, for the next four centuries.

The repercussions of Theodosius's virulent dogmatism were to circulate very quickly throughout every corner of his widespread dominions. Quite soon after reports would reach Alexandria that the emperor had banned all pagan practices, a crowd most probably composed of pugnacious troublemakers who almost certainly had been goaded into action by the local bishop, set out to raze the Serapeum and either pillage or destroy every single marvel it contained. No doubt because they had all been written by pagan authors, the works of literature, more than anything else, would have received particularly rough treatment at the hands of the mob. None of the men would have been literate, and the instructions to burn every volume they found must have

come down from a higher authority. Neither the nature nor the number of the irreplaceable masterpieces of ancient literature which were lost forever has been recorded, but the wanton destruction of so many venerable treasures must have left the local residents stunned and terrified, regardless of what their religious sympathies might have been. The savage obliteration of the Serapeum and its contents marked the onset of Alexandria's decline.

It could have been foreseen that Christian attitudes would soften, gradually but nonetheless steadily, once the general social standing of their community had begun to improve and the number of their followers increased. "The major change in the fourth century is not so much the defeat of paganism as its change of status. In the face of an imperially backed Christianity, support for the traditional cults of Rome was no longer taken for granted as part of the definition of 'being Roman'; they became a matter of choice."[9] As the population of the empire began to voluntarily adopt a new religion, which up to that point had been in turn either forbidden or imposed by imperial decree, Christian leaders would gradually come to take up certain traditional customs and conventions which they could have discovered only among their polytheistic contemporaries, Roman or otherwise. Certainly the evidence offered by the tombs found in any early Christian necropolis would indicate that the iconography used by budding Christian artists had been inspired directly by pagan prototypes. The very first depictions of Jesus could easily be mistaken for Apollo, the young Serapis or, in fact, for any number of other Roman gods. In the field of architecture the early Christian builders not only patterned their designs on existing pagan structures, but in most cases, as has been discussed, actually incorporated into their construction elements plundered from

abandoned Roman temples. At the very beginning of Christian art the line between pagan and Christian expression was, in the majority of cases, much too fine to be noticeable.

The official determination that Christmas would be celebrated annually at the end of December was made only in the middle of the fourth century. At that time the correlation between polytheistic and Christian traditions was still very much under negotiation, and in consequence the status quo remained subject to periodic adjustment: when Julian the Apostate had ascended the throne of the Roman Empire, he had immediately tipped the balance in favor of his instinctive paganism. It was Pope Liberius, just then the leader of the Christian community, who decided that it would be a clever idea to set the timing of one or another Christian celebration to coincide with *Saturnalia*, a prominent pagan festival dedicated to Saturn, the popular Roman god of agriculture. By that stage the Christian hierarchy must have come to the realization that it would be much easier for them to increase the number of converts if they could somehow manage not to disturb the timing of the traditional public holidays, events which the general population of the Roman Empire had always enjoyed with intense and joyful enthusiasm.

It made good sense for Pope Liberius to have selected the day of the Nativity of Jesus for his plan, if only because prior to that moment Christmas had never been part of the calendar of ecclesiastical festivals; Easter had always been the principal Christian feast day until then. The celebration of *Saturnalia*, on the other hand, had invariably taken place on the winter solstice, the shortest day of the year. This was the precise moment when, by long-established custom, almost all ancient cultures in the western world marked the beginning of the sun's return journey to the skies above the northern hemisphere. Pope Liberius deliberately—and quite cleverly—

took advantage of the great popularity of *Saturnalia* and announced that, from then on, the celebration of Christmas would take place every year on the 25th day of December, completely disregarding the rather critical fact that it was almost impossible for Jesus to have been born on that particular date. The arbitrary but expedient association of the birth of the Saviour with a crowd-pleasing bout of pagan revelry, like *Saturnalia*, was an act of dispassionate Machiavellian shrewdness appearing to show, more than anything else, that the elders of the Christian community were beginning to grow much more cunning in their ways. Their skill in manipulating the pagan world to their own advantage was only just beginning to emerge.

The establishment of Christmas as one of the key Christian feast days would turn out to be of incalculable importance to the development of colorful popular devotional practices in every part of the Christian world over the course of many centuries. All the same it is the later adoption of the grand imperial title of *Pontifex Maximus* by the Pope which might well represent the most extraordinary Christian appropriation of any pagan tradition. There have been a great many others, both before and since then, but none has ever approached the sheer audacity of that particular act of arrogance. It is not easy to explain how the representative of a humble Palestinian man who had spent his life as a simple itinerant prophet would ever have thought it appropriate, on any level, to assume for himself an honor which historically had been the preserve of pagan monarchs. *Pontifex Maximus* had been a dignity accorded to the Roman Emperor, but the actual meaning of the Latin designation is *the supreme bridge builder*. It is a title still used in modern times to refer to the Bishop of Rome, as are its obvious derivatives *pontiff* and *pontifical*. It would seem

that there was no holding back as soon as Christian gates were open to syncretic compromise.

A great many other similar developments appear to indicate that the members of the upper hierarchy of the ascendant Christian Church, having at last gained firm favor among the patrician elements of imperial Roman society, might have been, if not eager, at least ready to leave behind the humble social and intellectual roots of their chosen religion. Latin would eventually be selected as the liturgical language of western Christianity, disregarding the fact that in late classical times very few of the Christian faithful would have understood it to any extent, and that no part of the Bible had been originally written in that language. It would almost seem as if the Christian elders had deliberately wanted to make it difficult, if not entirely impossible, for the majority of their followers to understand the words regularly used in liturgical celebrations. It had always been the case that Latin was a language spoken primarily by the more affluent and better-educated members of Roman society; the majority of early Christians would not ever have been in a position to learn it at all.

The language known as *Koiné* was a late form of classical Greek which was to become the lingua franca among by far the largest part of the population of the Roman Empire, including even those who lived in the city of Rome itself. Most of the people in attendance at early Christian liturgies would have entirely missed the meaning of any service conducted in Latin. All the same the Roman Catholic mass continued to be celebrated in Latin until the Second Vatican Council introduced the use of the vernacular in the late 1960's. Until that change came about, the faithful would have remained as ignorant of the meaning of the words they heard in church as their predecessors had been in early Chris-

tian days. The majority of early converts to Christianity would have used *Koiné* Greek to communicate with each other; the whole of the New Testament was written in that language. Nonetheless, and in what must have been another effort to evoke imperial authority, the hierarchy of the fledgling Roman Catholic Church inexplicably decided to reject the linguistic traditions of her faithful members in favor of Latin, the majestic language of her pagan oppressors.

It would be seriously naïve and wide of the mark to presume that pagan traditions and rituals would have automatically disappeared after Christianity took over as the principal religion of the Western world. There is evidence that pagan festivals were still commonly held in the streets of Rome even as late as the very end of the fifth century, more than six decades after the death of Saint Augustine, the prolific author, highly influential theologian and Latin Father of the Church. By this time Christianity had been wielding officially unfettered religious authority in all of Europe for over one hundred years but, even at that stage, divergent religious practices still continued to enjoy syncretic currency among the people of the Christian world. It became necessary for Pope Gelasius the First, Bishop of Rome in the late 490's, to write a "stern letter to some of his fellow Christians in the city, denouncing those who continued to celebrate the ancient ritual of *Lupercalia*."[10] The great antiquity of this exceedingly curious Roman festival is suggested by the fact that it was dedicated to the *Lupa* or she-wolf that by tradition had suckled the orphaned twins Romulus and Remus, founders of Rome.

Lupercalia had been held each year in mid-February as long as anyone in the city could remember; it required those young men who were willing to take part, most likely every single one of them an ingrained narcissistic show-off, to run

almost entirely naked through the streets of Rome, striking anyone they would encounter with the short leather whip they were expected to carry with them. "It is no doubt true that in Roman religious practice, as in many others, rituals were maintained from year to year out of a general sense of scrupulousness, even where their original significance was long forgotten."[11] There might well have been reasons other than shameless exhibitionism, combined with prurient voyeurism, for the enduring popularity enjoyed by *Lupercalia* among the Romans, but if there were they have indeed been long forgotten. In any case, and unlikely as it may now seem to most people in the modern world, half a millennium into the current era, evidently there were still many sophisticated Roman citizens who were willing to risk the displeasure of Pope Gelasius to assert their right to celebrate this bizarre ritual just as tradition demanded. "Proper worship of the Roman gods ensured the success of Rome: that was an axiom not easily overthrown, even by Christians in the late fifth century."[12]

The enduring respect always shown by Roman citizens of a certain social class for religious traditions with the longest pedigrees might explain the longevity of many of these peculiar local festivals. "One thing is clear enough. The action of Christian bishops did not mean the ending of the old festivals, either at Rome or elsewhere in the empire. It was not simply a question of 'paganism' successfully resisting Christianity. There is, after all, no reason to assume that those who continued to watch the scantily clad young men race around the city thought of themselves as 'non-Christian.' The boundary between paganism and Christianity was much more fluid than that simple dichotomy would suggest and much more fluid than some Christian bishops would have liked to allow."[13] The real challenge facing the early Christian hierarchy would not have been how to eradicate traditional

festivals like *Lupercalia,* but rather how to find a way to preserve their form and practice while shifting their cultic focus from pagan to Christian objects of devotion. For obvious reasons *Lupercalia* has not survived but, if only some clever bishop had managed to switch the figure of the she-wolf for an early Christian martyr, it might still have been possible to watch the festival celebrated in the streets of Rome even today.

There were many members of the pagan intelligentsia who had continued to oppose the new religion on rational rather than on doctrinal grounds. Recognizing the potential benefit of eventually gaining such influential figures as converts to Christianity, the early bishops must have come to the conclusion that, if their opponents could ever be won over, it would only be on their own intellectual terms. A prodigious amount of time, and probably an even greater amount of perseverance, would have been spent searching through the few surviving texts of ancient Greek philosophy in the hope of finding even a small patch of ground common to both schools of thought. "Early Christianity was a very different religion from its modern descendant—much less familiar in its doctrines, morality or organisation than we might prefer to imagine."[14] The effort must be seen as most probably the final application of the same syncretic principles guiding Roman religious practice since they had been initially codified. The various scholars who would become engaged in the attempt to formulate Christian doctrine on the basis of rational criteria would come to be known as Christian Apologists. Saint Augustine of Hippo is perhaps the most eminent, and certainly one of the very earliest, of a long and distinguished line of Apologetic theologians continuing unbroken until modern times.

Unfortunately not all attempts to reconcile Christian

and pagan points of view would have adhered to the same exacting methodology. The ancient figures of the sibyls would inevitably have come up for considered reassessment at a certain stage of the process. At first they would have been perceived most probably as slightly inconvenient relics from the pagan past. There was no question, however, that simply ignoring their presence might have been a possible option: the authority commanded by these prophetic women throughout the Roman Empire, combined with the extraordinary degree of public recognition they had never ceased to enjoy among the general population of the classical world, would have meant that the early church hierarchy had no choice but to find a way to deal with them, and if at all possible even to use them in the context of advancing the Christian faith. The thorny question would have been how to manage to get around the inescapable fact that the sibyls' roots were firmly embedded in the deepest layers of polytheistic paganism. Almost no part of any story concerning the sibyls has ever been straightforward but, for once, on this occasion the solution would turn out to be quite simple: a crop of new sibylline oracular pronouncements would have to be found. "Oracles ended when paganism ended and paganism did not end with the coming of Jesus Christ."[15]

The first of the new oracles to be released to the public would have needed to deal with events in the past. The idea must have been to "provide a selection of prophecies that a regular reader could recognize as being substantially true so that the reader might be inclined to believe whatever other information the author was seeking to purvey."[16] As callous and dishonest as these stratagems might appear to be to a twenty-first century audience, it would have been neither the first nor the last time that such deceptive ploys would be attempted by well-meaning dogmatists during the early periods

of Christian expansion. The infamous document known as the Donation of Constantine first made its appearance in the eighth century, but its spurious date appeared to suggest that it had been written four hundred years earlier, and at the personal command of the respected Emperor Constantine himself. The alleged reason behind it was the emperor's intention to confer on the pope full temporal authority over all the western regions of the Roman Empire, an area which in Constantine's time had been under his control and therefore in his power to give away if he so wished. By the eighth century, however, these lands had become divided among a large number of secular rulers who held a dizzying variety of ranks and powers. Considering the widespread political and economic implications of the proposal, it is not in the least surprising that the authenticity of the document came into question at once. Under expert scrutiny it was eventually established beyond any reasonable doubt that it had been nothing other than a clever but unsuccessful forgery.

The series of pseudo-sibylline prophetic writings grouped together, regardless of their motley authorship and inconsistent dates, under the single collective label of Sibylline Oracles, were mostly composed over a period of a few decades starting in the middle of the second century. There is sufficient historical evidence to indicate that, already four hundred years earlier, there had been a sizeable number of Jewish authors living in Egypt who regularly adapted sibylline textual forms to further their own religious agenda. "As early as the second half of the second century AD Christians had taken over the genre of Sibylline literature from Hellenistic Diaspora Judaism, which had used it as missionary propaganda. After all, Sibyls enjoyed a high status not only in the Hellenic but also in the Latin world. Early Christianity, therefore, followed the example of Judaism and utilised the poten-

tial of the Sibylline genre to promote its religious beliefs."[17] By now it will have become obvious to all readers that these so-called oracles, despite their designation as 'sibylline,' had never been revealed to any of the sibyls, ancient or not. The history of interpretation, theological impact and precise content of the Sibylline Oracles all lie outside the scope of this study; for the purpose at hand it will be sufficient to note their most salient features.

The Sibylline Oracles must never be confused with the Sibylline Books once kept under guard in Rome to be consulted with the greatest reverence in times of trouble; in general the overarching theme of the pseudo-sibylline works is uniformly apocalyptic and eschatological. Since long before they were first published in the sixteenth century, they appear to have been preserved in two groups divided into fourteen books. Neither the chronology of their production nor the identity of the various Jewish and Christian writers responsible for their composition has ever been established. Nonetheless the various texts, at least in the form they have come down to us, would certainly suggest that all of the different authors were united in their wish to have their efforts accepted as genuine sibylline oracular sayings, handed down from Greek antiquity. Their literary style consistently follows the traditional conventions of ancient Greek oracular works, even to being set in classical Homeric hexameters. "The pagan Sibyl fell silent as the Judeo-Christian one began to speak. Like her pagan sister, she spoke Greek."[18]

Quite likely a few of the individual sections would have incorporated a number of short fragments transposed directly from much older and entirely genuine sibylline sayings; these bits would have been thrown into the mix for the purpose of creating a suggestion of authenticity reasonable enough to deceive the general reader. It would certainly appear that the

ruse worked remarkably well for a while: in early Christian times the vast majority of scholars and church historians considered the Sibylline Oracles to be the authentic revelations of a number of keenly visionary sibyls who had lived in pagan times and had foretold the rise of Christianity. The anonymous authors of the Sibylline Oracles "thus placed Christian prophecies concerning both the Nativity and the Second Coming into the mouth of the Sibyls to use apparently pagan prophecy to undermine pagan polytheism from within its own ranks."[19]

Titus Flavius Clemens, more widely remembered as Clement of Alexandria, was an authoritative and learned second-century theologian who is ranked still to this day among the most influential fathers of the early Christian Church. In his *Exhortation to the Greeks* he openly urges the sibyl to sing the song of salvation which, he wholeheartedly believed, she could do better and more accurately than anyone else known to him. Lucius Caecilius Firmianus Lactantius, the man who at one time held the extraordinarily prominent position of adviser to Emperor Constantine, certainly had the same exalted opinion of the prophetess. In one of his most significant works, the *Divine Institutes*, he "makes more references to the Sibyl than he does to all the Old Testament prophets combined. He cites the prophetess on monotheism, on everlasting life, the Fall of Man, the coming of the Son of God, His life and miracles, His Passion and Resurrection."[20] No other authority is quoted as many times or on nearly as many doctrinal matters.

Clement and Lactantius are but two of the early Christian scholars who held the sibyls in such high regard: a great many others were of the same mind. The unexpected appearance of the Sibylline Oracles must have created a commotion among the small but eager group of Christian Apologists and

early scriptural exegetes. In the midst of what must have been their tremendous excitement, the line dividing the figures of the pagan sibyls from their fraudulent Judeo-Christian counterparts slowly would have dissolved and eventually ceased to matter. Not only would the traditional authority of the authentic pagan sibyls fail to be adversely affected by this confusion, but in the process these pagan women would actually acquire new identities as veritable Christian visionaries. The case of the Sibylline Oracles would turn out to be still more surprising: not long after their appearance they would come to enjoy the same level of legitimacy as had been previously granted only to the long-hallowed prophecies of the respected canonical prophets in the Hebrew Bible. Ultimately it would have to be precisely in this illusionary proximity of the figures of all the different sibyls—authentic or fictional, pagan or Christian—to the Old Testament prophets, where an explanation can be found for the presence of their juxtaposed images on the ceiling of the Sistine Chapel.

EPILOGUE

Just as God our Lord granted prophets to the Jews in order for them to receive notice of the coming of the Son of God into the world, so did He grant to the Greeks and to the Gentiles prophetesses who would provide them with the same knowledge, so that at no time would they be able to claim ignorance of such an important matter.

BALTHASAR PORREÑO,
Oraculos de las doçe Sibilas Profetisas de Christo nuestro Señor entre los Gentiles

The figure of the sibyl is of such a beguiling nature not simply as a result of her ability to tell us what is going to happen, or by giving us the reassurance that whatever has happened had been ordained to happen. Perhaps much more than for any other reason, the sibyl might have endured because she offers a subliminal yet forceful suggestion that knowledge, understanding and ultimately wisdom are gained by human beings through intuition and not necessarily by deliberate intellectual effort. In the Western tradition humans first encounter God as creator and if it is accepted that humans are made in the image of the creator then we become most genuinely like God when we dream, when we imagine, when we ourselves create. Every attempt to explain human creativity merely on entirely rational terms has failed: creation might be reflec-

tive, but it is intuitive and not primarily rational in its most fundamental essence.

Intuition has been defined by many as a dynamic manifestation of the eternal feminine, a concept as frequently denounced as it has been thoroughly misinterpreted. The eternal feminine, understood as the intuitive side of human nature, might well be the primordial source of all human knowledge and enduring wisdom. In principle the rational and the intuitive aspects of individual human personalities should not oppose but rather complement each other; they coexist in variable degrees within all human beings of any age and either gender. Albino Luciani, who occupied the papal throne as John Paul the First for just one month in 1978, gave expression to this inescapable duality when he professed his conviction that "God is Father, and even more, God is Mother."

The very existence of the nine mythological women known as the Muses would appear to confirm the feminine nature of creative inspiration; this is tacitly acknowledged by Robert Graves when he writes that "the poet gives the Muse sole credit for his poems."[1] The sibyl proclaimed her prophecies in hexameter verses inspired by a divine source which could be labeled either Calliope or Ge, a Muse or the Earth Mother. Graves goes on to explain that "the poetic trance derives from ecstatic worship of the age-old matriarchal Greek Muse, who ruled Sky, Earth, Underworld in triad, and was worshipped on mountains. Hence her name—the Greek word *mousa* being etymologically connected with the Latin *mons*. Her altars—stone herms, or baetyls, around which women devotees danced counter-clockwise at lunar festivals—stood on the foothills of Parnassus, Olympus and Helicon."[2]

The twelfth-century French theologian Peter Abelard has been considered by most scholars of his own and later

generations to have possessed the keenest intellect among all of his contemporaries. According to the distinguished Cambridge academic Peter Dronke, Abelard had been alert to the affiliated idea of the feminine nature of prophetic intuition. "What moves Abelard most about the Sibyls is that these inspired teachers were women."[3] The erudite Scholastic thinker believed that in the field of prophecy, the ability shown by women eclipsed by far the highest levels any man had ever managed to attain at any time in history. The evident admiration which Abelard felt for the sibyl would move him to write that in his opinion "she seems to surpass not only the prophets but the evangelists themselves."[4] Loftier praise from a Christian author would be impossible to find.

The story of the transfer to Rome of the ancient Greek cult of the Great Mother from Mount Ida tells us a great deal about the role which both sibyls and goddesses played at a time when Rome counted primarily on female figures to safeguard the preservation of its institutions and ensure the successful expansion of its dominions. The Romans had not yet managed to establish full supremacy in the Mediterranean world, even though they had already fought one victorious war against Carthage, their most powerful rival. Two decades after the end of the first conflict the second Punic War had broken out and this time things were not going well for Rome. Hannibal had crossed the Alps with his Carthaginian troops and the Roman army had been massacred not too far to the north of the imperial city. It was reported that the number of Roman soldiers killed by the enemy had been so high that the water of a local river had turned red with blood. To this day the stream is still known as *Sanguineto* from the Latin word *sanguis*, which means *blood*.

As had by then become the tradition at times of crisis,

the *quindecimviri* were asked to consult the Sibylline Books: their conclusion was that Hannibal would be stopped only by the immediate establishment in Rome of the cult of the Great Mother from Mount Ida in the Troad, the area of Asia Minor where Aeneas was born and Troy had flourished. The Delphic Sibyl would almost certainly have been consulted by the cautious Roman envoys on their way to Mount Ida in search of the Great Mother. Erythrae, the city where the last of the three sibyls connected to the story had her shrine, was directly south of the Troad. There is no record that the Erythaean Sibyl was approached by the Romans on the way to Mount Ida, but she would almost certainly have been present to give her blessing to the proceedings before they returned to Rome. Just one year after the safe arrival of the Great Mother on the Palatine Hill the Romans won the war. "Historical tradition linked the final triumph to the coming of the Great Mother. The Sibylline Books had given instructions, the Roman people carried them out, and victory was attained."[5] In fact, it had taken the intervention of three sibyls and one goddess to defeat Carthage and establish Roman supremacy in the Mediterranean world. Men had done the fighting, but otherwise it would have been an almost entirely matriarchal operation with all the directions coming from women and the presence of the Great Mother to turn the tide and win the war.

Graves has expressed his certainty that "the chaotic ethics of our epoch derive, I believe, from a revolution in early historical times that upset the balance between male and female principles: namely, the supersession of matriarchy by patriarchy. This revolt, and the subsequent patriarchal cult of reason (as opposed to intuitive thought), gave men control over most domestic, agricultural and other arts."[6] In a recent interview the German violinist Christian Tetzlaff expressed

his views on his particularly demanding art. "As a player, you really don't interpret any more. You listen, together with the audience." This is precisely what the sibyls did during their long and fruitful lives: they listened. Intuitive thought may have been sidelined, but it has never been entirely suppressed. Men like Tetzlaff and Graves, along with the many daughters of the sibyls, have seen to that.

SELECT BIBLIOGRAPHY

Apostolos-Cappadona, Diane. *Dictionary of Women in Religious Art.* New York: Oxford University Press, 1998.

Ariosto, Ludovico. *Orlando Furioso.* Venice: Francesco Pitteri, 1741.

Augustine of Hippo. *The City of God against the Pagans.* Edited and translated by R. W. Dyson. Cambridge and New York: Cambridge University Press, 1998.

Beard, Mary, John North, and Simon Price. *Religions of Rome. Volume 1: A History.* Cambridge and New York: Cambridge University Press, 1998.

Bevan, Edwyn Robert. *Sibyls and Seers.* London: George Allen and Unwin, 1928.

Boccaccio, Giovanni. *Famous Women.* Translated by Virginia Brown. Cambridge, MA, and London: Harvard University Press, 2003.

———. *Genealogy of the Pagan Gods.* Volume One, Books I–V. Edited and translated by Jon Solomon. Cambridge, MA, and London: Harvafd University Press, 2011.

Bonnefoy, Yves. *Roman and European Mythologies.* Translated under the direction of Wendy Doniger. Chicago and London: University of Chicago Press, 1991.

Bundesen, Lynne. *The Feminine Spirit: Recapturing the Heart of Scripture*. San Francisco: Jossey-Bass, 2007.

Burkert, Walter. *Greek Religion Archaic and Classical*. Translated by John Raffan. Oxford, UK: Basil Blackwell, 1985.

Cicero, Marcus Tullius. *De Divinatione*. Translated by W. A. Falconer. Cambridge, MA: Loeb Classical Library, Harvard University Press, 1923.

Collins, John Joseph. *Seers, Sibyls and Sages in Hellenistic-Roman Judaism*. Leiden: Brill, 1997.

Connelly, Joan Breton. *Portrait of a Priestess: Women and Ritual in Ancient Greece*. Princeton, NJ: Princeton University Press, 2007.

Dronke, Peter. *Hermes and the Sibyls: Continuations and Creations*. Cambridge and New York: Cambridge University Press, 1990.

Fontenelle, M. de (Bernard Le Bovier). *Histoire des Oracles*. Amsterdam: Pierre Mortier, 1687.

Fontenrose, Joseph. *The Delphic Oracles, Its Responses and Operations*. Berkeley: University of California Press, 1978.

Fraschetti, Augusto. *Roman Women*. Translated by Linda Lappin. Chicago: University of Chicago Press, 2001.

Gales, Richard Lawson. *Old-World Essays: On the Sibyls*. London: Daniel O'Connor, 1921.

Goldwin, William. *The Double Tongue*. London: Faber and Faber, 1995.

Graves, Robert. *Mammon and the Black Goddess*. London: Cassell, 1965.

Greer, Germaine. *Slip-Shod Sibyls: Recognition and the Woman Poet*. London: Viking, 1995.

Guerber, H. A. *The Myths of Greece and Rome: Their Stories, Signification and Origin*. London: George G. Harrap & Company Ltd., 1907.

Holdenried, Anke. *The Sibyl and Her Scribes: Manuscripts and Interpretation of the Latin Sibylla Tiburnina c. 1050–1500*. Aldershot, UK, and Burlington, VT: Ashgate Publishing, 2006.

Ilarregui, Gladys M. *The Cumaean Sibyl*. Edited and introduced by Judy B. McInnis. New Orleans: University of the South, 1999.

Jacobus de Voragine. *The Golden Legend: Readings on the Saints*. Translated by William Granger Ryan with an introduction by Eamon Duffy. Princeton, NJ, and Oxford, UK: Princeton University Press, 2012.

Kahn, Charles H. *The Art and Thought of Heraclitus: An Edition of the Fragments with Translation and Commentary*. Cambridge and New York: Cambridge University Press, 1979.

Lactantius, Lucius Caecilius Firmianus. *Divine Institutes* (Divinarum Institutionum). Translated by Anthony Bowen and Peter Garnsey. Liverpool, UK: Liverpool University Press, 2003.

Lightfoot, J. L. *The Sibylline Oracles*. Oxford, UK, and New York: Oxford University Press, 2007.

Lucan. *Civil War*. Translated by P. F. Widdows. Bloomington: Indiana University Press, 1988.

Mâle, Émile. *Religious Art from the Twelfth to the Eighteenth Century*. Princeton, NJ: Princeton University Press, 1982.

Parke, H. W. *Greek Oracles*. London: Hutchinson University Library, 1967.

————. *Sibyls and Sibylline Prophecy in Classical Antiquity.* Edited by B. C. McGing. London and New York: Routledge, 1988.

Parke, H. W., and D. E. W. Wormell. *The Delphic Oracle. Volume 1: The History.* Oxford, UK: Basil Blackwell, 1956.

Parkin, Tim G. *Demography and Roman Society.* Baltimore: Johns Hopkins University Press, 1992.

Pausanias. *Guide to Greece. Volume 1: Central Greece.* Translated by Peter Levi. London: Penguin Books, 1971.

————. *Guide to Greece. Volume 2: Southern Greece.* Translated by Peter Levi. London: Penguin Books, 1971.

Pollard, John. *Virgil and the Sibyl.* Exeter, Devonshire, UK: University of Exeter, 1982.

Porreño, Balthasar. *Oraculos de las doçe Sibilas Profetisas de Christo nuestro Señor entre los Gentiles.* Cuenca: Domingo de la Iglesia, 1621.

Potter, David Stone. *Prophecy and History in the Crisis of the Roman Empire: A Historical Commentary on the Thirteenth Sibylline Oracle.* Oxford, UK: Clarendon Press, 1990.

————. *Prophets and Emperors: Human and Divine Authority from Augustus to Theodosius.* Cambridge, MA: Harvard University Press, 1994.

————. *The Roman Empire at Bay: AD 180–395.* New York: Routledge, 2004.

Ritchie, Anne Thackeray. *A Discourse on Modern Sibyls.* London: The English Association, 1913.

Sackur, Ernst. *Sibyllinische Texte und Forschungen.* Halle: Max Niemeyer, 1898.

Takács, Sarolta A. *Vestal Virgins, Sibyls, and Matrons: Women in Roman Religion*. Austin: University of Texas Press, 2008.

Torjesen, Karen. *When Women Were Priests*. San Francisco: HarperSanFrancisco, 1993.

Virgil. *The Aeneid*. Translated by Cecil Day Lewis. London: Hogarth Press, 1952.

Watson, Peter. *The Great Divide: History and Human Nature in the Old World and the New*. London: Weidenfeld and Nicolson, 2011.

Wood, Michael. *The Road to Delphi: The Life and Afterlife of Oracles*. New York: Farrar, Straus and Giroux, 2003.

NOTES

1: PROPHECY IN THE ANCIENT WORLD

1. David Stone Potter, *Prophets and Emperors: Human and Divine Authority from Augustus to Theodosius* (Cambridge, MA: Harvard University Press, 1994), 6.

2. Michael Wood, *The Road to Delphi: The Life and Afterlife of Oracles* (New York: Farrar, Straus and Giroux, 2003), 6.

3. H. W. Parke, *Greek Oracles* (London: Hutchinson University Library, 1967), 80.

4. Walter Burkert, *Greek Religion Archaic and Classical*, trans. John Raffan (Oxford, UK: Basil Blackwell, 1985), 112.

5. Ibid., 109.

6. Ibid., 113.

7. Marcus Tullius Cicero, *De Divinatione*, trans. W. A. Falconer (Cambridge, MA: Loeb Classical Library, Harvard University Press, 1923), Book 1, Chapter 34.

8. Wood, *The Road to Delphi*, 14.

9. Burkert, *Greek Religion Archaic and Classical*, 118.

10. Ibid., 112.

11. Ibid., 109.

12. Sarolta A. Takács, *Vestal, Sibyls, and Matrons: Women in Roman Religion* (Austin: University of Texas Press, 2008), xxiii.

13. Ibid., 60.

14. Burkert, *Greek Religion Archaic and Classical*, 111.

15. Ibid., 114.

16. Wood, *The Road to Delphi*, 28.

17. Burkert, *Greek Religion Archaic and Classical*, 114.

18. Wood, *The Road to Delphi*, 24.

19. Potter, *Prophets and Emperors*, 4.

20. Ibid., 5.

2: WOMEN AND PROPHECY

1. Richard Lawson Gales, *Old-World Essays: On the Sibyls* (London: Daniel O'Connor, 1921), 27.

2. Peter Watson, *The Great Divide: History and Human Nature in the Old World and the New* (London: Weidenfeld and Nicolson, 2011), xxvii.

3. H. W. Parke and D. E. W. Wormell, *The Delphic Oracle. Volume 1: The History* (Oxford, UK: Basil Blackwell, 1956), 10.

4. Giovanni Boccaccio, *Famous Women*, trans. Virginia Brown (Cambridge, MA, and London: Harvard University Press, 2003), Chapter 35.

5. Michael Wood, *The Road to Delphi: The Life and Afterlife of Oracles* (New York: Farrar, Straus and Giroux, 2003), 105.

6. Boccaccio, *Famous Women*, Chapter 35.

7. Sarolta A. Takács, *Vestal Virgins, Sibyls, and Matrons: Women in Roman Religion* (Austin: University of Texas Press, 2008), 81.

8. Saint Paul of Tarsus, Epistle to the Romans 12:6.

9. David Stone Potter, *Prophets and Emperors: Human and Divine Authority from Augustus to Theodosius* (Cambridge, MA: Harvard University Press, 1994), 92.

3: The Erythranean Sibyl

1. Pausanias, *Guide to Greece, Volume 1: Central Greece*, trans. Peter Levi (London: Penguin Books, 1971), Book 10, Chapter 12.

2. Lucius Caecilius Firmianus Lactantius, *Divine Institutes* (Divinarum Institutionum), trans. Anthony Bowen and Peter Garnsey (Liverpool, UK: Liverpool University Press, 2003), Book One, Chapter 6.

3. Giovanni Boccaccio, *Famous Women*, trans. Virginia Brown (Cambridge, MA, and London: Harvard University Press, 2003), Chapter 21.

4. Balthasar Porreño, *Oraculos de las doçe Sibilas Profetisas de Christo nuestro Señor entre los Gentiles* (Cuenca: Domingo de la Iglesia, 1621), 68.

5. Pausanias, *Guide to Greece, Volume 1*, Book 10, Chapter 12.

6. H. W. Parke, *Sibyls and Sibylline Prophecy in Classical Antiquity*, ed. B. C. McGing (London and New York: Routledge, 1988), 39.

7. Pausanias, *Guide to Greece, Volume 1*, Book 10, Chapter 12.

8. Ibid., Book 10, Chapter 5.

9. Charles H. Kahn, *The Art and Thought of Heraclitus: An Edition of the Fragments with Translation and Commentary* (Cambridge and New York: Cambridge University Press, 1979), 125.

10. David Stone Potter, *Prophecy and History in the Crisis of the Roman Empire: A Historical Commentary on the Thirteenth Sibylline Oracle* (Oxford, UK: Clarendon Press, 1990), 108.

11. David Stone Potter, *Prophets and Emperors: Human and Divine Authority from Augustus to Theodosius* (Cambridge, MA: Harvard University Press, 1994), 13.

12. Lactantius, *Divine Institutes*, Book 1, Chapter 6.

13. Walter Burkert, *Greek Religion Archaic and Classical*, trans. John Raffan (Oxford, UK: Basil Blackwell, 1985), 117.

14. Parke, *Sibyls and Sibylline Prophecy in Classical Antiquity*, 44.

15. Ibid., 138.

16. Augustine of Hippo, *The City of God against the Pagans*, ed. and trans. R. W. Dyson (Cambridge and New York: Cambridge University Press, 1998), Book 18, Chapter 23.

17. Lactantius, *Divine Institutes*, Book 1, Chapter 6.

18. Boccaccio, *Famous Women*, Chapter 21.

19. Anke Holdenried, *The Sibyl and Her Scribes: Manuscripts and Interpretation of the Latin Sibylla Tiburnina c. 1050–1500* (Aldershot, UK, and Burlington, VT: Ashgate Publishing 2006), 60.

20. Eusebius of Caesarea, *Oration of Constantine*, Chapter 18.

21. Augustine of Hippo, *The City of God against the Pagans*, Book 18, Chapter 23.

22. Eusebius of Caesarea, *Oration of Constantine*, Chapter 18.

4: THE CUMAEAN SIBYL

1. Alcina was the name of one of the principal characters in Ariosto's *Orlando Furioso*, an epic poem which enjoyed mythical popularity in Europe for a considerable time. The English scholar Barbara Reynolds referred to it as "one of the most influential works in the whole of European literature."

2. Giovanni Boccaccio. *Famous Women*, trans. Virginia Brown (Cambridge, MA, and London: Harvard University Press, 2003), Chapter 26.

3. Michael Wood, *The Road to Delphi: The Life and Afterlife of Oracles* (New York: Farrar, Straus and Giroux, 2003), 118.

4. Ibid.

5. Virgil, *The Aeneid*, trans. Cecil Day Lewis (London: Hogarth Press, 1952), Book 3.

6. Ibid.

7. Ibid.

8. Ibid.

9. Ibid., Book 6.

10. Ibid.

11. Ibid.

12. Ibid.

13. Ibid.

14. Ibid.

15. Ibid.

16. Ibid.

17. Ibid.

18. Ibid.

19. Ibid.

20. Ibid.

21. Ibid.

22. Ibid.

23. Ibid.

24. Ibid.

25. Wood, *The Road to Delphi*, 116.

26. Ibid.

27. David Stone Potter, *Prophecy and History in the Crisis of the Roman Empire: A Historical Commentary on the Thirteenth Sibylline Oracle* (Oxford, UK: Clarendon Press, 1990), 112.

28. Lucius Caecilius Firmianus Lactantius, *Divine Institutes* (Divinarum Institutionum), trans. Anthony Bowen and Peter Garnsey (Liverpool, UK: Liverpool University Press, 2003), Book 1, Chapter 6.

29. Potter, *Prophecy and History in the Crisis of the Roman Empire*, 110.

30. Marcus Tullius Cicero, *De Divinatione*, trans. W. A. Falconer (Cambridge, MA: Loeb Classical Library, Harvard University Press, 1923), Book 1, Chapter 34.

31. Virgil, *Eclogue IV*.

32. Ibid.

33. Augustine of Hippo, *The City of God Against the Pagans*, ed. and trans. R. W. Dyson (Cambridge and New York: Cambridge University Press, 1998), Book 10, Chapter 27.

34. Boccaccio, *Famous Women*, Chapter 26.

35. Wood, *The Road to Delphi*, 117.

5: THE DELPHIC SIBYL

1. Walter Burkert, *Greek Religion Archaic and Classical*, trans. John Raffan (Oxford, UK: Basil Blackwell, 1985), 117.

2. Edwyn Robert Bevan, *Sibyls and Seers* (London: George Allen and Unwin), 138.

3. Burkert, *Greek Religion Archaic and Classical*, 109.

4. Charles H. Kahn, *The Art and Thought of Heraclitus: An Edition of the Fragments with Translation and Commentary* (Cambridge and New York: Cambridge University Press, 1979), 125.

5. Burkert, *Greek Religion Archaic and Classical*, 110.

6. Pausanias, *Guide to Greece, Volume 1: Central Greece*, trans. Peter Levi (London: Penguin Books, 1971), Book 10, Chapter 5.

7. Ibid., Book 10, Chapter 6.

8. Joseph Fontenrose, *The Delphic Oracle, Its Responses and Operations* (Berkeley: University of California Press, 1978), 1.

9. A number of scholars believe that the two manifestations of Poseidon stem from one and the same mythological figure. The original earth shaker would eventually become god of the sea, but only after Kronos decided to divide the world among his three sons, Zeus, Hades, and Poseidon.

10. Pausanias, *Guide to Greece, Volume 1*, Book 10, Chapter 5.

11. In modern times the word *python* has come to be applied to a large snake that kills its prey by constriction.

12. Pausanias, *Guide to Greece, Volume 1*, Book 10, Chapter 5.

13. Ibid.

14. H. W. Parke and D. E. W. Wormell, *The Delphic Oracle. Volume 1: The History* (Oxford, UK: Basil Blackwell, 1956), 2.

15. Pausanias, *Guide to Greece, Volume 1*, Book 10, Chapter 5.

16. Kahn, *The Art and Thought of Heraclitus*, 125.

17. Ibid.

18. Michael Wood, *The Road to Delphi: The Life and Afterlife of Oracles* (New York: Farrar, Straus and Giroux, 2003), 120.

19. Ibid., 54.

20. Ibid., 54, 55.

21. Ibid., 55.

22. Pausanias, *Guide to Greece, Volume 1*, Book 10, Chapter 7.

23. Burkert, *Greek Religion Archaic and Classical*, 110.

24. Pausanias, *Guide to Greece, Volume 1*, Book 10, Chapter 5.

25. Peter Levi in Pausanias, *Guide to Greece, Volume 1*, Book 2, 184.

26. Pausanias, *Guide to Greece, Volume 1*, Book 10, Chapter 7.

27. Ibid.

28. Ibid.

29. Ibid., Chapter 8.

30. Marcus Tullius Cicero, *De Divinatione*, trans. W. A. Falconer (Cambridge, MA: Loeb Classical Library, Harvard University Press, 1923), Book 1, Chapter 19.

31. Peter Levi in Pausanias, *Guide to Greece, Volume 1*, Book 2, 415.

32. Burkert, *Greek Religion Archaic and Classical*, 116.

33. Pausanias, *Guide to Greece, Volume 1*, Book 10, Chapter 6.

34. Fontenrose, *The Delphic Oracle*, 10.

35. Germaine Greer, *Slip-Shod Sibyls: Recognition, Rejection and the Woman Poet* (London: Viking, 1995), xxiii.

36. Pausanias, *Guide to Greece, Volume 1*, Book 10, Chapter 5.

37. Ibid., Book 10, Chapter 7.

38. Wood, *The Road to Delphi*, 134.

6: THE TIBURTINE SIBYL

1. Eamon Duffy in his introduction to Jacobus de Voragine, *The Golden Legend: Readings on the Saints*, trans. William Granger Ryan, intro. Eamon Duffy (Princeton, NJ, and New York: Oxford University Press, 2007), xii.

2. Ibid., xi.

3. Ibid., xii.

4. Balthasar Porreño, *Oraculos de las doçe Sibilas Profetisas de Christo nuestro Señor entre los Gentiles* (Cuenca: Domingo de la Iglesia, 1621), 42.

5. Lucius Caecilius Firmianus Lactantius, *Divine Institutes* (Divinarum Institutionum), trans. Anthony Bowen and Peter Garnsey (Liverpool, UK: Liverpool University Press, 2003), Book 1, Chapter 6.

6. H. W. Parke, *Sibyls and Sibylline Prophecy in Classical Antiquity*, trans. Virginia Brown (Cambridge, MA, and London: Harvard University Press, 2003), 9.

7. David Stone Potter, *Prophets and Emperors: Human and Divine Authority from Augustus to Theodosius* (Cambridge, MA: Harvard University Press, 1994), 141.

8. Jacobus, *The Golden Legend*, 40.

9. Ibid.

10. Ibid.

11. Ibid.

12. Ibid.

7: THE FUSION OF PAGAN AND CHRISTIAN TRADITIONS

1. Sarolta A. Takács, *Vestal Virgins, Sibyls, and Matrons: Women in Roman Religion* (Austin: University of Texas Press, 2008), 123.

2. Ibid, 26.

3. Mary Beard, John North and Simon Price, *Religions of Rome, Volume 1: A History* (Cambridge and New York: Cambridge University Press, 1998) 228.

4. Ibid, 229.

5. Ibid, 228.

6. Takács, *Vestal Virgins, Sibyls, and Matrons*, 122.

7. Beard, North and Price, *Religions of Rome, Vol. 1*, 236.

8. Takács, *Vestal Virgins, Sibyls, and Matrons*, 61.

9. Beard, North and Price, *Religions of Rome, Vol. 1*, 365.

10. Ibid, ix.

11. Ibid, 46.

12. Ibid, ix.

13. Ibid, 388.

14. Ibid, x.

15. Michael Wood, *The Road to Delphi: The Life and Afterlife of Oracles* (New York: Farrar, Straus and Giroux, 2003), 152.

16. David Stone Potter, *Prophets and Emperors. Human and Divine Authority from Augustus to Theodosius* (Cambridge, MA: Harvard University Press, 1994), 137.

17. Anke Holdenreid, *The Sibyl and Her Scribes: Manuscripts and Interpretation of the Latin Sibylla Tiburnina* (Aldershot, UK, and Burlington, VT: Ashgate Publishing 2006), 56.

18. Takács, *Vestal Virgins, Sibyls, and Matrons*, 68.

19. Holdenreid, *The Sibyl and Her Scribes*, 56.

20. Ibid.

EPILOGUE

1. Robert Graves, *Mammon and the Black Goddess* (London: Cassell, 1965), 144.

2. Ibid., 145.

3. Peter Dronke, *Hermes and the Sibyls: Continuations and Creations* (Cambridge and New York: Cambridge University Press, 1990), 13.

4. Ibid..

5. Sarolta A. Takács, *Vestal Virgins, Sibyls, and Matrons: Women in Roman Religion* (Austin: University of Texas Press, 2008), 65.

6. Graves, *Mammon and the Black Goddess*, 145.

ACKNOWLEDGMENTS

Most sincere thanks go to Michael Dobson who patiently read through every working draft, spotted many infelicities and offered countless and always insightful suggestions. I thank Alison Cathie for giving her encouragement and support to this project from its earliest stages, my agent Andrew Nurnberg, my editors, Jon Jackson in London and Tracy Carns and Dan Crissman in New York, the members of staff at the British Library and the London Library, Professor Catherine Cornille and Professor Joseph Selling of the University of Leuven whose erudition and scholarship have been an inspiration.

INDEX